**Prai**

"Hal Glatzer's *Too Dead to Swing* is a strong debut."
—*Publishers Weekly*

"The evocation of time and place is note-perfect,
the musical background richly detailed, the
narration and character drawing bright
and varied, the surprise solution
generously clued."
—Jon L. Breen, *Ellery Queen Mystery Magazine*

"Authentic period atmosphere, current modes of
social conduct, and believable plot
recommend [*A Fugue in Hell's Kitchen*]...."
—*Library Journal*

"Plenty of red herrings, *musiker* talk, vignettes of a grubby
(and sometimes violent) Depression-era New York."
—*Historical Novels Review*

"...an interesting series, one with a lot of respect for
those days of swing, with more than a little
foreshadowing of today's times."
—*Mystery News*

"Glatzer's atmospherics effectively evoke the swing era
...a lively jitterbug down memory lane."
—*Kirkus Reviews*

*For information on the audio-plays and more, visit*
**www.toodeadtoswing.com**
**www.fugue-mystery.com**
**lastfullmeasure.info**

# The Last Full Measure

Also by Hal Glatzer —

*Kamehameha County*
*The Trapdoor*
*Massively Parallel Murder*

THE KATY GREEN SERIES
*Too Dead to Swing*
*A Fugue in Hell's Kitchen*
*The Last Full Measure*

A KATY GREEN MYSTERY

# The Last  Full Measure

## HAL GLATZER

Palo Alto & McKinleyville, California
Perseverance Press / John Daniel & Company
2006

This is a work of fiction. Characters, places, and events are the product
of the author's imagination or are used fictitiously. Any resemblance
to real people, companies, institutions, organizations, or incidents
is entirely coincidental.

A PERSEVERANCE PRESS BOOK
Published by John Daniel & Company
A division of Daniel & Daniel, Publishers, Inc.
Post Office Box 2790
McKinleyville, California 95519
www.danielpublishing.com/perseverance

Book design by Eric Larson, Studio E Books, Santa Barbara
www.studio-e-books.com

1 3 5 7 9 10 8 6 4 2

LIBRARY OF CONGRESS CATALOGING-IN-PUBLICATION DATA
Glatzer, Hal.
The last full measure : a Katy Green mystery / by Hal Glatzer.
    p.   cm.
ISBN 1-880284-84-7 (pbk. : alk. paper)
1. Women musicians—Fiction.
2. World War, 1939–1945—Pacific Ocean—Fiction.
3. Dance orchestras—Fiction.
4. Pacific Ocean—Fiction.
5. Ocean travel—Fiction.
I. Title.
PS3607.L38L37 2006
813'.6—dc22
                    2005021237

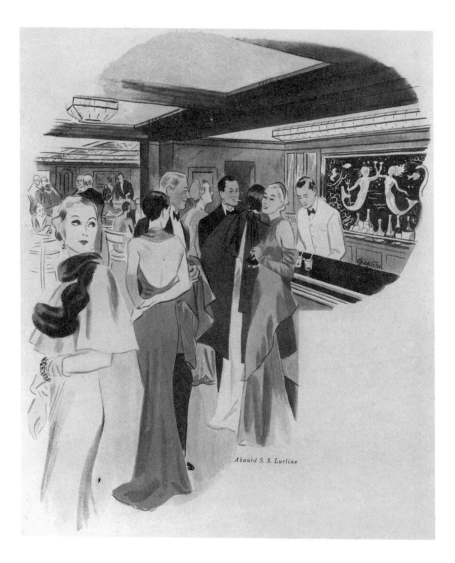

Aboard S. S. Lurline

# ❀ Cast of Characters ❀

## — The Swingin' Sarongs —

### Katy Green
saxophone, violin

A woman whose gigs tend to lead her into danger,
so she's lucky to know first-aid—or is she?

### Ivy Powell
bandleader, bass

A short gal with an even shorter temper

### Lillian Vernakis
trumpet

A dotty damsel, likely to do anything for love

### Roselani Akau (née Apapane)
vocals, piano, guitar

"The Heavenly Rose of Hawai'i,"
with a very down-to-earth plan

## — Aboard SS Lurline —

### — FIRST CLASS —

### Phillip DeMorro
"The Baronet of Broadway," whose hot show just closed

### John ("Quart") Brewer, IV (Stanford University, '27)
A big man in the sugar business, with a big axe to grind

### Nancy ("Nan") Brewer (Mills College, '35)
His wife, who might just be ready for a solo career

### Bill Apapane
Roselani's brother, a surf-riding champ, who needs to go ashore

## — CABIN CLASS —

### Shunichi ("Danny Boy") Ohara (Stanford, '29)
An electrical engineer with a felonious past

### Minoru ("Mouse") Ichiro (U.C. Berkeley, '29)
A mild-mannered chemist who's quick with his fists

### Sgt. Tadashi ("Tad") Mirikami, U.S.A. (Stanford, '29)
Still "Jingo" to his school chums, and well-schooled about bombs

### Tatsuo ("Rubbish") Mirikami (U.C. Berkeley, '29)
His cousin, a junkman who needs new customers for scrap metal

## — CREW —

### Stan O'Malley, Master at Arms
He's too much like too many cops Katy has met before

### Hobart ("Swifty") Boyd, M.D. (U.C. Berkeley, '27)
Does the doctor have the right prescription for Katy?

### Angelica Lanahan, R.N.
The nurse is apparently all business

### Les Grogan (U.C. Berkeley, '28)
The chief radioman is hearing voices

### Gloria Wiggins
The beautician has an ear for first-class gossip

### Frank Todd
The crew-chief of the cargo hold needs a big boost

— In Hawai'i —

## Clyde Chang Akau
Roselani's ex-husband, a fisherman—mostly

## Jeremy Waiau
A police officer from Hilo who's caught in a hot spot

# Foreword

Hannah Dobryn wrote her Katy Green mysteries after World War II, but set them in the preceding decade: *A Fugue in Hell's Kitchen*, for example, in 1939, and *Too Dead to Swing* in 1940. But the war particularly influenced Katy's "wartime" adventures, of which *The Last Full Measure*, set in 1941, is published now for the first time. (So Hawaiian words are rendered here with modern Hawaiian punctuation.)

From newspaper clippings in the file folder that accompanied her draft manuscript, and from several passages in the text, I estimate that she wrote *The Last Full Measure* during 1950 and '51, when yet another war was being waged in Asia.

Like every American adult of that time, Hannah would always "remember" Pearl Harbor. But she did more with her memories than most people did with theirs. In *The Last Full Measure*, she placed her American heroine—her alter ego—into the very moment when America's war began.

# The Last Full Measure

"REMEMBER PEARL HARBOR"?

I can practically smell it—*taste* it, even. The bitter ooze of petroleum. The sweet fragrance of sandalwood. The sour tang of gun smoke. And the salty undertow of a white-capped sea.

❀

# Friday, November 21, 1941

"LONG DISTANCE CALLING MISS KATY GREEN."

"I'm Katy Green."

"Go ahead, please."

"Katy! It's Ivy Powell—"

"—and Lillian Vernakis. Are you pregnant, Katy?"

"*What?*"

"Back off, Lillian, you're right in my ear! You still there, Katy? How the hell you doin'?"

Ivy was a bass player, a nervy little bird who could swear like a sailor, and scrap like one, too. Lillian, who played trumpet, was the excitable type, and a bit dotty from too many reefers.

"I'm okay," I said. "Where are you calling from?"

"Frisco. We've been here all along."

Which meant: about eighteen months. San Francisco was the last stop on the tour I'd played with them in May of 1940, in an all-girl swing band called the Ultra Belles.

"Listen, Katy," Ivy went on, "we have just picked up the greatest gig in the world, and we want you in our band. We need a sax player. But you double on violin, so we wouldn't need another soloist, which means more dough for you."

"But you can't take the gig if you're pregnant," Lillian called into the phone. "Are you pregnant?"

"No! What's the gig? The last time I was in a band with you two, I almost got killed."

Ivy chuckled. "The worst that could happen in *this* gig is you're gonna have to eat *poi*."

"What?"

"One more question, Quiz Kid." That was Lillian. "Do you get seasick?"

"I don't think so. Why?"

"We're sailing for Hawai'i next week!"

"We are gonna be the dance band," said Ivy, "on the *Lurline*....Did you hear me?"

"'The' *Lurline*?"

"*The*," Lillian mocked, "flagship of *the* Matson Navigation Company Steamship Line Incorporated Limited C. O. *The*."

"Do they pay union scale?"

"Well, it ain't *top* scale," Ivy admitted, "but it's close. If we don't need an extra soloist, you'll make a hundred and thirty-seven fifty a week, plus room and board on the ship."

"Plus time off for *baaad* behavior."

"Lillian! There ain't enough room in this phone booth for the four of us."

"Huh?"

"You, me, and those big bazooms o' yours. Back off, will ya?"

"Okay, Ivy, but tip the phone my way, so I can hear."

"You still there, Katy?"

"I'm here."

"What Lillian means is: San Francisco to Honolulu takes five days. We get two nights off in Hawai'i while they turn the ship around. It's a free vacation! We sail back to California, and get two nights to goof off in Frisco, or pick up an occasional gig. We're booked for the next two round-trips, so we'll be workin' through Christmas. And if they like us, they'll give us New Year's and a six-month contract. We could be workin' till next June."

"I don't know, Ivy. I'm just starting my busiest time of the year here in New York. Thanksgiving's next week. I've got bookings almost every night through Christmas. Tonight, I'm a strolling violinist for an anniversary party—I get big tips for that."

"So, you'll fiddle for tips at parties in *staterooms*!"

Lillian chuckled. "Or fiddle *around* in somebody's stateroom!"

"Say yes, will ya, Katy?"

"I'm tempted."

"Come on—it's a cinch. You know how to swing all the standards—Broadway show tunes, Tin Pan Alley songs. The only new material you'd have to learn are hula-hulas. And the Matson office here in Frisco has a whole library of arrangements we can take with us."

"Ivy, the way you're hustling me, you sound like the bandleader."

"Yeah? Well, I guess I am. This just happened today. We're still down here at the union hall. The Matson people showed up lookin' for female musicians. But none o' the other girls here in Local Six have the guts to—"

"Wait a second! How did it happen that the Matson Line and the American Federation of Musicians gave a plum gig like this to *women*?"

"They didn't say so, but it sounded to me like they wanted a novelty act, for the holidays. I walked up and said I got one."

"You do?"

"I do now. We're friends with a Hawaiian singer here. She's a good piano player, and she can make a pancake-guitar go wicky-wacky-woo. I figured if I put a swing trio behind her, I'd have all the dance music covered, and a floor show, too."

"Besides," Lillian shouted," they *have* to, now. Hire women, I mean. Too many guys in the union've got their draft cards, or reserve notices."

"I thought of you right away, Katy. I want you to come along."

"All the way from New York?"

"Look, if you don't think I can pull a band together and lead

it, I'll just get somebody else. There's another sax player right here in the union hall—I can see her from the phone booth—"

"That's not what I meant, Ivy! They have newspapers in San Francisco, don't they? You hear the president on the radio, don't you? Germany could declare war on us any time now. And who knows what Japan is up to, with—"

"We'll be safer if we sail *away*," Lillian insisted. "This man on the radio today, he said the Japs are gonna invade California in a fleet of little submarines that can drive right up on the beach. They've got wheels on their bottoms. The *subs*, I mean, not the—"

"Stick a mute in, Lillian. Sorry, Katy. You know how she can hang on a riff! But listen to me: if war's gonna break out, it'll happen when it happens. *You* don' know when. *I* don' know when. *Nobody* knows when. Besides, Roosevelt doesn't scare easy. I don't scare easy. And I happen to know that *you* don't scare easy."

"I'm just…concerned."

"Okay. That's on one hand. On the other hand: yes, for the first time in human history, there are some really great gigs openin' up for us women. D'ya want to spend December freezin' on Forty-second Street, or bakin' on the beach at Waikīkī? I gotta know right now. The ship sails on the twenty-eighth, and we're takin' it."

"That's next Friday! I'd have to be on the train tomorrow."

"So, be on it."

"There's a…a little problem."

"Lemme guess: you need help with the fare."

"Well, it's not as though I'm a pauper, but—"

"I just got some dough I can wire to you, but it has to be an advance against your pay. Is that all right? And I can only spring for a coach ticket. If you want a sleeper, you'll have to—"

"No. It's fine. Thanks." *She'd* gotten an advance, for fronting the band. I was impressed. "I can pay the difference."

"So you're coming?"

"Yes."

"Congratulations, Miss Green, you are now in the Swingin' Sarongs."

"Is that your band's name?"

"Yeah."

"She's not saying it right!" Lillian insisted. "She says 'swing-in'—like when you mean 'swinging.' But I think it ought to be 'swing—in—sarongs.' Like when you'd say, 'We play swing, wearing sarongs.' What do you think, Katy?"

"I have to wear a *sarong*?"

<p style="text-align:center">❁</p>

Hitting the road in a hurry is second nature to me. For the past twelve years, I've taken practically every gig that's come along, even if I had to travel to make it. I can play longhair violin, in the classical manner that I studied as a kid (and that I've got a conservatory diploma for). But most of the gigs I get nowadays are for saxophone—alto sax—in small combos, swing and sweet. And I can double on swing fiddle, too, which is kind of a rarity in the music business these days, and gets me an occasional bonus.

I'll even play *corn* if I have to; it doesn't matter, as long as I get my pay, because I don't make much money. In all eleven months of 1941, so far, I'd picked up eighty or ninety dollars in a good week, but only half that when times were rough. Traveling to gigs eats up a lot of my pay; and I need almost two good weeks' earnings to cover a month's rent, food, and music supplies. For a hundred and thirty-seven fifty a week, I'd have played December in Siberia.

True to her word, Ivy wired me enough for coach fare. So I felt okay about canceling my bookings and drawing down my passbook savings by twenty-eight dollars for an upper berth in Pullman cars all the way to the Coast.

I thought about taking enough out of the bank for two months' rent in advance. But my landlady, Mrs. Schmidt, charged only ten dollars a month to stow things in her basement trunk-room. So I put whatever I wasn't taking into my two

trunks: winter clothes, books, music books, and knickknacks—even my fancy toaster. I'd be able to afford a nicer room there when I came back to New York in January: a quiet room at the back, that didn't face the elevated train. And if the gig ran through June, I could afford to move.

But suppose there was a war...*no!* I couldn't back out of the gig now. Besides, I do read the news. Japan's got its hands full in China. And I remember my college history lessons, too: if there's any country that rubs Japan the wrong way, it's Russia—not America!

I caught myself saying that out loud, which made me chuckle: when you live alone, you can talk to yourself. I set down the clothes I was packing and took a couple of deep breaths, picked my sax up out of its stand, and blew a few wild notes that owed something to Benny Carter: a hot reed-man I'd gone to hear twice at the Savoy Ballroom. It relaxed me enough to accept my decision: I'd told Ivy I would go, and I would keep my word.

I poured a bottle of beer into a glass and sipped it while I packed, happy to find that I still fit into my summer-weight things. Both my sundresses were frayed around the hems, and my blue woolen swimsuit needed to have its buttons reinforced; but there'd be plenty of time on the train to fix them. So I wrapped them around my sewing kit and set it in the overnight case that I'd use on board.

Into my big suitcase, which would ride in the baggage car, went a comfortable pair of Mary Janes for knocking around in, black pumps with Cuban heels to wear on stage, and—I actually owned something that looked "tropical"—white lace-up sandals that I'd bought in August on the Jersey shore. Three skirts in quiet colors and subtle patterns would go well with my plain white shirtwaists. I took only my best brassieres, panties, slips, suspender-belts, and silk stockings. If I was sailing off to war, at least I'd be wearing durable clothes.

It might get cold on deck, so I added a pair of man-tailored wool trousers and a cardigan sweater, plus the woolen shawl from South America that Mother had given me a few Christ-

mases ago. And in case—well, *hoping*—I'd need something glamorous aboard ship or on shore, I tipped down from the shelf my one and only expensive evening gown: a sleek, bias-cut number in pale green silk that I'd taken in trade once for an all-day gig at Bergdorf Goodman. I kept it in its cardboard box, folded in a neat square with tissue paper between the layers.

I trimmed the contents of my makeup bag down to a manageable number of compacts, rouges, and lipsticks, and put the kit into the overnight case, along with my flannel nightgown, an old pair of mules (for padding to the bathroom), three changes of underwear, and an extra shirtwaist.

Finally, I went to the medicine cabinet and made myself a tiny first-aid kit, stuffing a mesh bag with a handful of adhesive bandages, a couple of gauze squares, and small bottles of aspirin, calomel, ipecac, and iodine. Then I packed my toilet kit with tooth powder and a toothbrush, soap, shampoo, cold cream, a hairbrush and comb, a packet of sanitary tampons…and my pessary from Margaret Sanger's clinic, in case I were to—you know—*meet* somebody.

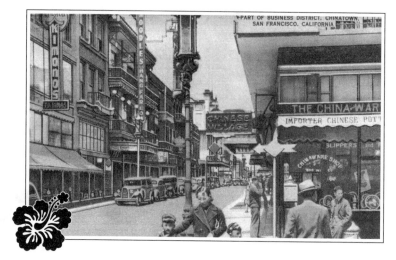

# Wednesday, November 26

YOU HAVE TO CHANGE IN CHICAGO for one of the crack streamliners to the Coast: either the Southern Pacific's *City of San Francisco* or the Western Pacific's *California Zephyr*. I picked the *City of San Francisco*. Riding the *Zephyr* last year, in that band with Lillian and Ivy, almost left me too dead to swing.

On Wednesday the 26th, I got off the train in Oakland, rode an SP streetcar over the Bay Bridge into San Francisco, and changed for one of the city's Municipal car lines up Market Street. By six o'clock I'd checked into the only place in town that I'd ever stayed before: the YWCA on Page Street. I'd told Ivy where I'd be, of course, so she'd left a note at the desk, saying I should meet her around midnight at a club in Chinatown called the Bamboo Hut, where my name would be on the guest-list.

The only truly unpleasant thing about a cross-country trip, even in a Pullman berth, is that for four days straight, there's no way to bathe. So the first thing I did at the Y was draw a hot bath, and soak for half an hour.

By five o'clock, the sun was gone, and by ten, the night was chilly enough for me to need my shawl. Chinatown was almost four miles away, uphill and down. But there's only so much walk-

ing you can do on a train. Despite the exercise I'd gotten that day, carrying my suitcases and instruments, I still felt stiff. At about ten-thirty, I decided to walk.

San Francisco and New York both have Chinatowns, but the guidebooks say this one's the biggest outside of the Orient. Plus, there's a Japantown and a Koreatown, and for all I knew there could be a Hawai'itown, too.

I thought about this as I picked my way through streets and alleys named for trees, like Oak and Hickory, that led me down to the wide Van Ness Avenue, where the City Hall—bigger than a lot of state-houses—was lit up with floodlights. From there, I zig-zagged through a run-down neighborhood—every city that has one calls it their "Tenderloin"—with cheap bars, and flagrant dealers in dope and flesh along the sidewalks.

As I was walking up California Street, a cable car with riders standing outside on the running-boards passed me going downhill. I heard the bell of an uphill car behind me; so, when it came abreast, I stepped up, swung aboard, and hooked my elbow around a white enameled pole. I couldn't suppress a grin as I leaned forward, into the climb, and a little to the outside, too, the better to see fancy Nob Hill.

The higher we went, the taller the hotels and apartment houses grew, until, at the very top, every street led down to water: eastward the Bay, northward the Golden Gate. Just as we perched at the top, a chilly wind lofted a small, wet cloud of fog up and around us, and I had a mental picture of the town, perched on its narrow cape, whipped by the breeze, drenched by the sea. And for a split-second, in my mind's eye, I was plunging off the tip-end of the continent, down into dark water....

※

Chinatown is a crowded bunch of blocks on the downtown side of Nob Hill. A lady at the Y warned me it's a dangerous place for a woman to walk by herself. But I've been going to New York's Chinatown for years, and this one didn't seem dangerous, either. There must have been gambling parlors and opium dens

and whorehouses somewhere. But the Fu Manchu novels, and the "yellow peril" stories in the Hearst papers, are all bunk. I had no fear of being dragged off a Chinatown street and drugged into white-slavery!

Besides, Ivy was right: I don't scare easily. I know first-aid, and I've had to use it. I also know a little *ju-jitsu*. That's what the Japanese call the "gentle art" of self-defense. My brother and I learned it from a book, when we were kids, and it has certainly come in handy. A single woman in the music business has to fend off a lot of wolves.

The people on the street here, though, looked like ordinary city folks who just happened to be Chinese. By day there'd be thick crowds, strange vegetables in the greengrocers' stalls, live turtles at the fishmongers', and screeching chickens at the butchers'. But even this late at night, there were cars on every street, and tourists on every corner snapping their Kodaks and dropping paper film-wrappers into the gutters. So a lot of souvenir stores were still open, their outdoor stalls crammed with everything from expensive antiques, ivory statuary, and lacquered trays, down to sandalwood boxes for a dollar, and chopsticks for a dime.

There were neon lights and painted signboards everywhere, for "Chinese" nightclubs, including Harold Koe's Twin Dragon (CHINATOWN'S NUMBER-ONE COCKTAIL HIDE-A-WAY), the Jade Palace (CHINATOWN'S MOST DISTINCTIVE COCKTAIL LOUNGE) and the Club Shanghai (CHINATOWN'S BEST DINING, DANCING AND FLOOR SHOW RENDEZVOUS). Most of the hotels offered some kind of exotic "Room" upstairs—I passed signs along my way for Zebra, Rose, Persian, Rainbow, and Papagayo. And there were supper-clubs with faraway themes, too, like Hurricane, Mocambo, Lido, Casino, Bal Tabarin, and Zombie Village.

I found the Bamboo Hut under an enormous neon palm tree that rose above black-lacquered entry doors, and a banner outside, almost as large, that proclaimed it was SAN FRANCISCO'S MOST UNIQUE TROPICAL COCKTAIL LOUNGE.

A hefty doorman in a flower-filled, short-sleeved shirt gave me a big smile as he waved me in. I mentioned my name to the slender woman inside, and she showed me to a small table beside the dance floor, where a young man was hoofing and tapping, solo, in a very expert way, fully living up to his billing on the table-card as TOMMY TOY, THE CHINESE FRED ASTAIRE.

A demure waitress brought me the drink menu. There was no cover charge, only a two-dollar minimum; but the drinks were all priced at eighty-five cents—a tip for the house, not the waitress. Figuring I might as well get into the tropical mood, though, I ordered something called a "Honolulu Punchbowl Punch." It came topped with a wedge of pineapple—rind and all—and a tiny paper umbrella; but other than a hint of rum, it tasted like the juice from a can of pitted cherries.

"What kinda drink is *that?*" said a familiar voice, close to my ear.

I smiled, turned around, and stood up—but not all the way up. Ivy is two inches shy of five feet, so I had to stay bent over to give her a peck on the cheek. She hugged me tightly. Carrying around a bass fiddle—even a three-quarter-size bass—kept her arms and torso muscular, but her figure was still trim, and well proportioned for her size. Since I'd seen her last, though, she'd grown her hair out, styled it in a pageboy, and dyed it a reddish brown (most likely to cover gray—she'd have turned forty by now). She was never a glamour-puss, but her Roman nose had puffed out a bit, probably from booze.

One thing hadn't changed. Being so short, she always kept her head tipped back, chin out, to look up—and look tough. But I knew she *was* tough, and quick-tempered. I had no doubt she still carried a straight razor.

She gripped both my hands in hers, then plunked herself down in the other chair.

I asked, "Where's Lillian?"

"She's got a sleep-over date! You'll see her tomorrow. Tonight, you're meeting Roselani Akau. And she'll want you to say her name right: 'Rose-a-*la*-nee Ah-*cow*'."

I practiced it a couple of times. "She's your Hawaiian canary?"

"Lillian and I met her when we worked the World's Fair on Treasure Island, after—you know—what happened to the Ultra Belles…and you went back east. Did you get work at the World's Fair in New York?" I nodded. "Well, we stayed here in Frisco, rounded up two other gals in Local Six, covered a few dozen standards, and called ourselves the Sirens of Swing. But you know what playing *any* fair is like. You're outdoors, where the loudspeakers are terrible, half the audience is walking by, and even the ones who're standing still are looking up at the sights. The Sirens weren't phoning it in, but we weren't playing any great arrangements, either. Anyhow, Roselani had a steady gig at the fair, in what they called the Hawaiian Village, and did her hula-hula in one of those Pageant-of-the-Pacific shows, twice a day. Y'ask me, it was vaudeville in grass skirts; but the crowds ate it up. Anyhow, Roselani and Lillian and me would get together and jam after hours, and—oh! Hey. Here we go."

She pointed to the stage as a spotlight hit a baby-grand piano. A man's voice through a loudspeaker said, "Ladies and gentlemen, the Bamboo Hut is proud to present the Heavenly Rose of Hawai'i…Miss…Roselani…Akau!"

A big woman—I was surprised at *how* big—in a clinging, floral-print gown, stepped out from behind the curtain, smiled, and took a half bow to the applause. She wasn't fat: her waist was smaller—though not much smaller—than her hips and bust. But she was tall, and beefy, and must have weighed close to two hundred pounds. As for her age, she might have been twenty or forty; I just couldn't tell. Her complexion was a toffee color. Her hair was black and thick, and she pushed it aside as she sat down, revealing a small flower—pink, with a yellow center—behind one ear.

"*Mahalo*—thank you—ladies and gentlemen," she said. Her lips were full, her speaking voice lustrous and low. "I'd like to sing for you tonight about the place I love best in the world—the Islands of Hawai'i, where every gesture has a meaning, and every song tells a story. Here are some of my favorite…stories."

Her first song was in Hawaiian, but she declaimed an English translation after each verse, while the band played instrumental breaks. The lyrics said each of the Islands had its own special flower, and flower *lei*—a necklace of blooms.

She was a soprano, especially terrific on the blue notes. Her range was modest, but it was bracketed at the low end by plenty of chest-voice power, and at the top by a truly compelling falsetto.

Ivy noticed my smile, and leaned in close. "Great pipes, huh?" I nodded. "Certainly worth building a band around *her*."

The next number was a novelty tune, all in English, and a little risqué, about a princess and her papaya fruit. She introduced it by saying she'd sing it in the style of somebody called Hilo Hattie. I didn't know who that was, but most of the audience apparently did. They applauded whenever she lofted her voice into falsetto—which was never shrill, even when she was playing it for laughs. And she brought down the house when she got up from the piano and started dancing, with wildly exaggerated hand gestures, shakes, and shimmies that fed the crowd's encouraging roar.

For her next number, she pulled the piano bench downstage, and took up her guitar. Ivy had called it a "pancake" guitar, which was figuratively true. Instead of being hollow, the body was just a round piece of wood, about a foot across and a couple of inches thick. And it was electrified, with a microphone under the strings, and a cord leading to a loudspeaker in a small box. I'd seen people play such an instrument before: it was a "Hawaiian" or "steel" guitar, that's held flat across the lap. The left hand slides a shiny metal pipe, about three inches long, up and down the strings, while the right hand strums and plucks them with metal fingertip picks.

What Roselani had said about each song telling a story came through in her choice of material. One was a poignant love song in Hawaiian that she (again) translated during the instrumental breaks, and whose tag line stuck in my mind: "Love, snatched away by the wind." Then there was a fast patter-song that could

have inspired a Zane Grey yarn, about three Hawaiian cowboys who won a rodeo competition in Wyoming, back in 1912. (I never knew there were cowboys in Hawai'i.)

"I'd like to close now," she said after a few more songs, "with one that tells a story that is rather personal. Because, a week from today, I can truly declare…'Honolulu, I'm Coming Back Again.'"

That turned out to be a sweet ballad in English, the kind of number *our* band would be closing with, too.

By that time, I was on my second Honolulu Punchbowl Punch; and Ivy had tossed back four shots of rye whiskey, washing each of them down with half a glass of beer—a combination that was listed on the menu as "The Boilermaker."

"This drink has got such a kick," she told me, "you could wake up with a guy in the morning, and not only can't you remember *his* name, you can't remember *yours!*" Never a shrinking violet, she also clapped loudly for each song, and—for the dance number—pushed shrill whistles out through the gap between her front teeth.

Roselani took several bows, and went offstage. The house band laid down a solid swing beat on a tune that had just been published, and was being heavily promoted to bandleaders, called "The Boogie-Woogie Bugle Boy of Company B." A dozen jitterbugs—many of them Negro soldiers in uniform—took their girls and hit the dance floor. Roselani emerged from backstage after a few minutes to work the room, stopping at various tables to shake hands, chat, or give somebody a kiss.

I asked Ivy, "Which way did you decide the band's name should go? Is it Swingin' or Swing *in* Sarongs?"

"I'd never drown out Lillian when she's playin' a good riff, and this one's golden. I'm using 'em both. The signs'll be painted with *Swingin' Sarongs* for the headline, and 'We Swing in Sarongs' under our picture—which they'll shoot the first day aboard. We've got some short routines worked out already, too, for playing while I'm introducing us, or when we're winding up our sets, or signing off for the night. Roselani plays one of her noodling

themes, and then—uh, that reminds me: when we get to Hawai'i, Roselani—oh! Here she is. Hi!"

She had made her way over to our table. Pulling up a chair, she stuck out her hand as she sat. "You must be Katy. I'm glad you're coming with us."

"Thanks. Me, too."

"I hear you can really hold your own!"

"Hold my own what? Liquor?" I chuckled. "Sure. I'm only on my second Punch."

"They water down the umbrella drinks." She waved the waitress over, said, "Bring a Sidecar for my friend, please," and then touched her arm. "I thought I saw my brother come in. I hope I was wrong."

"I didn't see him, Miss Akau."

"Ask backstage, would you?"

"Sure."

Roselani swung back around to me, "I don't care if you drink, as long as I can count on you."

She had no reason to call my sobriety into question! But I let it pass. I was intrigued by her speaking voice: she must have gone to college, or if not, to some girls' academy for erudition and elocution. Lower in pitch than her singing voice, it nonetheless emerged in almost musical cadences. I liked both voices; so I withheld judgment of her, and hoped she'd do the same for me.

"It'll be fun working with you," I said. "I know some nice violin lines I can slide in under those ballads. And I can squeeze a 'dirty sax' into your, uh…was that a hula-hula dance you did?"

"There's only one 'hula' in 'hula.'"

"It's not 'hula-hula'?"

"Just 'hula.'"

"Okay. Thank you."

"But it was a comic hula that I did. It plays better in clubs than slow and sentimental hulas. We'll talk about that in rehearsals."

"And we'll have two whole days in Honolulu," I said, "to work up some serious arrangements for the trip back."

She glared at Ivy. "Didn't you tell her?" Then back at me: "You're not tired, are you?"

"Were we supposed to rehearse *now*? I'm sorry. I didn't get that message. My instruments are back at th—"

"No," said Ivy.

"Something's come up, since Ivy phoned you last week."

"I was just going to tell her, when—"

"What's up?" I demanded.

Roselani looked left and right, then straight into my face. "You better be as strong as Ivy says you are."

"Huh?"

"Sure she is," said Ivy. "I've seen her fight! She knows that 'jujube' stuff."

It took me a moment to say, "D'you mean *ju-jitsu?*"

"Right! Don't worry, Roselani. Katy's real strong."

"It doesn't make you 'strong,' exactly. It gives you—" I searched for the right word "—*leverage.* But what's that got to do with the band?"

"Think you could 'leverage' somebody *my* size, in a fight?"

Roselani had said it with a smile, so I stayed on that note. "Could we rehearse first, like the wrestlers do?"

She chuckled, and I relaxed a little.

Ivy said, "What I was gonna tell you is: when we get to Honolulu, Roselani's gonna be sort of our tour-guide."

"What do you know about Hawai'i?"

"Schooldays' history. It's an American territory, since the Spanish-American War, right?"

"There's a lot more to it."

"You better tell her later," Ivy said, then turned to me. "Y'know how she said every song's got a story? Well, with Rose-lani, every *story's* got a story: a long, lo-o-ong story."

I shrugged. "We'll have a lot of time to kill on the ship."

"O-*kay*." Ivy put an arm around each of us. (It didn't go far around Roselani.) "I'll collect Lillian at eleven, and we'll all meet around noontime."

The waitress appeared, and set down my Sidecar cocktail

(which certainly was a lot stronger than the Punch, and tasted better besides). Then she leaned close to Roselani's ear and said, "Your brother *was* here. He went backstage during your set, but he left before you finished."

"How did he get past the doorman?"

"I don't know, Miss Akau."

Roselani frowned, and said, "Thanks."

I was yawning through closed teeth. "Where, at noon?"

"At the Matson office, on Market Street," Ivy said. "We'll check out their band arrangements, grab some lunch, get to know one another, and go explore the ship. Then we'll get our instruments and rehearse."

"Aye aye, Skipper!" I gave her a pretend salute. But I was more exhausted (and higher from the drinks) than I wanted to be. I excused myself, shook their hands, and left.

I expected the doorman to hail me a cab, but he wasn't at his post, and there was a hubbub outside just beyond the club's door, where a tiny alley joined the street. I peered between the shoulders and heads of the crowd that had gathered. The doorman sat groaning on the pavement, leaning up against the building, wiping blood from his nose that dripped onto his flowery shirt.

Maybe Chinatown wasn't so safe, after all.

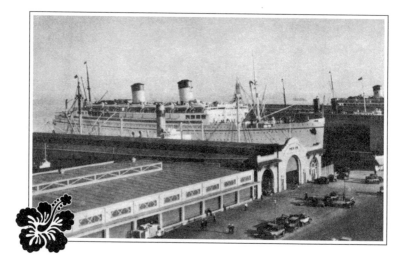

# Thursday, November 27

SOMEBODY KNOCKED ON MY DOOR at eleven the next morning, to call me to the phone. Ivy was making sure I was awake, and reminding me to meet her and the others at noon. She would, indeed, run a tight ship.

I put on a simple blue skirt and white shirtwaist, draped my cardigan over my shoulders, and walked downhill to Market Street, catching one of the new streamlined streetcars. It let me off half a block from the Matson building. In the lobby, I told the woman at the desk why I was there.

"Are you Miss Powell?"

"No. She should be along in a minute."

"You can wait here—" She pointed to a chair.

But a six-foot scale-model of an ocean liner in the middle of the lobby was more compelling. I walked around it twice, slowly. Above the waterline, it was white all over, with two yellow-and-black funnels. I leaned over and read the bronze plaque on the cradle:

SS *LURLINE*—PREMIER VOYAGE: 1933—LENGTH: 632 FEET—BEAM: 79 FEET—SPEED: 22 KNOTS—GROSS TONNAGE: 18,500—ACCOMMODATIONS: 722 PASSENGERS.

Photographs of the line's other ships in the fleet—*Malolo,
Mariposa,* and *Monterey*—hung on the walls. From a rack, I picked
up a sailing schedule, a pamphlet about the *Lurline,* and a couple
of travel brochures about the Hawaiian Islands. I was tucking
them into my pocketbook when a voice I'd know anywhere
yelled, "There she *i-is!*"

Lillian (of course) trotted over to me, ahead of Ivy and Rose-
lani, arms opened wide, and before I'd turned completely
around she'd wrapped me up in a big hug. "I'm *so* glad you're not
*pregnant!*"

The receptionist's eyes widened.

Since I'd seen her last, almost a year and a half ago, Lillian
had lost a lot of weight—and right where she'd needed to lose
it, too. You know how the ladies' magazines have these picto-
graphs of different shapes of figures, like triangular, pear-
shaped, and so on? Well, Lillian used to have what they call a
"spare tire." She still had quite a few pounds and inches to go
before she'd match any supposedly ideal shape, but her waist
was now definitely smaller than it'd been last year. And that
made her chest—always her most prominent feature—seem
bigger than ever.

"Can you believe it?" She released me and twirled once, like a
mannequin, flaring the pleats in her skirt. "I'm on a diet! I can't
wait to tell you all about it."

"You look great." She was the same age as Ivy, and had started
going gray, too; some of the black in her thick hair came from
dye—I saw the roots, when she hugged me. But some things
hadn't changed: she still had those girlish, permanently rosy
"apple-cheeks" that don't need rouge.

"Are you all here now?" the receptionist asked. "Which of
you is Miss Powell?"

"Me. I am."

"Then this is for you." She gave Ivy a leather briefcase.
"There's a copy of our contract with your band. Also your cabin
assignments; your boarding passes; a set of instructions for your
performances; the permission-slips for meals and laundry and so

on, that you'll give to the appropriate stewards; a deck-plan of the ship—which you'll want to study carefully—"

"I got a good sense of direction."

"It's not for *your* benefit, Miss Powell. If someone asks for directions, we expect every employee to help passengers find their way around."

"Don't worry. I'll tell 'em where to go."

"The music library is on the eighth floor. Show this—" she handed Ivy a small square of paper "—to the elevator operator, and give it to the librarian."

Matson kept its music in filing cabinets; we each started with a drawer. The first song I thought was interesting was "Hello, Hawai'i, How Are Ya?" so I called out the title, and "What do you think, Ivy?"

"Ask Roselani. She's got song approval. We can't play anything if she thinks it ain't 'Hawaiian' enough."

"That's not what I told you, Ivy."

"Don't start an international incident, will ya?"

In the hour or so that we spent there, Roselani vetoed far more songs than she okay'd. Of course, some of the songs in the files were so outlandish that *none* of us would have performed them—especially the wrong-headed criss-crosses of "race" routines from vaudeville, like "When Rosie Riccoola Do Da Hoola Ma Boola," and "Since Maggie Dooley Learned the Hooley Hooley," and "When Old Bill Bailey Strums His Ukalele"—the publisher had even spelled '*ukulele* wrong!

Roselani did approve several well-known titles, including "On the Beach at Waikīkī," "Little Brown Gal," and "My Little Grass Shack in Kealakekua." Those, she explained, were either written by real Hawaiians, or had actual Hawaiian words in the lyrics—which, as far as she was concerned, made them all right. The ones she rejected out of hand were ditties like "Yaaka Hula Hickey Dula," and "Yaddie Kaddie Kiddie Kaddie Koo."

"The words aren't Hawaiian," she explained, "they're nonsense, written by guys on Tin Pan Alley who've never been further west than Jersey! Imagine if the only songs you ever

heard, that were supposed to be in English, were 'Ja-Da' or 'Mairzy Doats.'"

"Or 'Three Little Fishes'!" Lillian piped up. "Boop boop did-dum daddum waddum, *chooo!*"

So I understood what put Roselani off songs like that. I even got the impression that they embarrassed her, and—like Ivy—she didn't seem the type to be easily embarrassed.

By one-thirty, we'd picked out sixteen instrumental band-scores, and thirty more single-sheets of published songs from which we could easily work up our own arrangements. The librarian put them in alphabetical order for us, slid them into the corresponding pockets of a brown cardboard accordion-folder, and tied it up with a ribbon. Ivy stuck it in the briefcase.

We walked the rest of the way down Market Street to the Ferry Building, turned north along the waterfront, and stopped at a diner between two fruit-and-vegetable warehouses, just across the freight-rail tracks from the Matson Line, at Pier 35.

"Do you want to see something?" Lillian asked me as we sat at the lunch counter, waiting for our sandwiches. What she pulled out of her pocketbook looked like a matchbox but wasn't.

"Where'd you get that?" Roselani asked.

"Bill gave it to me, last night." Lillian held it up to my nose. "It's sandalwood. Smell it! It's like perfume or incense."

Suddenly, I felt I was a little girl again, visiting Chinatown in New York with my mother.... I don't know why, but some aromas can trigger vivid memories.

"Isn't it beautiful?" Lillian placed it in my hand. "You know Bill—he's so generous!" But then she remembered that I *didn't* know Bill, and added, "That's the man I'm seeing now."

"Bill Apapane," Roselani explained. (She pronounced it "Ah-pa-*pa*-nay.") "He's my brother."

"We've been keeping company for a whole week now," said Lillian. "And since I'm sailing away tomorrow, we squeezed a couple of weeks' worth of you-know-what into one night, last night."

I smiled, to pretend I was glad to know that.

"Bill showed up in Frisco last week," said Ivy, "and it turned out that he was Roselani's brother."

"Isn't that a coincidence?" Lillian grinned. "I'd met him last year in Santa Barbara, when Ivy and I went to a surfboard-riding competition where he was the winner. They say he's the best surf-rider in Hawai'i, too! Anyhow, he came to San Francisco just to look me up. Isn't that just so-o-o romantic!"

I nodded.

Roselani was still staring at the little box.

Lillian held it up to my face. "And isn't this just the cutest thing? See the top?"

Three stick-figures of men were carved there. (You could *see* they were men, from what was between their legs). The smallest stood on the shoulders of the middle one, and he on the shoulders of the largest. "Are they supposed to be acrobats?" I asked.

"Bill says it means 'son, father, and grandfather.' Isn't that poignant? Look inside, too."

She slid the top off, through grooves in the long sides, revealing a bright yellow feather. Its edges fluttered, and I flinched, thinking it might blow away; but an amber drop of mucilage held it down.

"When he went out for beer last night, he ran into a friend of his from Hawai'i who needed some dough and sold it to him. Bill said I just *have* to take it on the trip with me—to remember him by—isn't that sweet? The feather's from a bird that's...uh, what's the word? You know—like 'dead,' but—"

"Extinct?"

"Yeah. Thanks, Katy. It's called the 'oh-oh' bird. Isn't that funny—like 'Uh-oh! I'm extinct!'"

"Maybe they meant 'Ohhh! Ohhh!'" Ivy mocked, with a breathy, sexy innuendo.

"It's just ō'ō," said Roselani.

"Bill must be a sweet man," I said, "to give you something so precious."

"Aw, thanks, Katy." Lillian waved her wrist. "It's not expen-

sive, though. Is it, Roselani? Bill wouldn't tell me what he paid for it."

"It's not a cheap trinket, but it's not a diamond ring, either."

She was implying "engagement ring", and was, just as clearly, unhappy that Lillian was "seeing" her brother. He had gone to the Bamboo Hut last night, too, where the doorman was supposed to keep him out.

"I don't know about the feather," said Ivy, breaking the silence. "I guess it's rare enough, if the bird's dead. But you can buy little boxes like this one all over Chinatown."

Tact was never Ivy's strong suit, but she had plucked us out of a thorn-bush by redirecting the conversation. I touched Lillian's arm and said, "I think it's romantic, that he gave you something from Hawai'i, to remember him by."

"You're sweet, Katy. Thank you!"

Roselani turned away, saying, "Just don't lose it, okay?"

"Why? Is it expensive, after all?"

Roselani looked over her shoulder and grinned. "How much were those boxes in Chinatown, Ivy?"

"I don't know. Couple of bucks?"

"What's it worth?" Lillian asked.

Lillian wasn't easily embarrassed, either. If she was willing to talk about the price of her sweetheart's love-token…well, I had to get used to it—to her—to all three of them, really. Playing music would be easy, compared with keeping track of all the gossip I'd be privy to over the next four weeks.

But I needed to get in their groove, so I piped up: "I saw boxes like this in outdoor stalls last night. They were a dollar, I think."

Roselani turned all the way around to face us again. "Then, believe me, they weren't sandalwood. They were some other kind of wood, dunked in scented oil. For the heartwood of a real sandalwood tree—which *this* is—you'd have to pay a lot more than a dollar. Twenty or thirty, at least."

Lillian brought it up to her nose and took a sniff. "Why so much?"

"Do you really want to know?"

"Yes, I'd like to know."

Ivy *harrumphed*, and turned to me. "Ask how much something costs, and can she just tell you? No. It's gotta be a story!"

I shrugged. "It's the thought that counts."

"I want to hear!"

Roselani smiled at Lillian. "It's expensive, because there's hardly any real sandalwood left in the world. A hundred years ago—"

"Make it snappy!" Ivy checked her watch. "We gotta eat, and go to the ship. What the hell's keepin' our sandwiches?"

Roselani folded her arms. "A hundred years ago, sandalwood grew wild in the forests, and it was easy to harvest. The chiefs and the royal families hired commoners to work as woodsmen and log the trees. But I'm sorry to say that the chiefs were very greedy: they made just about everybody who lived on their land go out and get it—it was almost like a tax. They had to quit farming and fishing, quit whatever jobs they'd held, to go cut sandalwood. And nobody likes to be forced to work. It's like slavery, isn't it? Which is what the American Civil War was all about—"

"Jeez!" Ivy sighed. "Are you gonna recite the Gettysburg Address?"

Roselani went right on. "So the commoners fought back, the only way they could. They went up into the forests and cut down every sandalwood tree—pulled up the saplings, too—so they'd never have to harvest them again. Pretty soon, there was no more sandalwood for furniture or chopsticks or pretty little boxes: just sawdust for incense."

"Sounds to me," said Ivy, "like you Hawaiians cut off your nose to spite your face."

"Everything in history can look like a mistake, a hundred years later," she replied. "But something good came out of it: a feeling among the Hawaiian people that we can do things for *ourselves*, if we work together."

"Well, I'm all for working together," Lillian declared. "That's why we've got a band."

"And a union!" I added.

With two fingers Ivy pinched up the box, held it out to Lillian, smiled, and chuckled. "Maybe you oughta keep it in the purser's safe, on the ship!"

Roselani grinned. "Just don't lose it."

"One crab-salad sandwich—" The waitress set it in front of me. "One meatball sandwich—" That went to Ivy. "One fried fish sandwich—" to Roselani "—and one lettuce-and-tomato sandwich."

"That's practically all I eat, these days," Lillian explained, as much to the waitress as to me.

❀

The *Lurline* was the biggest ship on the waterfront that afternoon, and was berthed prow-in, facing us, as we crossed the wide Embarcadero. Ivy showed our boarding passes to a uniformed guard, who waved us into Pier 35.

Inside the pier, it was almost painfully loud. The shouts of longshoremen and stevedores; the rumble and whinny of motors, hoists, and tackles; thumps and scrapes of baggage, crates, and bales—and automobiles being driven up onto pallets and tied down for hoisting aboard—all reverberated against the corrugated tin roof and walls. The shed was longer than the ship, and almost as tall; but with only a row of small windows, high up, it was dark inside. A little more light came through big sliding doors on the side that was open to the ship, but they were entirely in its shadow.

Up a short flight of stairs, and through a gate marked BOARD HERE, we got outdoors again, and onto the edge of a gangway ramp that juddered slightly as we stepped on it. Green water below, constrained between the hull and the pier, surged and plopped, lofting bits of wood and refuse from the Bay against the pilings.

I looked up—it was impossible not to. The *Lurline* was a huge white wall rising high overhead, and stretching out hundreds of feet on either side. My idea of an ocean liner was based on the

ones I'd seen docked in New York, where the Atlantic liners are all painted black. So I realized now why I'd circled the ship-model twice: a white vessel seemed unreal, somehow. And then the strangest thought popped into my head: I remembered reading somewhere that in the Orient white—not black—is the color you wear when you're mourning for the dead.

The ramp up was connected to the *Lurline* at the Cabin Class Promenade on Deck-C, where a section of the ship's rail had been swung out and clamped to the railing of the gangway. We headed through a door into the Main Foyer for Cabin Class passengers, with clusters of sofas and chairs, and a telephone booth. Then we took the nearby stairs down to a smaller foyer on Deck-D, where the Cabin Class purser and chief steward, as well as the ship's doctor, all had their offices.

After consulting the deck plan, and after turning it around once, rather than turning ourselves around, we found that our staterooms were yet another flight down, on Deck-E. I was relieved to discover that we'd be living among the passengers, not the crew, although the line had given us the cheapest accommodations, on the lowest passenger deck in the ship. Nonetheless, our rooms came with maid service!

Staterooms 531 and 533 were all the way back, and on the right side. (The pamphlet about the ship translated that into nautical terms: our cabins were astern, and on the starboard side.) They were also just ahead (forward) of the Ladies' Room, where the toilets and showers were. At least it'd be a short walk to the bathroom at night.

Roselani and I would be sharing 533, which had upper and lower bunk beds, two small wardrobe closets, a chair and a tiny writing desk. But the cabin was disconcertingly L-shaped, with its one and only porthole at the far end of a narrow corridor, above the wash stand.

"Want to draw straws for the lower?" she asked me.

"It's okay. I'll take the upper. I don't mind."

Ivy and Lillian were in 531, which was a little larger and square-shaped. It was furnished like ours, but came with two

portholes, a second chair, and an extra day-bed. "Let's you and me take the bunks, and keep the day-bed—" Ivy jerked her thumb at it "—for a sofa, so we can all shoot the breeze in here together. I need the lower, though. My back gets sore from carrying the bass."

Lillian shrugged. "You've been saying that for years."

"It's still true!" Ivy glanced around. "Okay. We've seen it. Now, let's go look around this tub, an' see what the *paying* passengers get for their money."

Cabin Class was essentially the rear third of the ship. We walked forward, past the rooms on our corridor. There was a matching corridor on the other side—the port side—of Deck-E; and just past the main stairway we found the Cabin Class Dining Saloon, with the kitchen just beyond it, ahead.

We took the stairs up one flight to Deck-D, and returned to the small foyer, which was also the social classes' dividing line. Just ahead of it, beyond a diamond-fold partition, like an elevator gate, were the First Class cabins.

Up one more flight to Deck-C, the entry foyer, where we'd come aboard, separated the Cabin Class Lounge from the Smoking Room. A bar called the Verandah was on Deck-C, too, with big French doors that overlooked the stern end—the fantail—of the ship, and the water beyond. Above the Verandah, and entirely out of doors on Deck-B, was the Cabin Class swimming pool, which (Matson's employee instructions warned us) was the only pool we were entitled to use.

To get to First Class, we had to go back down to Deck-D, past the doctor's office, and through the gate. Today, it was unlocked and unattended, but our instructions noted that, at sea, we'd have to show our passes to a uniformed crewman who'd be stationed there.

The rest of Deck-D, forward of the gate, had First Class cabins along two corridors that ran almost all the way up to the front (the bow) of the ship. A barber shop and a beauty parlor were lodged between the corridors. About two-thirds of the way forward, toward the bow, there was a sweeping grand

staircase, and we took it down to the Main Foyer, which was on Deck-E.

For First Class passengers, that was the grand entrance, where they'd come aboard, visit the purser's office or the baggage office, or make a phone call from a booth beside the switchboard. A set of tall doors led into the First Class Dining Saloon, which—we realized from the deck-plan—was simply on the other side of the kitchen from the Cabin Class eatery.

There was an elevator in the Main Foyer, too, so we climbed in and headed up. Deck-C and Deck-B were both filled with staterooms—but those on the higher level, Deck-B, looked out onto a wide promenade that—unlike the Cabin Class Promenade—ran all the way around the ship. In First Class, too, I noted with a sigh, you got a private toilet and bath.

We stepped out into a small foyer on Deck-A where there was only a handful of staterooms. Housekeepers were vacuuming the carpets (*our* cabins had linoleum floors). We called out friendly hellos, as though we were supposed to be there, and trotted inside, to see what the most expensive rooms on the ship looked like.

They were suites, really, with either a living room or a private balcony, or both. And the two suites that faced straight ahead had big picture windows overlooking the First Class swimming pool and the bow beyond it—the same view that the captain could see from the bridge, which was on the Sun Deck, right overhead.

The bathrooms alone were as big as our staterooms, and the beds were wide doubles. The wardrobes weren't much larger than ours, but there was a trunk-room opposite each suite's front door, to keep steamer trunks handy. (Everybody else's trunks—plus everything with NOT WANTED ON VOYAGE stickers—were stowed down in the hold on the Cargo Deck, according to the pamphlet, along with automobiles and other big or bulky things. Passengers could go there to retrieve items, during a few set hours every day.)

We needed to check out the rest of Deck-A, though, because

except for playing one set a night in the Cabin Class Lounge, Deck-A was where we'd be earning our passage. The Library ran along one side, the Writing Room along the other, and in the middle was the First Class Lounge, our biggest venue. It had a formal, raised stage with steps up both sides, and a grand piano.

"They're supposed to tune it before every crossing," Roselani called out, as she mounted the steps. She lifted the cover from the keyboard, sat down on the bench, and played a few bars of "Aloha 'Oe," with an overly theatrical glissando up the keys at the end of each phrase. She smiled. "It's 'ono!—that means 'delicious.'"

There was no warm-up room—what musicians call a green room—alongside the stage; but there was a tall storage closet off to one side. It held a dozen folding chairs, bandstands with the Matson "M" on them, music racks with lamps attached, and (as the label proclaimed) a Radolek DeLuxe Public Address Sound System, with six microphones, a three-tube amplifier, and two big speaker boxes covered in brown tweedy fabric.

We took out what we'd be needing, including four mikes and stands, and by trial and error worked up the best layout that would keep Roselani in view of the audience, and still let the rest of us see one another's faces for cues. Our instruction sheet mentioned that one of the ship's crew would be responsible for aligning the rack of floodlights that hung above the front edge of the stage, and would then man the follow-spot that stood, today draped with a fitted cover, on a floor-stand at the back of the room.

Our other regular venue would be the First Class Dance Pavilion, at the stern end of Deck-A. Like the Cabin Class Verandah two decks below, the Pavilion had big French doors and a view over the fantail. But it didn't have a real stage: only an alcove that the deck plan called a music platform, and a spinet piano. There were no adjacent storage closets, either; but microphones and bandstands had been assembled and left out for us to set up as we wished, along with an appropriately smaller Radolek P.A. system.

By now it was past four o'clock, but we made one more expedition, starting with the First Class Men's Club Room and the Smoking Room, which were furnished with green baize tables for card playing, but which, the pamphlet noted, were open to women, too.

Up one more set of stairs, to the Sun Deck at the top of the ship, we went out of doors. There was a shuffleboard and deck-sports area there, and between the two big funnels, a pair of full-size tennis courts surrounded and topped by a high, fishnet fence, to keep errant balls aboard. Forward of the officers' quarters stood a gymnasium with exercise machines, a children's lounge decorated with murals of Mother Goose rhymes, and something that looked like a steam-room but whose sign over the door called it the Medicinal Bath. The sun was near to setting behind the city's hills and buildings, and the white sides of the ship's lifeboats, hanging all along the rails, were darkening in the twilight.

We felt very proud of ourselves for having gotten a sense of what was where on the *Lurline*. And when we'd worked our way back down, off the ship, through the pier, and onto the street, Ivy bought us all a round of beers in a sailors' joint on the Embarcadero—plus turkey sandwiches, in lieu of a real Thanksgiving dinner—and treated me to a taxicab back to the Y, so I could pick up my instruments before meeting them for rehearsal.

<p align="center">❀</p>

Since it was a holiday, Ivy was able to book four hours for us in an empty studio at the NBC radio station, downtown. When I got there, Roselani was challenging one of the songs she had okay'd before lunch.

Ivy turned her back and made a dismissive wave. "You wanna draw up the set-lists, too, Roselani? Be my guest."

"You gave me song approval—"

"Yeah—" she spun around "—and you're the canary, and we can't go on without you. But I'm Big Chief Sarong here: my

name's on the contract. And if you want us to come along on your safari—"

"Katy!" Lillian called. She'd been sitting apart, oiling the valves of her trumpet.

Ivy glanced up. "Oh. Hiya. Wet your sax reed, and tune up your fiddle. We'll start in a minute. Roselani and me are just workin' something out. Take a gander at our schedule for the trip, too." She gave me one of the Matson Line's instruction-sheets.

Our workday would begin at three P.M., with a tea-dance in the First Class Dance Pavilion on Deck-A. At five, we'd go down and eat dinner in the Cabin Class Dining Saloon. At six, we were expected to play—no singing, just background music—in the First Class Main Foyer, while people strolled in for what was called the first seating, the earlier of two fixed meal-times, in the adjacent Dining Saloon. We'd continue to play there until eight o'clock, when the second-seating crowd went inside to eat.

At eight-thirty we'd play our Cabin Class set, in the Lounge on Deck-C, then head up to Deck-A again, where we'd start our floor-show in the First Class Lounge at nine-thirty. We'd wind up back in the Dance Pavilion at eleven, and play three sets there, until they closed the bar at one A.M.

Lillian had switched to polishing her instrument's silver finish with a chamois cloth, but she interrupted whatever Ivy was whispering to Roselani. "I think," Lillian said, "that we're going to get requests, and we have to be ready to play whatever the crowd wants. People want to hear those 'wicky-wacky-woo' songs because they like to *make* 'wicky-wacky-woo.'"

"Those songs you sang last night," I said to Roselani, "didn't sound like any Hawaiian songs I've ever heard."

"Remember what I said about 'hula'? Until we went through the Matson library today, you probably thought *all* Hawaiian songs go 'wicky-wacky-woo'—right?"

I shrugged, and I think I blushed, too. But I said, "I don't know why you're still stuck on this issue. We took plenty of Matson's material." (All of which—as I *did not* say out loud—had earlier passed muster with our Hawaiian canary.)

What Roselani was so charged up about now were two novelty songs: "They're Wearing 'Em Higher in Hawai'i" and "My Little Bimbo Down on the Bamboo Isle." Ivy found them funny; Roselani insisted they were demeaning. Lillian smiled and nodded and kept on cleaning her trumpet, seemingly oblivious. But suddenly she asked, "Do I get a vote?" And when our heads turned, she explained, "'Cause I vote for *not* doing them, unless we're gonna go into a strip-tease!"

That settled it. We dropped them.

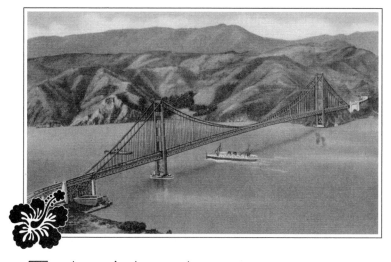

# Friday, November 28

BY NINE A.M. ON SAILING DAY, the noise inside Pier 35 was almost unbearable. The freight and provisions were aboard, but hundreds of passengers and well-wishers, baggage and bag-handlers, filled the shed from end to end. I had to excuse and sometimes even bully my way through the crowd, carrying my suitcase, overnight case, and two instrument cases up the gang-way, across the promenade at Deck-C, through the double-doors into the foyer, down two flights of stairs, and all the way aft along the narrow corridor to 533.

Roselani was already in our tiny, L-shaped cabin. The ward-robes were barely wide enough for the clothes we had to hang up; we'd be digging into our luggage all the way to Hawai'i.

"I've got room for my valise under my berth," she said. "See if yours will fit standing up in the tunnel."

"In the what?"

She pointed into the L. "See the porthole, down there, over the basin? Doesn't it look like the headlight of a train, coming at you through a tunnel?"

I chuckled. "I guess it does."

She squinted. "You're…what? Thirty-two? Thirty-three?"

"I'll be thirty-five, come February seventh. And you?"

"Thirty-nine, last Tuesday."

"Happy birthday! Um…is 'Akau' your stage name?"

"It's my married name, Katy. He's Clyde Akau. We're divorced now. But you're right—I kept Akau as a stage name: it's easier to spell and pronounce than Apapane."

"And your brother, Bill—are you his big sister or little sister?"

"We're twins."

"Oh, that's charming! I've always thought it would be fun to be a twin. I have a kid brother, two years younger—"

"Where's home?" She was blunt, like Ivy.

"Manhattan," I said.

"Got a penthouse with a view?"

I chuckled. "Just one room, with a pull-down bed, a hotplate, and a toaster. And an El train outside the window, for an alarm clock."

"Do you have a 'steady' for company?" She was nosy, like Ivy, too.

"Not even a 'sometime.' It's been months!"

"You're lucky you've still got your looks, and your figure."

I smiled. I'm no glamour-puss, but my face is closer to a Hollywood pan than a Halloween mask. And while nobody'd mistake my figure for that of a bathing beauty, Atlantic City variety, I don't need a girdle to squeeze me into my dresses. Still, I patted my tummy and said, truthfully, "I puff up during the winter, so I am definitely looking forward to being out of doors on this trip, and walking it off."

"You'll get plenty of exercise in Hawai'i! On the Big Island. They call it that, because it's really big. The tourist-bureau likes to call it the Orchid Isle, because orchids grow wild along the roads, and the Volcano Isle, because there's an active volcano that may even be erupting when we get there. But that's—"

"Hold it! Hold it!" I waved my arms. "If you wanted me to be a sacrificial virgin, you are *too late!*"

I thought she'd laugh. But she frowned and said, "That's only in the movies!"

"What kind of exercise? Will we go hiking?"

"Not exactly. We'll—"

There was a knock on the door. "It's Lillian. Can I come in?" And without waiting for our answer, she did, saying, "Did you see the passenger-list? Look who's on board!" She waved a booklet at me, and I scanned the names.

"Brigadier General Howard Davidson?"

"Keep going."

"Two football teams: Willamette University and San Jose State College."

"Willamette, huh?" said Roselani. "They must be playing the University of Hawai'i next Saturday."

"You are *blind*, Katy! Why do you think I ran in here to show you? Look! 'Mr. Phillip DeMorro, and companion. Suite two, Deck-A.'"

Actually, I *had* seen his name, and was holding out deliberately, to tease her. But I couldn't tell if she realized that.

She beamed, "D'you think we should play a couple of his songs? Maybe he'll sit in with us?"

Roselani shrugged. "I think he'd expect *us* to sit in with *him*."

"He'll play, though, I betcha. I was just reading that he likes to show off. It's in this story about him, in the new *Band Star*. Want to see?" She held out the magazine.

"Read it out loud, Lillian," I said.

"It's by Darlene Duncan. You know her from New York, don't you, Katy?"

"I haven't seen her lately."

"Well anyhow, here's what she wrote...uh: 'Whenever I hear one of Phillip DeMorro's songs, let's just say that the Baronet of Broadway still knows how to flutter the tender heart of a girl.' She means *her*, right? The girl?"

"Oh yes. Slipping herself into the very first paragraph—that's Darlene, to a T. Go on."

"Umm...'heart of a girl. Songs from his glittering shows have been covered by every combo worthy of being called a band. His current revue, *Shakespeare on the Half Shell*, was in its

final weeks on Times Square. But the golden touch that has been his for almost twenty years seems to have tarnished. Ticket sales have been disappointing. So, rumors have been flying up and down Broadway that he will move to Australia, and produce an entire season of musical theater there. Is it true? Well, the Baronet himself admitted as much, after two Manhattan cocktails at the Astor Roof Garden. "When *Shakespeare* closed October thirtieth," he said, "I decided to forswear Broadway." I was stunned. Could 1942 actually arrive *without* a DeMorro revue in rehearsal? He blinked his sea-blue eyes at the sunset, lit a cork-tipped cigarette, looked deeply into my eyes, and said—'"

"Are you indecent?" Ivy had knocked first, but—like Lillian—opened the door anyway. "Come on. Let's go up on deck. It's almost time."

"You go," said Roselani. "I've done this before."

The hoopla for the sailing was a lot like a New Year's Eve party, except that it lasted only a little longer than a bottle of champagne. The city's noon whistles were blowing, and the *Lurline's* horn was jamming with the band. Men and women and children, on and off the ship, all along its length, were yelling and waving, as a handful of crewmen—professionally oblivious—cast off the lines that tethered ship to shore.

We stood at the rail just outside the Cabin Class Verandah, at the stern end of Deck-C. Below us, the water foamed, churned up by the propellers. The rumble of the engines grew louder and higher-pitched, as the *Lurline* edged away from the pier and the pilings, and backed slowly into the Bay.

Crepe-paper streamers, held at both ends, finally broke. A few people who were waving from the pier began to cry, almost like children whose balloons have floated off, while their friends and families aboard blew final kisses back, and threw the last of their confetti. Some of the colored paper bits lofted up to swirl in the gray smoke from the *Lurline's* yellow-and-black funnels; the rest settled back, scuttling into wisps like a winter's first snow. As each knot of giddy passengers wandered away,

or headed inside to unpack, a crewman would appear with a scraper, broom, and dustpan, and quietly clean off the teak-wood deck.

Finally, the ship swung around, parallel to shore. Like a bus shifting from reverse into first and then high gear, the engine's noise dropped in pitch, then rose again as we built up speed and aimed for the Golden Gate.

"That's it!" Ivy declared. "Let's get ready. They're taking the band-photo at two-thirty, and we're playing for the tea-dance at three."

"I want to...I'll join you in a few minutes," I said. "I'm a tourist here, remember? I've never seen the city from the water."

Lillian grinned. "We'll be in the cabin."

I wasn't alone on deck: several people stayed to watch the San Francisco skyline drift past us. I regarded the buildings, and imagined them as odd-shaped books on a shelf, with the two huge bridges like bookends: the one over the Bay angular and gray, and the one leading to the ocean streamlined and...no—that couldn't be rust! They'd just built it, in 'thirty-seven.

"It's 'International Orange,'" said a man, nearby.

"I'm sorry. What?"

"You were staring at the bridge," he explained, "and you were probably thinking: 'The Golden Gate Bridge is supposed to be *golden!*' Am I right?"

He was one of two Oriental men standing just a few feet away. They were Japanese—not Chinese, I was pretty sure—but he had no Oriental accent at all. "Yes," I said. "Are you a mentalist?"

He smiled. "Electrical engineer, actually. My name's Shunichi Ohara."

"Minoru Ichiro," said the other man, with a slight nod.

Japanese names—I was right. I smiled, too, and extended my hand for a shake. "I'm Katy Green."

"People think it's the golden 'gate-bridge,' but it's the *bridge* over the 'Golden Gate.' And they picked that orange color because you can see it through the fog."

"Thank you—uh, I'm sorry. Please tell me your name again."

"Shunichi Ohara."

"Thank you—"

"But everybody calls me Danny Boy."

I chuckled. "As in: 'Oh, Danny Boy, the pipes—'?"

"'—the pipes are calling,' yes."

"People think he's Irish—until they see him," said his friend.

"But there's no apostrophe in *my* Ohara family."

"A lot of us guys took nicknames in high school."

Danny Boy grinned. "Yeah. My buddy here is Mouse. Like 'Minnie Mouse,' from Minoru."

"At least I had a choice! The alternative was 'Itchy,' from Ichiro."

I smiled and said, "I sympathize."

They were shorter than I, though not by much. Danny Boy Ohara had tight, sun-browned skin, crew-cut black hair, and a straight carriage in a wiry build, like a bantam-weight boxer. His necktie was red, and dotted with collegiate crests; his brown tweed sports jacket had gussets at the sleeves, and patch-pockets with buttoned flaps, like what an outdoorsman, or may-be a hunter, would wear.

Large horn-rimmed spectacles made Mouse Ichiro look more aesthetic than athletic. He was thinner and paler than his friend, too, and wore his coarse black hair longer—a loose forelock fluttered across his face in the gusty breeze. And he dressed more expensively, or at least, more like a businessman. A blue necktie—also patterned with college insignia—lay under a three-piece suit of blue worsted wool, and a scholar's Phi Beta Kappa key depended from a chain across his vest.

"Is this your first trip to Hawai'i?" he asked me.

"Are you on vacation?" Danny Boy added.

"I'm working on board. I'm in the dance-band."

"I'm with the Mutual Telephone Company in Honolulu," said Danny Boy. "Radio relays. If you call the Islands from the ship, somewhere in that connection, you're using a circuit I de-signed."

"Musicians can't afford ship-to-shore calls."

Mouse leaned closer and whispered, "Danny Boy knows how to make calls for free!"

"Don't go telling my secrets!"

"All I know about radio," I said, "is what I saw when I played for a studio broadcast."

"Where're you from, Miss Green?"

"New York. Manhattan."

"I *love* Manhattan!" Mouse exclaimed. "After Cal, I did my graduate work at Columbia."

"What's 'Cal'?"

He pointed behind the ship, toward the green hills above the eastern side of the Bay. "See that clock-tower? That's Cal: the University of California, at Berkeley. Class of nineteen twenty-nine."

"I went to Stanford," said Danny Boy. "It's down the Peninsula, that-a-way—" He gestured toward the south. "And I'm also class of 'twenty-nine."

"Well, I graduated from Syracuse University in 'twenty-nine."

"What a coincidence!" both of them said, simultaneously. "We went to different schools together!" That was obviously a routine, and they laughed at their own gag, so I chuckled, too.

"Are you also an electrical engineer?" I asked Mouse.

"Nope. I make fertilizer." He paused, mouth slightly open.

I took the hint. "I'm supposed to play the stooge, and set up the punch-line, right? Okay. I'm asking: 'How do you make fertilizer?'"

Mouse glanced at Danny Boy, who frowned and shook his head. So he sighed, "Aw, I'm an agricultural chemist. I work for a sugar company here in California, where they—oh! Excuse me a second. I have to talk to that guy over there." He strode to the opposite side of the ship, where two men were standing with their backs to us: one a U.S. Army soldier in uniform, the other a pudgy civilian in a brown suit and porkpie hat, smoking a cigarette.

When Mouse approached, they turned around, and I could

see they were Japanese, too. Mouse raised his right hand in a fist. The soldier did the same. I thought they were going to fight. But they shook their fists down three times; Mouse stuck out two fingers, the soldier splayed out all five; and I realized they were playing the old children's game of scissors-paper-rock. Mouse won (scissors cuts paper), and got to give the soldier a gentle punch in the shoulder. Then they both chuckled and shook hands.

Mouse raised his fist to the chubby man, who smiled and tucked his cigarette into his mouth, and held down his hat against the breeze with one hand, while he raised his other in a fist. But he, too, lost Mouse's challenge—making "rock" to Mouse's "paper"—and had to take a punch.

Danny Boy explained, "Mouse is *incredible* at that. He wins all the time. Though it's the only sport he can really play! Anyhow, that's our friends: Captain Jingo Mirikami, and his cousin, Rubbish."

"More of your schoolmates with nicknames?"

He nodded. "Since childhood. Honolulu's not a big city; people know each other all their lives. So, nicknames tend to stick!"

"Even names like 'Jingo' and 'Rubbish'?"

"When we were in the Cub Scouts and the Boy Scouts, Tadashi always carried the flag; that's why we called him Jingo. He likes to be called 'Tad' now, though. His cousin is Tatsuo. We tried to call him Fatso—you can guess why—but he always beat us up when we did. So we called him Rubbish, 'cause he had to work in his father's junkyard every day after school."

"I gather you're all traveling together."

"Oh, yeah. The four of us went to college here. And every fall, rain or shine, for twelve years now, we've come back for Big Game: Stanford Indians versus Cal Berkeley Bears. D'you follow football?"

"No, but let me guess: they're traditional rivals."

"Mortal enemies! Of course, *we've* stayed friends. Jingo was at Stanford with me," said Danny Boy. "He joined the Army right

out of college, which is why he's a captain now. Rubbish was at Cal with Mouse, only he took a business degree, and now he runs his family's junkyard."

"Who won the game this year?"

He frowned. "Cal! And did they ever! Sixteen to nothing, on Stanford's home field. We have an ongoing wager: we each have to bet on our alma mater, even if we think they might get beat. And the losers have to pay for the winners' trip."

"Ouch!"

"Well, for Cabin Class, the round trip's only a hundred bucks. And like the Brooklyn Dodgers say: 'Wait'll next year!' Besides, it's an excuse to get back to Frisco."

"This was only my second visit here," I said. "The first time, when I was in the radio studio, that was in San Francisco."

"Did you have a national hookup?"

"Oh, no. It was just a local broadcast."

"Well, let me know when you're going on the air again, and I'll *get* you a national hookup—sort of. You see, I'm not only a radio professional, I'm a radio *amateur*, as well."

"A 'ham'?"

"That's right. I can patch you in to folks all over the country. In fact, the radioman on board the ship, here—he's a ham, too. We've talked lots of times, when I'm at home and he's on the ship—off duty, of course. See that?" He pointed to a wire stretched between the ship's two masts, high above the funnels. "It's the master antenna. The radio shack's here on the Sun Deck. I'm going there tomorrow afternoon. Would you like to see it?"

"How will you get through into First Class?"

"My buddy the radioman'll phone the deck officer at the gate. And if you're in the band, you must have a pass, or something. Come with me. Oh. I'm sorry. You're looking at your watch. I didn't mean to bend your ear with—"

"No. It's just that I have to get to work. And they're taking the band-photo today. Come hear us tonight, will you? Bring your whole collegiate rooting section. We play one set every night in the Cabin Class Lounge, at eight-thirty."

He looked at his feet. "I'll try, but, uh...we always play cards on the first night."

"Another tradition?"

"It gives us losers a chance to earn a little dough back. But what I said about the radio shack still goes. Would you ring me up tomorrow? Or knock on my door? We're on Deck-D; my stateroom's number four-oh-six. It's right off the foyer, just past the doctor's office. Okay?"

I said, "Well, if I'm not rehearsing..." but I let him see that I was smiling. Then I walked away. The *Lurline* was passing under the bridge; and in its shadow, no color showed. From beneath, the steel skeleton looked as black as our smoke, which was streaming away behind us, flattening and fanning out in the breeze off the ocean that loomed ahead, dark blue and tipped with whitecaps.

<center>❀</center>

Down on Deck-E, in 531, Ivy had wrapped a floral-print cloth around her hips, leaving nothing on top. She turned her head toward the room's only mirror, and stuck out her chest. "What d'ya think, Roselani? I'm goin' native!"

"*Auē!*"

"I ain't goin' *away*. I said—"

"I know what you said. And I said '*auē!*'—it's Hawaiian. It's like saying, 'Oh no!'"

"But, but," Lillian protested, "didn't you say '*ono* means delicious?"

I cleared my throat. "I am *not* going on stage without a—"

"Don't worry, Katy," said Roselani. "There's a *right* way to tie a sarong."

Ivy chuckled. "You're sa-right and I'm sa-wrong!"

Roselani picked up the other sarongs, which had been lying folded on the day-bed, and handed one to me and one to Lillian. Ivy stepped out of hers. All four were printed in the same pattern: random sprays of five-lobed flowers—yellow, with pink centers—on a black background. "Strictly speaking, this isn't a

'sarong'—which is a simple loop of fabric. It's what the Tahitians call a 'pareu.' But there's—"

"We're *not* changin' the band's name!" Ivy muttered.

"—no mystery to tying it," Roselani went on. "It goes around your neck and *covers* your chest. I'll show you how, and we'll all do it together. Follow me, now."

After a few tries, I got the hang of it. Looking like a big apron, about four feet square, its top two corners tapered into ribbon-like tails. You stand up and hold it behind you, with the base of one tail in each hand, and bring your right hand around in front (like you're saluting the flag), making sure the cloth goes under your arm, and holding it down with that arm, against your chest. Then, with your free hand, bring the other side around to the front, and run the tail up behind your head. You reach behind your head with the first tail, tie both tails together at the back of your neck, and *voilà!*—or maybe I should say *aloha!*—you're inside something that looks like a bias-cut gown, draped to your knees. The free edge of the square hangs loosely down one side, but if you fasten it at the waist with a safety pin—which Roselani strongly advised us amateurs to do—the flap won't blow open.

A sarong is more comfortable and cool than a silk evening gown, because it's just thin cotton. And though it covers much more of you than any bathing suit, it does make you feel like you're practically naked. If you've got any curves at all, you're very aware of *how* curvy you look. Which can be embarrassing, because there's no support for your bosom. And you can't wear a brassiere underneath, because everybody'd see the shoulder straps!

Lillian—the only one of us who really had to worry about support there—solved the problem in the same way she'd have prepared for wearing a strapless gown: by snapping herself first into a snug strapless brassiere.

"*Now* we're the Swingin' Sarongs," Ivy said with a grin. "And—" she modulated up, like Eleanor Roosevelt "—it's time to watch the birdie!"

We touched up our makeup, then we headed upstairs for our photograph, and our first gig.

❧

They served tea at the tea-dance, along with cookies and white-bread sandwiches with the crusts trimmed off. But most of the waiters' trays bore cocktails, and several of the passengers were already, loudly, drunk. Out of perhaps fifty or sixty couples, only eight or nine were keen to dance: they were the ones who stayed on the floor between numbers, and turned to face us when they applauded.

We knew enough not to expect much more attention, especially on the first day aboard, and figured we'd get noticed even less by the dinnertime crowd that evening. Which was just as well. Since this was the first time we'd actually played together in public, we gave them standards—songs practically everybody recognizes—including a few Broadway hits by Phillip DeMorro, whom I looked for, but didn't see.

On the novelty songs, and the ones with sparse lyrics, Lillian or I would fill in the lines with elaborations on the melody. During ballads, we'd run arpeggios inside the piano chords. And we held our dance numbers to a consistent length: about the same three or four minutes as a record would last. Typically, Roselani would lead off the first few measures with a piano lick, sing the verse, then the chorus. Either Lillian or I would take the first solo on the chorus; then the other would do the second, but only up to the bridge, at which point Roselani would come back in and sing through to the end. To give it a *wow* finish, we'd repeat the last line, and stretch out the last full measure.

Only three people asked for requests, and one was for "Happy Birthday to You." The others were also standards that we'd each played hundreds of times, and for which we easily improvised arrangements in whatever key Roselani wanted to sing them.

We went down to eat supper after the tea-dance. Like our sailing-day musical arrangements, it was a simple menu, easy for

the kitchen crew to prepare: roast chicken, mashed potatoes, peas-and-carrots, and ice cream. And as with our music, we expected the food to grow spicier and more exciting the closer we got to Hawai'i.

Most of our tea-dance material worked all right as instrumentals, too, in the Main Foyer for the First Class diners, because over supper, we had figured out where we needed to transpose, speed up, slow down, smooth out, or cut. The passengers' inattention to what was, after all, background music also worked to our advantage that first night, allowing us to test our theories and try numbers in different arrangements, until we agreed on the best versions. By the time we were through, we felt the Swingin' Sarongs were finally swingin'.

<p style="text-align:center">❀</p>

"Hey, Miss Green! Over here!"

Mouse Ichiro was waving to me from a table several rows back from the dance floor, at the end of our set in the Cabin Class Verandah. All four men at his table stood up.

"This is a first, Miss Green, believe me," said his friend Danny Boy Ohara, as I approached. "We held off playing cards to come to your opening night. Captain Mirikami here didn't even wait to change into civvies."

"Please sit, won't you," said the captain, pulling a chair from an empty table nearby. "Tadashi Mirikami. Call me Tad."

"*We* call him Jingo," said the heavy-set man. Danny Boy had told me his nickname, but he immediately added, "Everybody calls me Rubbish. Everybody." His voice was raspy from cigarettes, and he had to place the one he was smoking back in his mouth before shaking my hand.

"How do you do?" I replied. "I hear congratulations are in order, for your alma mater's victory."

"Thank you, thank you!" Like many fat men, he was engagingly pleasant, though his smile revealed teeth stained ochre from tobacco. His hands and face were smooth, and of the four friends he was suntanned to the darkest hue.

"We've had our nicknames," said Rubbish, "ever since high school."

"In Japan?"

"*No!*" They'd all said it, practically in unison.

"Honolulu," Rubbish explained.

"Pearl City, actually," said Danny Boy. "It's up the hill from the navy base at Pearl Harbor."

"We're *Nisei*—second-generation," said Jingo.

"Born in Hawai'i," Mouse added.

Rubbish sighed. "These days, you know, everybody's touchy about Japan. But I read where there's a delegation from Tokyo in Washington right now. I sure hope the Americans and the Japanese can come to some understanding."

Jingo frowned. "Like the English and the Germans did, in Munich?"

There was an awkward silence, until Mouse said, with a grin, "Whassa-matter you?"

"Whassa-matter *me?*" Jingo replied. "Whassa-matter *you?*"

"Whassa-matter me? *You* whassa matter!"

Another collegiate routine, I figured, as all of them chuckled. But it glossed over the political question the captain had raised. And just then, Ivy and Lillian walked over. So I restarted the party by making introductions. Jingo drew up extra chairs.

Lillian touched his epaulets and collar pin. "Do these things tell you who you have to salute, and who you can tell to do push-ups?"

"No, Miss Vernakis, that's not my job at all. I'm not a drill sergeant. I'm a captian in the Ordnance Department."

"Oh. 'Ordnance.'"

"Do you know what that means?"

"Sure. You *order* guys around."

That got such a good laugh, I had to wonder if Lillian had set it up.

Rubbish offered us cigarettes from a black-enameled case— one of those big Ronson cases, with a built-in lighter. I declined,

but the other girls took smokes. He snapped the flame, asking, "First trip to Hawai'i?"

"Yes, and we can't wait to see Waikīkī Beach."

What Lillian really wanted to see were the *beach boys*, which soon became obvious, as she told them of trying to ride on a surfboard in Santa Barbara. I wasn't surprised that she held their attention. Being a chatterbox, she was good at spinning yarns. Of course, the swell of the sarong over her bosom was an unmistakable drawing-card, too, but she never deliberately called attention to it. She hadn't wanted to do those risqué songs, either.

Mouse tapped Rubbish's arm, and made a fist; Rubbish made his, and they shook them down three times. Mouse's rock broke Rubbish's scissors, only instead of taking a punch in the shoulder, Rubbish pulled a five-dollar bill out of a clip and headed for the bar, to buy the next round of drinks.

Jingo—Tad, that is—seemed to take greater interest in something behind me: he looked frequently past my shoulder, in the direction of the bar, where Roselani was drinking alone. "Your singer—Miss Akau," he said. "Is that her real name?"

"It's her stage name. Her real name is...uh...uh—"

"Apapane?"

"That sounds right, Captain. Or...Jingo, or—"

"Tad. Please. It's what I go by in the army. If I didn't attend Big Game with these three jokers once a year, *nobody*'d call me Jingo anymore. But about Miss Akau—isn't her brother Bill Apapane, the surf-riding champ?"

"Yes."

"Do you know *Bill*?" Lillian interrupted her tale to ask him.

"I've seen him ride his board at Waikīkī," Tad said. "I thought he might be on the ship, too."

"No, darn it!"

"Hey!" Mouse nudged Tad with an elbow. "Miss Vernakis here was telling us an interesting story."

"I want to hear it, too," said Rubbish, who'd returned with enough beers for all of us.

"She'll have to finish it later," Ivy told them. "We've got to play another set, up in First Class."

Rubbish pulled a ten-dollar bill from a silver money-clip, and pressed it into Lillian's hand. "We're no pikers, down here in Cabin Class. You tell me if anybody tips better up in First, and I'll match it tomorrow night."

With a smile and a chuckle Tad declared, "Rubbish believes that 'appeasement' will prevent *class* warfare, too."

Lillian didn't seem to catch Tad's allusion to Munich, though *I* had, and earlier, too, because it was the first time in days that anyone around me had said anything about the war in Europe.

Lillian smiled, glanced at the "ten" in her hand, stood up and said, "Thank you!" I'm sure it was a terrible disappointment to the boys, but she did *not* tuck the bill into her bodice. She was intemperate and uninhibited, but she wasn't actually vulgar.

"Yes, thank you," I added. "But please excuse us. I'm sorry."

"We'll be back tomorrow night," Ivy said, giving Danny Boy a smile in the process.

They all rose—far enough to satisfy Emily Post, anyway—and said good-nights to us as we walked away. But Danny Boy called: "Tomorrow afternoon, Miss Green? The radio shack?"

"Oh." I hesitated, but Ivy had gone on ahead. So I said, "All right. Sure!"

<center>❀</center>

Between sets in the First Class Lounge, around ten o'clock that night, Ivy took me aside. "Katy, we elected you to ask DeMorro if he wants to play a few tunes. Tell him we'll back him up."

She pointed. In the smoke and dim light at the back of the lounge, it was hard to see them clearly. But even seated, Phillip DeMorro was taller than the other people at his table: a prosperous-looking couple on his right, and a ship's officer in a white uniform on his left. He also sat a bit farther back from the table than the others did, probably so he wouldn't hit them as he spoke, swinging his arms in big, room-encompassing gestures.

"We are *loving* the Sarongs. And the girls inside them!" he

declared, rising from his seat as I approached. "Phillip DeMorro. And you are…?"

"Katy Green."

"My friends, Mr. and Mrs. Brewer. And Doctor Boyd, the ship's physician. Please join us, Miss Green."

"Thank you."

The doctor pulled an unoccupied chair from the next table, and smiled as he held it for me. The Brewers were the formal type—I didn't expect the wife to offer me a hand to shake, and she didn't; so I withheld mine, too. But they did give me polite smiles.

"We heard that you were on board, Mr. DeMorro," I began, "and then we read that interview with you, in *Band Star*—"

"It will haunt me all the days of my life! Have *you* ever been interviewed by Darlene Duncan?"

"Well, not interviewed, exactly."

"I'll be happy to mention your band to her; I'm sure she'll give you some ink. But you'll have to endure her presence!"

"Thank you. But we haven't been togeth—to *see* her, yet. And actually, I know Darlene Duncan. We were in the conservatory together."

"Then it's *true*? She said she could play piano."

"She was pretty good, in her school days."

"Where you played…what, Miss Green?"

"Violin."

"Got you, Quart!" The doctor poked Mr. Brewer in the shoulder. "Drinks are on you!"

"We have four more days, Swifty. I'll get even."

Mrs. Brewer turned to her husband. "I told you, dear. The way she holds her left wrist straight, and keeps her right pinky all the way out, down to the end of the bow—that's classical training." Then she turned back to me. "Quart—that's my husband, here—bet that your first instrument was the saxophone; and that you'd picked up the violin subsequently. Doctor Boyd, who is Swifty to his friends, said you'd more likely have played violin first."

"Swifty?" I asked. "And Quart?"

"It's a legacy of our years at the Punahou School, in Honolulu," said the doctor.

"Prep school. *Hobart* Boyd was the star of the track team," said Mr. Brewer. "Hence: Swifty."

"And my schoolmate here was born John Clay Brewer, the Fourth. So the upperclassmen dubbed him Quaternary. Or at least, they did, until someone—"

"Guess who!" The woman tipped her head toward the doctor.

"—made a pun on Brewer, and turned quaternary into Quart."

Mr. DeMorro declared, "I could never be satisfied with just *one* nickname. Like Walt Whitman, 'I am multitudes.'"

"This must be the official ship for men with nicknames!" I said. "Besides you two, I've met a Mouse, a Danny Boy, a Rubbish, and a Jingo."

Mr. Brewer snorted. "Oh. *Them!*"

"You know who I mean?"

"Of course I do. They were at Big Game last weekend, as always. They're not in First, I hope."

"They're in Cabin Class, right by my office," Doctor Boyd said. "I'm told they take the same cabins every crossing—just as you do, Quart."

"*Japs!* They give themselves nicknames, and right away they think they're Americans, like us!"

"Come off your high horse, Quart," said his wife. "Two of them got into Stanford, same as *you* did."

The doctor turned to me with a grin. "The other two were across the field, on *my* side, the Cal side."

"The winning side!" I said.

"Go Bears! Beat Indians!" He punctuated his cheer by giving Mr. Brewer's shoulder another brotherly tap.

I smiled. "Did you know the—the other two fellows, at Cal, Doctor?"

"Mouse and Rubbish? Sure. I was two years ahead of them, but Mouse is really brilliant. He was in one of my classes—

upper-division chemistry, while he was still a freshman. We studied for exams together."

"And Rubbish?"

The doctor smiled. "Rubbish taught me how to drink *sake*—that's the Japanese rice-beer. They drink it warm, like tea."

"Speaking of drinks," said Phillip DeMorro, "let's have some more." He looked up, caught a waiter's eye, and twirled a finger in the air. It was all he needed to do: the order was understood immediately. He turned back to me. "'And I knew her when...*quelle Parisienne!'*" he sang, quoting one of his own lyrics. "I was thinking of your friend Miss Duncan—when she interviewed me. You'll appreciate this."

He gathered his hands together, and we all leaned in to hear. I felt a little flushed, being treated as an equal by the Baronet of Broadway.

"There we are on the Astor Roof. Miss Duncan *lights* my cigarette. She *touches* my arm. She *lowers* her voice—" he does, too "—'Oh, Mr. DeMorro, am I the only "Darlene" whom you have ever met?' You may imagine that I have heard this line before, the name, of course, being the variable in the equation. 'Yes,' I reply, 'I think you are the sole "Darlene" of my acquaintance.' Whereupon the girl flutters her eyelids, and says, 'Well then, I should love to hear a song from you, one day, called "My Soul, Darlene."' She actually spelled it out for me: s-o-u-l. 'Then I'll know it was written just for me.' And before I can disabuse her of this hideous fantasy, she adds, 'And you'll send me the sheet music, won't you? Autographed and dedicated.'"

I chuckled. "That's her, all right." I noticed, during his anecdote, that Mrs. Brewer didn't look at him—or at her husband—but at the doctor. He noticed it, once in a while, and gave her half smiles.

"So, now, Miss Green—" the Baronet touched my arm. "You must tell me some lurid adventure from Miss Duncan's flaming youth, so that I may blackmail her into never coming near me again."

The corners of my mouth twitched. I was once drawn into

a *very* lurid adventure with Darlene—one that Mrs. Brewer's wandering eye had actually put me in mind of. But I was *not* about to relate it. "Actually," I said, "I came over to invite you to sit in with us, some time during the voyage. We'll be playing here every night, and—"

"I thought you'd never ask. Of course I'll play with you. But it must be completely spontaneous."

"Sure."

"So, I'll let you know when we can rehearse."

"Thank you."

I walked away, smiling at my ability to banter with—of all people!—Phillip DeMorro. And yet, I was a little anxious, too. He was so above-it-all, he might have been leading me on, for a lark. Or worse—setting me up to be the stooge later, in some routine.

# Saturday, November 29

SLEEPING ON A SHIP IS LIKE sleeping on a train. Unless you look out of a window, you don't notice the forward motion so much as the side-to-side. On a train it's sudden and fast, like the tick of the tracks, and when you're humming to the beat, it's an uptempo tune like "That's A'Plenty" or "The Joint Is Jumpin'." On a ship, though, you're leaning into every beat, with the engines doing a slow roll that's...almost sexy. It makes you hum "Mood Indigo" or "The Man I Love."

But the ship had stopped. And where there'd been a low-pitched rumble all night, there was now a shrill whining and grinding, too loud to ignore. I woke up. Morning had lit up the porthole. I checked my watch: it was a little after eight.

Roselani had been awakened, too, got to the wash basin first, and looked out. "We're alongside the Matson pier, in the L.A. harbor at Long Beach."

"And that grating glissando...?"

"Crane-hoist—right outside—hauling up cargo on a pallet."

We got dressed, comforting ourselves that we'd be able to sleep longer when we were at sea. By eight-thirty we were

eating breakfast with Lillian and Ivy in the Cabin Class Dining Saloon.

Suddenly, a man's voice—loud, but rather high-pitched—said, "Lillian! Where you' *sarong?*"

"Bill?" She spun around and blinked. "*Bill!* Wow!"

Roselani squinted at him. "Did you come to see us off?"

"Later for that, sister."

Lillian jumped up, gave him a big hug, and a peck on the cheek. "Katy—this is my…this is Bill Apapane. Katy Green."

"Hello." I put my hand out.

"Miss Green." He leaned across the table and shook my hand, then Ivy's, and took both of his sister's hands in his own.

He resembled Roselani in being fleshy, bronzed, and black-haired. But he was bigger: well over two hundred pounds, maybe even two-fifty. His open-necked shirt rode over a prize-winning pumpkin of a belly. Yet he carried his head up, and shoulders back, with far more grace than his bulk suggested. But then, of course he would—he was an athlete, a surf-rider.

When we shook hands, I expected to be gripped hard. But he unfolded his arm and extended his hand deliberately, the way a dancer would. (I'd like to see him dance!) His palm and fingers were heavily callused, but he was apparently well-to-do: his blue shirt was a fine silk weave, hand-embroidered around the buttonholes and down the front; and his white linen trousers were so large they must have been custom-tailored.

He pulled up a chair and sat down on it, his backsides spreading far beyond the edges of the seat. Lillian stood beside him, laid her arm on his shoulder, and stroked his cheek with the back of her fingers. Beaming a wide smile at her, he said, "Where'd they put you girls, Lillian? Down in the hold?"

"Almost! We're here on Deck-E, all the way back there—" She pointed toward the stern. "Katy and Roselani are in five thirty-three. Ivy and I are next door, in five thirty-one."

"I'd like to see your room."

"I can't wait to show you!"

"Hey, you stowin' away, or what?" Roselani demanded. "By 'n'

by, the crew go catchin' you. 'Fore the ship go sailin', more better you stay *goin'*!"

"Easy, sister. I no more stay goin'! I go *stayin'*!"

That clipping of words and sentences got a name as soon as Roselani said, "Okay, no more talk Pidgin!"

He grinned, and enunciated clearly—almost theatrically: "I have a ticket. First Class! I'm sharing a cabin with a friend of mine."

Lillian planted a kiss on his cheek. "That's wonderful! How'd you get here, anyway?"

"Train. I had to pick up a new surfboard. A company here in L.A.—Pacific Home Systems—they make all the boards I use in competition. Wintertime in Hawai'i's when the waves get real high, so they made this board extra-big and heavy. Anyhow, a guy I know was sailin' for Hawai'i today, and when I told him I'd like to go home for Christmas, he gave me a ticket and said, 'Come along.'"

Roselani sneered. "What you givin' *him* for Christmas?"

"Aw, no make trouble, sister! I feelin' so good now. Here I am, goin' home again, with my new board. An' I get to see my *ku'u ipo* on the trip."

"'Koo-oo ee-po.' That means 'sweetheart,'" Lillian said proudly.

Without getting up from his chair, he slid his arm around her waist, and hoisted her—giggling, her cheeks extra-red—an inch or so off the floor. Then he set her down, saying, "I gotta go now." There was a silent moment. He looked at the rest of us, ending with a glare at Roselani—to whom he added, in that clipped Pidgin-English way, "I owe you money, or what? No gimme da stink-eye!"

She turned away.

Lillian stroked Bill's hair. "Before you go to your *suite*, wanna come see your sweet *sweetie's* room? Ivy's gotta stay here and finish her breakfast, right, Ivy?"

"Yeah. We *both* need to put some meat on our bones."

Bill smiled, but he extended his arm, shifted Lillian away, and

pulled a gold watch from his pocket, on a chain from which a round seashell, almost as large, also depended. "Later for that, *ku'u ipo*. I gotta go down to the hold first. They loadin' my board, an' I like see they don' break it, yeah? Then I gotta get up th' stairs again, and unpack. I come see you tonight."

"No slumming: Cabin Class stays in Cabin—First stays in First. It's in the rule-book!" Roselani said.

"We play a couple of sets in First, every night!" Lillian told him. "You come hear us—"

"Bring your rich roommate!" Ivy stuck in.

"—and I'll sneak you down here somehow, honey. Maybe wrap you up in a sarong, and pass you off as one of *us*!"

"Bye 'n' bye, love. I'll see you. All of you."

"Me, too?" said his sister.

"Eh, I no more *huhu*. So, you no more *huhu*. Okay, yeah? Cool head—main thing." He held out his hand to her.

Roselani had turned away. Lillian looked at him, then at her, and waited in the silence that followed, until Roselani swung her hand out, and followed it around, to face him. He shook her hand and smiled, rose—looming large—and strode away without another word. There was just a hint of a waddle in his otherwise graceful gait.

Lillian brought out again the enormous grin she'd worn when Bill first appeared, and said, "What a guy, huh? He talked his way onto the ship, just to be with me. You're okay with that, aren't you, Roselani? Or are you 'hoo-hoo'? That's the Hawaiian word for angry, isn't it?"

She shrugged. "Yeah. No *huhu*. It's just...I'm sorry. Bill has a real knack for ingratiating himself—"

"Hey! Quit it," Ivy protested. "Let's work up some arrangements."

❀

So we rehearsed, in the Cabin Class Verandah, for two full hours.

We started with what we'd gotten from Matson's library. The published song-sheets were in pretty good condition: torn

pages had been promptly repaired with cellophane tape. And the handwritten lead-sheets had been professionally copied in ink. We could play all of those pieces as written. The hard part for us—for any band, really—was to do something new with them. So I was especially pleased—we all were—with the sound we managed to create for ourselves.

Ivy was a hardy bassist, with a consistently strong downbeat. She could even play solos. On some standards, like "Sweet Georgia Brown," a band can play "stop-chords," and let the next few measures go by in silence. It gives the bass player an opportunity to show off, plucking melody lines and riffs all alone. You hear jazz bassists do that in theater appearances, and they do it after hours, too, of course, in those spontaneous competitions that musicians call "cutting-contests." Dancers don't usually warm to it, because it calls attention to the band. But the *Lurline*'s passengers, especially those in Cabin Class, had applauded whenever Ivy took a solo, so we arranged to showcase her in a song with stop-chords at least once in every set.

Off-stage, Lillian might be dotty in the head, but she was always fully alert on the job, even when she was smoking reefers. (Which reminded me—these past few days, I hadn't noticed any of that smoke on her breath. Or Ivy's. Maybe they'd quit?) She had total control of her mouth and lips—what wind-players call the *embouchure*—coupled to a light touch on the valves that produced marvelous tone and timing. For romantic tunes she'd insert one of several mutes she carried—but more to gain a special effect than to squelch the volume, since she could play as loud or as soft as she wished easily, without relying on a mute. Lillian also had an uncanny ability to conjure up unique riffs, launching them with an unpredictable choice of a note or phrase built inside the supporting chord, yet always making the sequence come out right at the end. On stage, at least, I never had to worry about what she might do next.

Roselani played with a heavier touch than most nightclub pianists I'd heard or worked with before. But she was flawless in the straight passages, and able to embellish melodies in subtle

ways that sounded easy but weren't. I had to declare her a wizard on the electrified Hawaiian guitar, too. Anyone who thinks it's limited to making those famous *oooo-eeee* chromatic glissandos hasn't discovered what a virtuoso can do with it. Not only could she take solos on Hawaiian tunes, she could play sophisticated melody lines like "Fascinating Rhythm" and "Autumn in New York." I had never before heard standards played on that instrument, but I was sure that the renditions she produced would please any composer: Porter, Gershwin, Duke, Arlen, Coward, Rodgers, Berlin—and DeMorro, of course.

What a lucky break having *him* on board. If we all hit it off with him as well as I had, he might give us a spot in a revue.

<p style="text-align:center">❀</p>

We were packing up when we heard the whistle blow, and felt the ship pull away from the Long Beach pier.

"Why don't you go up on deck," said Roselani, "and watch us head out to sea again. I need something from the stateroom. I'll join you on deck in a minute."

The rest of us took the stairs to the Cabin Class swimming pool. The wind must have been blowing at the same speed and in the same direction as the ship, because it was calm enough on deck for both Ivy and Lillian to light their Lucky Strikes from one match.

Out of the blue, Lillian said, "In case you're wondering, Katy, I don't smoke reefers anymore. They always made me hungry. So I switched to these—" she waved the Lucky "—but I'm still trying to lose weight! See, on this diet you can't have any little snacks, and—"

"Tell me about Bill."

"Oh, I'm really sweet on Bill, and vice-versa. But Roselani hates him. Isn't that right, Ivy?"

"Yeah."

"She won't play—she won't go on stage—if he's in the audience! The other night, while you were at the Bamboo Hut, he had to stay away; that's why I couldn't join you there."

I blinked. Bill *had* come to the club. But Ivy looked away—deliberately, it seemed—and kept mum. I took a different tack. "What's their beef? D'you know?"

"Well…Bill told me, but don't tell him I told *you*, okay?"

I looked at Ivy. Her shrug told me she knew what was coming.

"Okay."

"He used to…steal things. Back when they were kids. He doesn't do it anymore, of course! But he got in trouble with the law once."

Now it was Ivy's turn. "Roselani's ashamed to be seen with him. That's what she says, anyway. But who would ever know? It's not like he wears a sandwich-board!"

"And besides, he's a famous surf-rider. Out on the beaches, a lot of people like him. And respect him. He doesn't need *her* to—"

"Was he ever in jail?" I suppose I shouldn't have been so callous, but she *had* mentioned "trouble with the law."

Lillian nodded. "It's not like he was…you know, an international jewel thief, or a kleptomaniac. And it was fifteen years ago. He only did a little shoplifting. And gosh! Who hasn't?"

<div align="center">❀</div>

Just as your ears are right behind your eyes, the radio room was in back of the ship's bridge.

Danny Boy and I came up the stern-most stairs a little after two o'clock, and walked the length of the Sun Deck squinting into the west ahead. California had vanished behind us hours ago, and there was a steady, almost predictable rhythm to the engines' hum and the roll of the ship. By now, I'd gotten the hang of walking in a straight-enough line: extending my foot just a bit when I knew the ship was moving away, and holding it back just a bit when I knew the deck would be coming up to meet me. Which was good to know, because the motion of a ship is exaggerated the higher up the decks you go, and we were on top.

The radio room was dark inside: it had no windows, just a small, bare bulb overhead and a desk lamp with a green glass shade. Half a dozen microphones and telephones filled a wide oak desk, bracketed by trays of fresh radiogram pages on one side, and spikes clogged with those that had been sent on the other. The only wall that wasn't covered with equipment was the one with the door we'd come in through, alongside which was a bulletin board full of postal cards.

"Katy Green, Les Grogan," said Danny Boy.

The radioman covered the nearest mike with one hand, raised himself from his seat just high enough for a quick hand-shake with the other, and said, "Stand by."

He was white—though so deeply suntanned that I thought at first he wasn't—and about the same age as Danny Boy and I. Above the neck, he wasn't handsome, with black hair too close-ly cropped for his wide face, and a nose just askew enough to hint it'd been broken some time ago. But his uniform jacket, but-toned up and stretched tight when he'd risen, called attention to a muscular physique.

He continued to listen through black Bakelite headphones, spoke a string of numbers and "*Lurline* out," into one of the mikes, flicked two switches off, and finally leaned back in his oak swivel chair, arms outstretched. "Welcome to the rest of the world, Miss Green."

I hadn't thought of it that way before, but I quipped, "It can't be too big a world, if it can fit in this dark little room." Then I added, "But I guess it's the ship's lifeline, huh?"

"Yeah, although when there's sunspots, or congestion in the airwaves, grabbing hold of that lifeline can feel more like hang-ing on to one end of the rope in a tug-of-war."

"Don't say war!" Danny Boy gave his friend a gentle nudge with his fist. "There's too much war talk in the world lately, already."

"If I didn't know where you stand, Danny Boy, you wouldn't be welcome here. Which reminds me: you know the Jap lingo, don't you?"

"Only a little. My parents sent me to Japanese school in the afternoons, after regular school, for a couple of years. But they're the ones who're *nihonteki*—very Japanese. They speak it when they don't want me to know what they're saying."

"Well, check this out, Danny Boy: I've been hearing stuff like this for the past two or three weeks. It's puttin' out a signal on the eighteen-hundred kilocycle band." He flicked a switch on one of the radio sets, pressed his earphone tighter against his left ear, twisted a large knob—a tuner, I supposed—and listened for a moment, before passing him the earphone.

Danny Boy listened, eyes half-closed, and nodded. "It's Japanese, all right. I'm only getting a couple of words, though. *Sakura.* That's cherry blossom...and uh, what's the word? Oh, uh...out of season. Well, that's obvious: cherries bloom in the spring. Uh...something...rock-garden, probably.... Ha, ha, ha!" He grinned at us.

"What?"

"He said, 'Listen for the weather report on Radio Tokyo.' It must be a commercial station! What's the big deal, Les?"

"If he's commercial, he shouldn't be on a ham band. But if he's a ham, I don't recognize him. Do you?"

"No. Do you think he's transmitting from Hawai'i?"

"He's comin' out of the North Pacific *somewhere*. And there's only one place, for thousands of miles, where somebody could be growin' cherries."

Danny Boy shrugged. "It's a new one on me. Ask him for a DX." Then he added, "See those, Miss Green?" and pointed to the postal cards on the bulletin board. "Those are DX's. They're what hams send to each other, to show they've made contact. Les got these from hams who've raised him here on the ship. See this?" He tapped a bright yellow one, stenciled with a red palm tree. "'K-six-C-O-G.' That's me, and my push-pull rig at a hundred watts."

SHUNICHI OHARA, his address in Pearl City, Hawai'i, and the date and time he'd made contact with the *Lurline* were typewritten on the card.

Les looked at me. "D'you know why we call ourselves 'hams,' Miss Green?"

"From 'ham-ateur radio'?"

"Good try!" he chuckled. "But no. The commercial operators—the guys who work for Marconi Wireless, or Radio Corporation of America—they're always sayin' we hog the airwaves, like ham actors hoggin' the stage. But we turned their insult into a compliment, by taking the name for ourselves. Would you like to hear some ham traffic, Miss Green? I can't let you listen to the ship's official communications, or the radiograms and radio-telephone calls. You understand."

"Of course."

Les held the headset out, and I leaned my ear against the hard, black earphone. What I heard was like the static you get when you're between broadcast stations on the radio dial. After a moment I made out some voices, but I couldn't understand them. I shrugged and smiled, and let him take back the headset.

All the while, I'd been staring at the variety of radio equipment around us. Some of the cases were as tall as closets or lockers, others were only the size of a valise, but all of them were studded with nickel-plated switches, Bakelite or Ivoroid knobs, red glow-lamps, and white-faced gauges.

"I've gone behind the scenes in a broadcast studio," I said, "but I've never been in *this* kind of radio station. It looks like there's more than just one radio here; but then, I guess there must be."

Oops. Translated into radiomen's lingo, I must have said, "Tell me what all *these* things are," because Les proceeded to give me the grand tour. So now I know that there are a dozen different "bands" of radio waves, some for the hams, some for commercial stations, some for the army and navy, and some just for emergencies. Whoever's on duty here—the other radioman was off-shift, sleeping—has to keep all of those channels open all the time, and be ready to respond.

"This one's the marine band," he said, pointing to one of the sets.

"And you don't mean John Philip Sousa's 'Marine Band,' right?"

Danny Boy laughed. "Good pun, Miss Green! I'll remember that."

"Anyhow," said Les, "the marine band'll let us know if there are any other ships in the vicinity, especially if one of them gets in distress and needs our help. Every liner, every freighter, every seagoing yacht, we all keep that circuit open, just in case. This one's for the head office in Frisco, to talk to all the ships in the Line. We get the United Press teletype over the air for news, through that radio over there. The radiogram traffic—" he waved his arm at the spiked pile of papers "—is handled by that unit beside the door; but all the ship-to-shore telephone circuits pass through this big one."

While Les was talking, Danny Boy bent down and unscrewed the face-plate of what I had assumed was a radio set.

"Did Danny Boy tell you why the Matson Line gives him a pass to come on up here?"

"No."

"Well, every trip, he has to come up and check on his 'baby.'"

Danny Boy moved to one side, and when I saw his "baby," I was mesmerized. Right in the middle of what he'd been working on was a green light bulb—well, not exactly. It was the size of a tennis ball, but flat in front, with a thin white line of light quivering across its face, like a jump-rope in the grass.

"They call it an 'oscilloscope' because the trace *oscillates*," he said to me, without looking up from the tubes and wires inside. "If you could see a radio wave traveling through the air, that's what it would look like. A couple of guys I know *make* these 'scopes. They're swell guys—Dave Packard and Bill Hewlett. They were a few years ahead of me at Stanford. I worked for them, before I got the job at Mutual Telephone. They're—"

"Hey, 'Stanford'!" Les exclaimed. "What happened to the Indian backfield last Saturday?"

"You Bears barreled right through our lines, 'Cal.' That's what happened!"

"Oh, no!" I said, touching my forehead with the back of my hand, to feign shock. "Is there *anybody* on this ship you didn't go to school with?"

"There's *you!*" Danny Boy retorted. "Whereas, we—"

"We," Les joined him in saying, "went to different schools together."

I turned to Les. "And when you went to Cal, did you know Mouse Ichiro and Rubbish Mirikami, too?"

"Sure! That's how I met *this* guy. Rubbish introduced us, when he heard I was a ham." He nudged Danny Boy with his elbow. "So, how about that fourth quarter, huh?"

I was feeling drowsy, lulled by the humming of vacuum tubes, the whizzing of a small fan by the door, and the flickering of the scope's white trace across the green lamp. Before I embarrassed myself by yawning—and to keep from having to smile while they reprised the Big Game's plays—I said, "I better go. Thank you."

"My buddies and I will be at your show again tonight."

"Great. See you there. And thank *you*, Mr. Grogan."

"My pleasure, Miss Green." He turned back to Danny Boy, as I opened the door. "Fourth quarter—that's when we Bruins mauled you Braves."

"*Whoo!* It was murder!"

❀

Down one deck, in the Writing Room, Phillip DeMorro and his companions from the previous evening were deep in cushioned wicker armchairs.

"Ahh, Lady Paganini!" he announced when he saw me, with a swoop of his arms that carried his long, thin frame forward. The pomade in his dark brown hair glistened under the bright windows. "Let me *re*-introduce you to my table-mates."

I said, "Please, don't get up," as the men rose; but I did extend my hand to them.

"This is Doctor Boyd, who specializes in shipboard ailments. With luck, you'll never be seasick, or require his ministry for any

other reason, since *either* of those conditions is likely to disable you for the rest of the voyage."

The doctor smiled, and I did, too. He was very handsome and lean. His skin was tanned, though his hand, at least, was soft, almost like chamois leather. His teeth were straight, his chin firm, with no pelican-pouch underneath, and the outer corners of his eyes resolved into only the tiniest of crow's-feet. He wore a closely cropped pencil mustache, like Clark Gable's, but tinged with gray. Gray hairs inched up from his temples, too, and a few more salted his otherwise pepper-black crown, making him look almost fifty. But if he'd been only two years ahead of Mouse Ichiro, he'd have graduated in 'twenty-seven, and wouldn't be more than a couple of years older than I. So I figured he cultivated the appearance of an older man, to give his patients extra confidence in him.

"And Mr. and Mrs. Brewer, from Crackpot, California."

"That's 'Crockett'!" the gentleman corrected him, though by the half smile he tacked on, I could tell he'd endured the jibe before.

I turned my head away from the doctor (it was an effort—he was *very* good-looking), nodded at the couple, and said, "I think my train went through Crockett, heading toward Oakland."

"Yes, it probably did," he replied. "Crockett's the station-stop just before you reach the Bay."

"Somebody on board said there's a big sugar refinery there."

"Right, again."

"And it's *his* sugar!" DeMorro added.

In the darkness of the Lounge, last night, Mr. Brewer's hair had looked yellow-white, so I had thought he was much older. But if he and the doctor were prep-school classmates, they had to be about the same age. And now, in the daylight, I could see that his fleshy face was baby-smooth, with a hint of pink, and that his eyes were a clear, bright blue. I'd met men before who looked like him. They came mainly from New England, and were very rich. Mr. Brewer was evidently no exception: set in his tie tack and cufflinks were emeralds as big as shelled peas.

His wife was younger, by ten years at least, and exceedingly slender, with tightly marcelled jet-black hair. She had widely set brown eyes in an almond-shaped face which (though it was apparent only in profile) dwindled into a receding chin. Her gloves, I noticed as we shook hands, were a salmon pink that matched her day-dress. A big jade pendant, carved in the shape of a bird (not an albatross, I hoped), hung from her throat, and seemed to flutter whenever she turned her head to look at the men on either side of her.

"We're great fans of swing music," said Mrs. Brewer. "Quart and I held the reception for Benny Goodman at our home, when he came through the Bay Area."

"I'll see if we can work up some of the Goodman tunes for you," I said with a smile. "We play requests."

"My wife is quite the singer, you know." Mr. Brewer glanced at her. "What was the expression you used, Nan? Oh, yes—" he turned back to me "—perhaps she could 'sit in' with the band one night?"

"Oh, Quart!" She gave his shoulder a gentle slap. "Miss Green and the other girls are professionals. They'd never—"

"Don't be silly, Nan. I'm sure they'd love to hear you sing. Wouldn't you, Miss Green?" Before I could say anything— neither a polite "Of course," nor a more honest "Are you kidding?"—he jumped back in with, "I don't mean *during* your performance. We're making a party tomorrow night, in our suite— number four, on Deck-A—and we'd be pleased if you ladies would join us, so we can get to know you better. You can hear Nan sing there."

Far be it from me, to queer our chances for a good tip. "We'll come right after our last set, at one o'clock."

"We're having a piano brought up, for Phillip," said Mrs. Brewer. "Will your little bass player need a big crewman to carry her instrument?"

Ivy'd never ask for such help, and I was about to say so, but then I thought she might well be flattered by the gesture. "That's very kind of you."

And Phillip said, "Tell your sister Sarongs we can rehearse tomorrow. Come 'round to my cabin and knock me up, any time after eleven. Suite number two—" he pointed forward "—here, on Deck-A."

"Eleven o'clock? *That's* a first," said Mrs. Brewer. "I don't know about your companion, but *you* are never up before noon."

But the Baronet topped that, in a stage-whisper. "I have heard that some people eat a whole *meal* before noon. And I believe it is called 'breakfast.' Is that true?" He pulled a gold cigarette case from an inside pocket of his jacket and flipped it open for me.

"No thank you. I don't smoke."

He plucked out a Herbert Tareyton, placed the cork tip between his thin lips, and lit it with a match from a book that had the *Lurline* on its cover. "See you tomorrow," he said.

That was my cue. I rose, smiled, said, "Thank you," and left.

It was going to be a very enjoyable crossing. If I was not on an equal footing, I was at least accepted as an amiable satellite in the orbit of the Baronet of Broadway.

<div align="center">❀</div>

None of them came to our gig in the First Class Dance Pavilion that night. But Bill Apapane did. He sat at a table by himself and applauded loudly every time Lillian took a solo. Between sets, she joined him at his table and sipped on a beer. He however, by my count, consumed at least six beers during those first two sets. She drew her chair as near to his as his bulk allowed, and let her hand rest on his arm while they whispered to each other.

Roselani and Ivy and I took our breaks on stools at the bar, where a sign above the displayed bottles read: TRY A MATSON COCKTAIL.

Ivy gestured toward Bill with her elbow, and whispered, "Where's his room-mate? Anybody know?"

"No."

"You'd think Bill would bring him around to hear us."

Roselani muttered, "Umm…"

"He says the guy won't let 'em use his cabin, so he and

Lillian're gonna use *ours*, after the last set. I told her she better not take more'n an hour. But if I could hang around with some guy, while they're—you know, goin' at it—I'd give 'em more time. I like to chat up guys, you know, even if they're not my type."

Roselani sniffed, and said, "You got a type?"

Ivy glanced side-to-side and—this was rare—lowered her voice. "That Danny Boy Ohara, down in Cabin Class. And the captain—what'd they call him? Jingo?"

"Call him Tad," I said.

"D'you think they're good-looking?"

I nodded.

"Most men are so tall—too tall for me, really. Just once, when I'm on a guy's arm, I'd like to be able to whisper in his ear without getting up on tip-toes, or making him lean over. Those two are the right size: they've only got a couple of inches on me."

"They've got nice builds, too."

"You can say that again, Katy!"

"They're Japs!" Roselani declared. "You're a white girl. What do you want to go outside your race for?"

That was unexpected! I was embarrassed. I don't like that kind of talk, especially in public. And I had never heard anyone who wasn't white, themselves, make a remark like that. So I grabbed the reins and said, "I happen to know that Danny Boy is a gentleman."

Ivy perked up. "Yeah? How d'you know?"

"When I met him that first day, up on deck, he gave me his cabin number, and said to look him up. But he didn't ask for *my* cabin number. So he's probably not a wolf."

"That's good news," said Roselani. "But of course, there's something else he isn't."

"What's that?"

"He isn't white, like you, Ivy."

"Yeah, but I, uh, never had a yellow one. Don't you think I oughta give one of 'em a tumble, before I die?"

"You don't *have* to."

Ivy poked Roselani's arm. "Come on. Didn't you ever go, uh, 'outside your race'?"

"My ex-husband. He's half-Chinese."

"Which half?" Ivy guffawed. "Above the waist, or below?"

"Then, tell me, Roselani," I put in, "why don't you think it's a good idea to—"

"I got married too young—I didn't think of my responsibility to my own people. I'm pure Hawaiian. And I should have had kids that are pure Hawaiian, to keep the race alive. I owe it to the future of my people to—"

"Did you ever *have* kids?"

Roselani waited a beat or two. "I had one, with Clyde, but I lost it, okay? Subject's closed. You want to give the Jap a tumble, Ivy, you go ahead." She waved to the bartender, and pointed to the sign behind him. "Say, what's in that Matson Cocktail?"

"Gin, Cointreau, and pineapple juice."

"I'll take one."

Ivy nudged me. "So, you like the muscles on Tad and Danny Boy?"

"Sure."

"You didn't happen to see a ring on either of their fingers, did you?"

"Nope. You'll probably run into them tomorrow, at—"

"I think I'll go down to Cabin Class right after our last set; see if they're hangin' around the bar. I like to make the first move on a guy. That way, I can duck out if we don't click. Wish me luck!"

❀

With one set left to play, at about a quarter past twelve, I strolled out on the deck that overlooked the stern and watched the ship's wake in the light of half a moon. The breeze quickly shook loose my hairdo, though, so I turned to go back inside, to retrieve my brush from my pocketbook. But the French doors opened right in front of me, and a pair of white uniform jackets flashed in the moonlight. It was Dr. Boyd and another ship's officer.

"Miss Green," said the doctor, "may I present the *Lurline's*

master at arms, Stan O'Malley. He's in charge of security aboard ship."

Only their uniforms were alike: white jackets with brass buttons, black trousers, and spit-shined shoes. The master at arms was older, taller, and far more muscular, especially across the chest and shoulders. Topping a thick neck, his face was out of square—from boxing or wrestling, I supposed—with one ear and the opposite eyebrow bigger than their mates.

He wagged a finger at me, but smiled, too. "You and your girlfriends have been naughty young ladies."

"What?"

"Are you going to throw her in the brig?"

"Not if she confesses, Doctor."

I demanded, "What's going on?" though I sensed a practical joke. "What have we done?"

"You were supposed to introduce yourselves to me, the first day, like the Doc here did. All new staff and crew are supposed to."

"I'm sorry."

"I need to be able to recognize everyone who works for the Line. Especially the pretty ones."

Uh-oh! Was the cop a wolf? To his credit, he didn't follow that up with a leer or an off-color joke, so I smiled and extended my hand for a shake. The doctor smiled, too.

The master at arms leaned closer to me as he took my hand. "Miss Green, I'm sorry, but I also have to inquire: Did you bring any form of valid identification? A passport, maybe?"

"No—only my driving license. I was told you don't need a passport to go to Hawai'i."

"That's right. Your license will be sufficient. But you don't want to lose it."

"No. Of course not. Thank you."

"I also have to ask—" he hadn't yet released my hand "—have you ever been arrested, tried, or convicted of a crime?"

He was still smiling, so I returned it with a smile of my own, along with a shake of my head, and a quiet "Uh-uh."

But that was a lie. I was never convicted, or even tried, but I *have* been arrested. A couple of years ago, when I was visiting my grandmother in upstate New York, somebody was killed; and for a while, the people in her town thought *I'd* done it.

More often than most women, I seem to land in the kind of trouble that policemen get called in on. So I've met plenty of cops and sheriffs, private detectives, too. Men like that don't mean to be unfriendly, when they meet you, but they do give you the once-over, asking pointed questions, and processing your reply with their head tipped to one side. Which is exactly what this one did as he shook my hand once more, firmly, then let it go and said, "You're all right, Miss Green. Welcome aboard."

"Thank you, Mr. O'Malley. Or is it Officer O'Malley?"

"Not since I was a cop in Honolulu. Ships' officers are always 'Mister,' 'cept for the captain—and the doctor, of course."

He was looking me up and down. To change the subject, I pointed to the foamy wake we were leaving on the sea. "Look! Isn't that beautiful? Shining like that…"

"Uh-huh," he replied. "You wouldn't think so, but it's alive."

"What?"

"Millions of little critters, just below the surface. The Doc here can probably tell you the name of 'em. The propellers stir 'em up and spin 'em around, like an eggbeater, and they glow. It's called uh, fosil, fosdick…"

"Phosphorescence?" the doctor suggested.

"Yeah."

I lifted my glass out over the rail, in a toast. "Here's to *them*: to the essence of every little phosphor and phosphorette."

"Or maybe the female form is phosphorix, like aviatrix?"

"Are you an expert on the female form, Doctor?"

"*She's* a smart one, Doc!" Stan chuckled. "Both of you. You're a couple of Quiz Kids!"

"*There* you are, Stan!" That was Quart Brewer, from a few feet away. He strode up, waving to a steward carrying a bottle of champagne and a tray of glasses, who immediately poured for us

all. "A toast," Quart declared, "to a better game *next* year, when the Stanford Indians will hunt the Cal Bears down to extinction!"

"Thank you, Mr. Brewer," said the master at arms. "We were just watching the…what did you call them, Doc?"

"Stan—" Quart told him bluntly "—what you *ought* to be watching is a gang of Japs on Deck-D. Especially the one named Mirikami."

"The soldier?"

"No, the other one."

"Rubbish Mirikami's a regular passenger, Mr. Brewer."

"You'll have to excuse Quart here," the doctor said to Stan. "He just doesn't like Japs. The union men especially, but not even the rich ones. He and his pals won't even let Jap businessmen join the Chamber of Commerce."

"They have their *own*," Quart snapped back.

"The Japanese are a great asset to Hawai'i."

The master at arms nodded. "I'm with *you* on that score, Doctor. I worked with a lotta fine Japs on the police force in Honolulu. The chief's an Irishman, like me, name of Jack Burns, and he thinks the same way. 'Course, he became chief after I retired from the force and took this job aboard ship. Most ships' doctors are retired, too, except young Doctor Boyd, here. Or *are* you retired, Doc?"

"Well, I just sold my practice. But I prefer to say I did it so I could run away to sea!"

We all chuckled.

But Quart hadn't finished. "Oh, some Japs are all right. Mouse Ichiro is developing a synthetic fertilizer for us, on the Big Island."

"What's the matter with good old sh—heh-heh—*regular* fertilizer?"

"When war comes, Stan, we'll have trouble getting guano from South America. It'll be *man-made* fertilizer that keeps sugar in our soldier's rations."

Swifty beamed. "Well, there you are! And you all heard him say it: *some* Japanese are okay. There must be others, right, Stan?"

"There's thousands of them—born in Hawai'i, and loyal to America."

"How about Danny Boy Ohara?" I suggested. "He told me he's a radio-telephony engineer. I'm sure the people at his telephone company think he's an asset to *their* business."

"And Rubbish Mirikami," added Mr. O'Malley, "the guy you're warning me against—he's a credit to his race! His little family junkyard employs a dozen men. In his own way, he's adding to the Islands' prosperity."

Quart wagged his finger. "Maybe you've been out here on the high seas too long. Do you know what they're saying in Honolulu about Rubbish and his, uh, 'little family junkyard'?"

"Pay attention, Stan," the doctor chided. "Our G-man here is about to reveal a sinister international plot. Naturally, he'll give *you* the credit for breaking up the spy-ring—"

"It's no joke! Since nineteen thirty-one, Mirikami-san has picked up about seventeen thousand tons of scrap iron, steel, and copper."

"So?"

Quart looked around and opened his hands. "Where are they?"

Swifty shrugged. "In his junkyard, I guess. I forget where it is."

"Iwilei district," said Stan, "between the streetcar barn and the Dole cannery."

"No." Quart shook his head. "I meant: where's the scrap? How much of those seventeen thousand tons is still in his yard?"

"What's your point?"

"The point, Stan, is that *none* of it is there. He's sold it all."

"Isn't that what junkmen are *supposed* to do with—?"

"He shipped it off to Japan, to the Daihei Kiribatsu. Do you know what that is? There was an article in *Fortune* magazine a couple of years ago. Did you read it?"

Mr. O'Malley chuckled. "I can't afford to take *Fortune*. It *costs* a fortune: a dollar a copy, isn't it?"

"The Daihei Kiribatsu is one of the big companies over in Japan," said the doctor.

"It's 'one of the big companies,' all right," Quart mocked him. "They merely *run* the nation of Japan, behind the scenes. It's—"

"Listen to the pot calling the kettle black!" Swifty turned to me, as well as to Stan. "Quart Brewer's got a 'family business,' too: a little outfit called C. Brewer and Company that's one of the 'Big Five'—the five largest companies in Hawai'i. They're the real power behind the Territorial Legislature." He turned back. "How different is that from—?"

"*We* don't make armaments! The Daihei Kiribatsu melts that iron and steel and copper down, and sends the ingots to the Nippon Shipbuilding Works in Nagasaki, where they're turned into battleships and aircraft carriers. And it's *those* ships that the Imperial Navy has been sending down to Malaya and the East Indies. They're trying to create what any dictionary would call an empire, but which the Japs, ah-so-politely, call the 'Greater East-Asia Co-Prosperity Sphere.'"

"Well, Rubbish couldn't be involved with *that*. He's an American citizen, like us."

"Oooh, I'm sorry, Doc, you could be wrong," said Stan. "A fellow may be born in an American territory, and still not be a U.S. citizen, if his *parents* aren't citizens."

"He's right, Swifty," Quart went on. "And their little god-emperor, Hirohito, likes to say that any Jap, anywhere in the world, is a citizen of Japan. That way, he can claim to be emperor of *all* of his people, even those who're born overseas—and that includes Hawai'i. If Mirikami *senior* never took the oath, then Mirikami *junior* is a citizen of Japan. So, Stan, you might have a reason to question his loyalty, after all!"

Stan nodded. "Yeah, okay. I'll take a look at his I.D."

"I can guess why Japanese families might not have 'taken the oath,'" Swifty said. "It's because we Americans won't *let* them. And it's a dirty shame. We impose stricter quotas on the Japanese than on any other immigrants, except maybe the Chinese." He looked straight at Quart. "Why is that, do you suppose?"

"I don't make the rules, Swifty. And you spent a couple of years over in Japan, after medical school, didn't you?"

"*Hai!* That means yes. I worked in a clinic there."

"Well, you tend to the sick, and I'll tend to business. There are more Japs in Hawai'i than any other race: they're *one-third* of the population. And if they're not American citizens, why should I assume that they're American patriots?"

"What about Rubbish's cousin, Jingo? Obviously, *he's* a citizen. And a patriot. He made captain in the U.S. Army."

"As Stan said about Rubbish: he's a credit to his race."

The doctor snorted. "Coming from you, Quart, that's damning with faint praise."

"He's in ordnance! He's in a position to pick up military intelligence about the bombs and other explosives that're stored in Hawai'i, and pass it along to the High Command in Tokyo."

"Oh, you're crazy!"

"We'll see who's crazy when the—"

"Gentlemen!" Stan raised his voice and both palms.

"—Imperial Navy comes steaming around Diamond Head, in those warships that Rubbish helped them build. You watch! And when that Jap force hits, our local Japs'll form a fifth-column, and deliver up the Hawaiian Islands to Hirohito before we can fire a shot. As for 'Captain' Mirikami, they'll probably make him a general! I think we better strike first."

"How? Invade Japan?"

"One day, Stan, we'll have to. But we can start by locking up guys like Rubbish, who are selling us out. Which is what I came over here to tell you in the first place."

"Wait a second, Mr. Brewer. I'd need to see some evidence of a crime, or a treasonable act, before I'd toss the junkman or anybody else in the brig."

"Call it 'preventive detention.'"

"Ha, ha! Maybe I should round up *every* Jap on the ship. Or every Jap in Hawai'i! I'd be sure to get the troublemakers, along with—"

"You may have to do that, one day, to get the saboteurs. If we go to war with Japan, we'll have to round up every Jap in *America,* so they can't undermine us."

Swifty chuckled. "And then what? Do like the Germans do? Put them in camps, at hard labor?"

"That's how the British dealt with the Afrikaners, in the Boer War," Quart replied. "Sometimes you have to do things that are unpleasant for the few, to secure the safety of the many. If we lock up the Japs, it's for the good of the country."

Stan shook his head. "Be realistic, Mr. Brewer. What about the Honolulu police? D'you think the Japs on the force would arrest their own *families*? Arrest *themselves*?"

"We have an ordinary American here—" Quart looked at *me*. "What do you think, Miss Green? Do you trust the Japs?"

I'd been hoping to make an exit. "Well, I'm not sure, Mr. Brewer. I do know a Chinese family who got out of Nanking just ahead of the Japanese invasion, and told me some pretty frightening stories about what happened there. But Nanking was back in 'thirty-seven, and I've been based in New York most of the time, so I really haven't followed the news in the Pacific. What you said, though, made me remember that my landlady, Mrs. Schmidt, is German. I don't know if she's a citizen, but she's very nice. And if we go to war against Hitler, I hope the New York police don't arrest *her*. I'm sorry. I've got to get back to the bandstand now, for our last set. Excuse me."

On my way inside, though, I wondered—absurdly—if Mrs. Schmidt were arrested, how would I get my trunks out of her basement?

<center>❁</center>

Lillian heard my Cuban heels on the uncarpeted floor of Deck-E, as I headed for my cabin. After the last set I'd lingered in the bar with some passengers who'd asked me about playing fiddle in the swing style. Lillian had probably just finished romping with Bill; she was in a terrycloth robe. "I need to talk to you in private, Katy. Let's go into the 'Ladies.'"

She trotted down the corridor ahead of me, and checked under every stall door, to ensure that we were alone—it was after three in the morning, and we were. But she lowered her voice

anyway. "I have a secret I'm going to tell you, but you can't tell Ivy or Roselani, okay?"

Steeling myself for something intimate and personal, I said, "Of course."

"When we get to Hawai'i, Bill and I are going off on our own."

I grinned. "Are you getting married? Eloping?"

"Not yet! First, we're going on a treasure-hunt."

I snickered. (Had Lillian *really* given up reefers?) "An actual treasure-hunt? Gold and jewels and pieces-of-eight?"

"What are pieces-of-eight?"

"Coins, I think. What about this treasure?"

"Coins, maybe. It's a ton of cash, Bill says, though he won't tell me how much. His family hid a lot of money someplace, about forty years ago, and nobody knows where it is, except him. And no—he won't tell me, either. But he needs a couple of extra hands to haul it out, so I said I'd ask *you*. You can handle yourself in a tight spot. Do you want to—"

"Have you asked Ivy?"

"She's Roselani's friend!"

"She's been *your* friend longer."

"But she's taking Roselani's side, against Bill and me."

"Why?"

"Well, it's not like Ivy hates Bill, or anything. But Roselani sure does. Why d'you think Roselani has song approval? Ivy's got to keep her happy, and the hell with you and me."

"Roselani has song approval because we can't carry off this gig without her. How come Bill knows about this family treasure, and his sister doesn't?"

"Oh, she knows about it, all right. But she doesn't know where it is."

"And Bill does?"

"Yes. So we're going after it. But we'll tell everybody that we're on a little romantic tryst."

"For which you're taking *me* along?"

"Bill says we need three people, at least. You'll think of some-

thing to tell Roselani. Bill's already arranged for a boat—with Roselani's ex-husband! Isn't that a scream? He's a fisherman, and—"

"A boat? Where the hell *is* this treasure, anyway?"

"I told you: I don't know! But Bill says it could be dangerous, if somebody tries to steal it from us. That's why we could use *you*."

"I don't like to be 'used.'"

"Oh, come with us, Katy. Please. We'll give you a share of the treasure."

"Umm...let me sleep on it, okay? I'm a little befuddled from the drinks right now." That wasn't true, but I wanted to know a lot more about this "treasure" before I committed myself to going after it. I especially wanted to hear about it from Bill himself.

"Sure. You won't say anything to Ivy or Roselani?"

"No."

"Thanks, Katy. You're a pal!"

# Sunday, November 30

ABOUT NINE THE NEXT MORNING, neither Roselani nor I was fully awake or dressed, but Lillian pounded on our door and barged in, yelling, "I'm calling a band meeting right now. C'mon, Roselani. You, too, Katy."

I must have been too tired to notice during the first night aboard, but all through that *second* night, our stateroom was never truly quiet. The hull was insulated against tropical heat with heavy cork, which also muffled noise. But we were only a couple of decks above the engines and propellers, so the cabin walls vibrated unendingly. Whenever the ship speeded up or slowed down, the modulation in the rhythm rattled the cosmetics in our medicine chests and on our bureau-tops, adding their little flutters and clicks to the whirring, juddering, and thudding from below.

I threw on my bathrobe and padded next door. Roselani—barefoot—ambled in behind me, and sprawled on the day-bed. I leaned up against one of the wardrobes.

Ivy was still in pyjamas, stretched out on her lower berth. She shook a Lucky out of its pack, and said, "You got a beef, Lillian?" as she lit up. She coughed a little, too, and—gesturing

with the cigarette—added, "First one of the day's always the best."

"Somebody stole my little sandalwood box. You're the bandleader. Make her give it back."

Ivy shrugged and looked at Roselani. "Did you take it?"

"It was never Bill's. He stole it from *me*."

"When?" Lillian demanded.

"My last night at the Bamboo Hut. Bill came to the club while I was doing my show. He—"

"He only went out for beer! And he ran into his friend—"

"He 'ran into' the doorman, and left him bleeding in the alley. Then he went backstage, and stole the box out of my handbag."

"Why didn't you say so before," I asked, "when Lillian showed it to us in the diner?"

"Giving it to Lillian was Bill's way of saying I couldn't go to Hawai'i without *him*. But as long as he wasn't coming with us, I didn't worry. Now that he is, though, he might not need me to...uh—"

"To find the treasure!" Lillian concluded.

"So, he told you about that."

Lillian nodded. Roselani sighed loudly.

Ivy blew smoke up and away. "We're *all* in this, now. We better lay our cards on the table."

I raised both hands. "What is going on?"

Lillian shrugged and looked at Roselani. "Bill says your parents buried a lot of money someplace. And I asked Katy to help us get it. I don't know where it is, or anything more about it."

Ivy waved her Lucky at Roselani and said, "Take it away, honey! It's your solo now."

Roselani waited a couple of beats. "Okay. When we get to Hawai'i, Ivy and me are going straight over to the *island* of Hawai'i, the one they call the Big Island."

"Hang on," Ivy told her. "You wanna come along, Katy? Go to the Big Island with us?"

"Shouldn't we stay in Honolulu and work up some arrangements, so they'll give us six months' work, and—"

"You sayin' you don't *wanna*?"

"No. I *do*. But—"

"'Cause if you wanna quit—"

"Ivy!" I touched her arm. "I came all the way out here to play with you. I trust you to keep the band on the beat. I'd just like to know what *else* I've signed up for."

She snorted. "Get you! What you signed up for is two free trips to Hawai'i, and a hundred and thirty-seven fifty every time your Mary Janes touch land. You quit now, it's no dough. What's it gonna be? You with us, or—?"

"Hey, no *huhu!*" Roselani said.

Ivy whipped her head around. "What's that mean—'no hoo hoo'?"

"It means, 'Don't get mad,' Ivy."

"Hey!" Lillian piped up. "Were you and Roselani going after the treasure without *me*?"

I held my tongue; Lillian and Bill had certainly intended to go without *them*.

Ivy ignored her. "What d'you say, Katy? We stickin' together?"

"I hope so."

"I want to go, too," Lillian said quietly.

"Then you'd better know why." Roselani was glancing around at each of us in turn. "What do you know about Hawai'i?"

Ivy lit up another smoke. "This is gonna be a long riff. But hey—you asked for it, Katy."

I sat down on the foot of her berth, and answered Roselani as best I could. "What I know about Hawai'i is what I learned in school. It's been a U.S. Territory since…the Spanish-American War, I think."

"And before that?" she asked.

I shrugged.

"My people have been there for a thousand years, at least," she said. "Captain Cook 'discovered' Hawai'i only about a hundred and fifty years ago. But the local chiefs liked what they heard about European royalty so they gave up their loincloths

and drums, and got themselves military uniforms and brass
bands, and turned Hawai'i into a kingdom with a royal dynasty.
The last king even built a European-style palace, in Honolulu.
When he died, his sister became queen. That was Lili'uokalani."

"She wrote 'Aloha 'Oe'!"

"A gold star for you, Lillian. She wrote a lot of other songs,
too, and a history book of Hawai'i. It's in the ship's library, if you
want to look it up. Lili'uokalani was...what's that Gilbert-and-
Sullivan ditty? 'A regular royal queen.' She went to England;
Victoria loved her. The Hawaiians loved her. Everybody loved
her, except the *baoles*."

"'*How*-lees?'" I tried repeating.

"*Haole* means foreigner, but mainly from the white race, and
mainly from America."

Ivy snorted. "That's *us*!"

"The *baoles* bought thousands of acres of land and planted
sugar cane; they owned the shipping lines, too, including Mat-
son. The chiefs, unfortunately, were pushovers: they liked what
they could buy with the *baoles*' money, so they kept selling off
their land. They got richer, but their health wasn't too good,
and a lot of them never lived long enough to enjoy being rich.
But Lili'uokalani was strong, and intelligent, and talented. And
when she became queen, she—"

"Did she only *write*?" Lillian called over. "Or could she play,
too?"

"She played guitar and piano."

"Like you! Wow."

"Let me finish. By the time Lili'uokalani became queen, most
of the *baoles* in Hawai'i were Americans, and they had always
lobbied the Hawaiian kings for an alliance with America. There
was a legislature, too, but the *baoles* had rigged the election laws
so that only men who owned property could vote. That meant
none of the Hawaiians—except for a few chiefs—had any say-
so in how their own country was run."

"Can't you hurry it up?" Ivy called out.

Roselani ignored her. "In 'ninety-three, the queen declared

that she wanted universal suffrage, and she rewrote the constitution to do it—which worried the *haoles*. Anything that made the queen stronger, they figured, was a threat to their control. So, a committee of *haole* merchants persuaded a boatload of U.S. Marines to muster in Honolulu, and surround the queen in her palace, while they went in and deposed her. Then they declared that Hawai'i was a 'republic,' and one of their own was now governor. You know the name Dole? From the pineapples?" I nodded. "The original Mr. Dole got the job, and announced that he and his cronies were *giving* the Islands to America."

"Gee," said Lillian. "It sounds more like we *stole* it. I'm awfully sorry. I wish—I wish we could give it back."

"Aw, you Hawaiians got off easy," Ivy declared. "We didn't herd your people onto reservations, like the Indians out west. Or—"

"Let me finish, will you?"

"*Today*, please!"

"Lillian, you're not the only one who knows armed robbery when you see it. President Cleveland did, too. He turned down their, uh, gift. A lot of senators said no, too. They didn't like the idea of taking over another country, especially if we weren't at war. So they got up a resolution that would nullify the takeover, and return the Islands to the queen. But the *haoles* had friends in the Senate, too, who debated and filibustered, and stalled any action on the resolution.

"In 'ninety-four, a few hundred Hawaiian men decided to fight back. They brought over a shipload of rifles from San Francisco, and marched on the palace. But they were outgunned by the *haoles'* troops. And the queen was a pacifist at heart: she didn't want anybody getting killed in her name. So only a few people died or got wounded, on both sides, and the insurrection failed. The *haoles* have controlled the Islands ever since.

"In 'ninety-six," she went on, "McKinley became president, and he was an imperialist—he believed in what people called America's Manifest Destiny, to push further and further west, even out into the ocean. The imperialists wanted Hawai'i

because they'd need the navy base at Pearl Harbor, if America ever fought a war in the Pacific."

"And we *did*—against Spain, in 'ninety-eight." I must have sounded like the class show-off, but this was interesting. "That's how we got Cuba and the Philippines."

"'Ninety-eight is also the year McKinley annexed Hawai'i and made it an American territory. That put the *haole*s in control of the Islands—legally, officially, and permanently."

"I'm gettin' hungry for breakfast." Ivy turned to me and Lillian. "Want me to give the punchline?"

Lillian didn't seem to be impatient, or even especially curious. She had taken up her camera, and was trying to load it. But her fingernail had torn the film's paper backing, and she was licking the edge to flatten it.

"No," I said. "Let Roselani tell it in her own way."

Which she did. "During the years when the senators were debating, the *haole*s were worried. Another popular uprising could put the queen back on the throne. So they arrested the Hawaiian men who'd rebelled against the takeover—including some prominent chiefs who'd supported them and given them the guns—and charged them all with *treason*. The judges were friends of the governor, of course, so everybody was convicted, and a few of the leaders went to jail. But then the *haole*s arrested Lili'uokalani, hauled her into court, and charged *her* with a crime, too."

That got Lillian's attention. "What'd *she* ever do?"

"They claimed she knew about the uprising in advance, but didn't turn the men in. And that's a crime on the books, called misprision. It's when you know somebody is committing a crime, but you don't report it to the authorities. Well, Lili'uokalani said she *didn't* know. Personally, I think she did. In any case, she had put a *stop* to the insurrection. But it didn't matter. They convicted her anyway."

"Did they send her to jail?"

"They might as well have, Lillian. She spent a couple of years under house-arrest, in the palace."

"All right." I got up and made a theatrical curtsey. "On behalf

of the United States of America, and every *haole* in it, including me, I'm ashamed of what we did, and I apologize. But—"

Lillian nodded. "I'm sorry, too."

"—where," I continued, "does the Big Island come in? And your brother? And the money?"

"Hold your horses, Katy; I'm comin' to that. A lot of people—and not just us Hawaiians—were unhappy about finding themselves living in a U.S. territory, all of a sudden. Americans are notoriously anti-Asian, so local Chinese merchants and traders were at a disadvantage. Most of the Japanese in Hawai'i worked on the sugar plantations; and as if race-hatred weren't enough, American labor laws were stacked against the working man. A lot of *haole*s were upset, too. Most of them weren't big wheels: they were middle-class people—schoolteachers, doctors, ministers—who'd had nothing to do with what happened to the queen. And even some who *did*, didn't like the way it was handled: especially putting her on trial! Besides, in the kingdom, they had all been big fish in a little pond."

"But as citizens of an American territory, they could be eaten by bigger fish swimming in from the States."

"Gold star for *you*, Katy!"

"Thank you."

"Anyhow, the Hawaiians had lost the most, and were the most resentful. Those who had money were—"

"Wait a second!" Lillian looked up. "When you told us about the sandalwood, you said the Hawaiians were poor."

"Not all of them. Not the *ali'i*—the chiefs, the nobility. Hawai'i was a kingdom, remember? With royal families on every island. Most of *them* were well-to-do, especially the ones who had sold their land."

"Are you and Bill...'ah *lee*-ee'? Is that how you say it?"

"Yes, Katy. Our family are *ali'i*. In fact—" she chuckled "—on our father's side, I'm ashamed to say, *his* father, our grandfather, was one of the chiefs that forced his people to harvest sandalwood! Our mother's mother was a distant cousin of one of the kings, the one called Liholiho. And our parents were—"

"Wow!" Lillian had set the camera down, smiling. "Are you

saying...if Hawai'i were still a kingdom...then you'd be the queen of Hawai'i?"

"Jee-*zus!*" Ivy sat up.

"No! Wait a second." Lillian was panting. "You're twins, but Bill's a couple of minutes older. So *he'd be king!* How about *that,* girls?" She rose straight up from the chair, shoulders back, head high. "Can you see Bill presenting me at court, with a—"

"Quit dreaming!" Roselani tossed a pillow at her. "There is no throne, and we wouldn't be in line for it—*any* of us in my family—even if there were."

"Then what—?"

"There *is* a man who'd be king, today—*if* there were a Hawaiian nation to be king *of.* Only he's not the sort of man who should be running a country these days. His name is Henry Kalaukoa. Officially, he's the head of the Home Rule party in the Territorial legislature, but only because of his pedigree. He's a figurehead, and doesn't do much for the Hawaiians in politics. Most days he plays golf, and most nights he goes out drinking with his buddies."

I chuckled. "Sounds like the Duke of Windsor!"

"My parents do have a connection to Lili'uokalani, though it's not by blood. When my mother was young, she was one of the queen's secretaries; and my father was her representative on the Big Island. That's how they met. When the queen came to visit, he made the arrangements, and escorted her around."

"And fell in love with her secretary! That's so sweet," Lillian gushed.

"When I was very small, I went with my parents to visit Lili'uokalani in Honolulu. And they took me with them to her funeral, in nineteen-seventeen."

"I'm tired of waitin' for the big finish," Ivy declared. "Will you give 'em the Readers' Digest, already?"

"All right," Roselani conceded. "What I'm leading up to is... well, there's no other word for it: buried treasure!"

"But Bill's the only one who knows where it's hidden," Lillian insisted. "So he has to come with us."

"No," said Roselani. "He knows *where* to go, but *I* know where to look, when we get there."

"So, shouldn't you cooperate?" I suggested.

"The hell we should!" she retorted. "I've got a fair idea of where it is, anyway. So we—*us*—we're gonna go dig it up before he can get his hands on it."

"Ha, ha, ha!" I threw in a chuckle and a snicker, and looked over at Ivy. "I guess the joke's on me, and you're all in on this gag. Lillian, you had me going last night. But Roselani—you take the cake! The queen, the *haoles*, President McKinley…this is just too crazy. You can't be serious."

"It's no gag," Roselani declared.

Ivy spun around to face her. "It better not be!"

"I get it now!" Lillian giggled. "Roselani is 'young Jim Hawkins,' see? She's found a pirate's treasure map. And Long John Silver, the buccaneer—that's you, Ivy—you've rounded up your old gang of cutthroats—"

Ivy puffed loudly. "That's *Short* John Silver to you, matey!"

"And for the female gender," I piped up, "shouldn't she be a 'buccanatrix'?"

We all laughed, until Roselani said, "Let me finish."

"What is this treasure, anyway?" I demanded. "Lillian says it's money. And if what you told us is true, Roselani, that makes sense."

"Oh, yeah? Why?"

"I'm guessing that, back in the 'nineties, those disgruntled citizens took up a collection for enough money to go lobby in Washington, to get their country back. Only somebody stole the money they collected."

"You're jumping to conclusions, Katy, but you're not entirely wrong. They did raise a lot of money, but they spent it all on the Senate lobby. The trouble is: they were *out*-spent by the *haoles* who wanted annexation."

"Okay. So what *is* buried there?" I asked.

"Be patient, will you? I'm trying to catch you up on fifty years of history."

Ivy checked her watch. "We've missed breakfast now. And we've got a little over six hours before our gig. D'you think you'll be finished by lunchtime?"

"Unless you know the history, you won't understand why it's so important."

"To *you*."

"Of course, to *me*, Ivy. But I can't do it by myself. I need your help."

Lillian asked, "What about Bill's help?"

"No!"

"But he told me that—"

"Let me finish, all right?"

Nobody said anything for a few beats.

Roselani rocked back, then forward, using the momentum to boost herself off the day-bed, and begin pacing the room. "When Lili'uokalani was convicted and sentenced, the Hawaiians knew they didn't stand a chance of turning back the clock. But they read the news from around the world. The European countries were all having trouble holding on to their colonies in Asia and Africa. The Filipinos were in armed rebellion against America, because McKinley never delivered the independence he'd promised them, after the war with Spain. So the Hawaiians could see that a colony or a territory might not stay that way forever. In a generation or two, the situation might be different. So they took up another collection, in secret. Hawaiians—*ali'i* and commoners, together—gathered up rare and precious things: relics and artifacts that had been hidden away since the *baoles* came to the Islands."

"Relics and artifacts. D'you mean like antiques?"

"Yes, Ivy."

"Tables and chairs?"

"No. Important things. Like fish hooks. Hundreds of them."

Ivy snorted. "My pop's got a hundred fish hooks in his tackle-box."

"But his aren't carved from human bones!"

"Holy cow!"

"Don't worry, Ivy. We don't make them anymore."

"You better not! Anybody tries to take *my* bones, I'll *cut* 'em!" She mimed a swift razor-slash.

"D'you mean this treasure is just a box of fish hooks?"

"No, Lillian. There are feather standards—tall staffs, topped with bird-feathers. And cloaks! Have you ever seen a feather cloak? Any of you?"

We shook our heads.

"The yellow ōʻō feather in this box—you know?" She pulled it out of her bathrobe pocket and slid the top back.

"So, you *did* take it!"

"Sure I did, Lillian. Yesterday morning, while you went up on deck to watch us leave L.A. I couldn't let you give it back to Bill."

"I want to know what turns feathers into treasure."

"I'm trying to tell you, Katy. A feather cloak is the size of an opera cape, floor-length, only it's made from *thousands* of yellow feathers like this one—red feathers, too—in geometric patterns, all stitched together by hand, with thread made from vines. It took *years* to make a feather cloak; and some of those birds, like the ōʻō here, are extinct now."

"I guess that ought to be worth a few bucks," Ivy conceded.

"And there should be dozens of *kiʻi*—those are statues that—"

"'Kee-ee'?"

"Yes. Effigies—figurines, representing the Hawaiian gods. The missionaries hated them. They said the *kiʻi* were 'idols' and 'graven images,' and they burned as many *kiʻi* as they could find. Supposedly, the only ones that've survived are in the Bishop Museum, in Honolulu. But in fact, there were a lot more— hidden away."

"And *that's* what we're goin' after?" Ivy demanded. "Statues? Fish hooks? Feather-dusters? You told me there'd be real *dough* in it."

"Wait a second!" I waved both hands at Roselani. "What's *your* claim on this...treasure? If it was collected for the queen, and you're no relation to her, then I don't see how it belongs to *you*. Whose is it? The heir to the throne?"

"I'm sure he'd say so. But it doesn't belong to him, either. It belongs to the Hawaiian race—to what's left of us pure-blooded Hawaiians. We—"

"Bill's pure Hawaiian, too!" Lillian insisted. "So it's *his* treasure, as much as yours."

"No! Because if Bill and the 'king' get their hands on it, they'll sell it."

"Ohh," Ivy perked up. "So there *is* money in it."

"I'm sure we'll get a reward."

"Is that all?"

"Look, Roselani," I said, "assuming that you find it—"

"That *we* find it, Katy."

Lillian gave her a Bronx cheer. "You say 'we' but you don't include your own brother!"

"Damn right."

"But," I said, "what then? What would *we* have to do to collect the reward?"

"Yeah," Ivy put in. "And where's that reward comin' from? You got rich Hawaiian relatives?"

"Some of the *ali'i* still have money."

"Do you have a plan?" I demanded. "Or is this just—"

"My plan, Katy, is that, with all of you helping—'cause it'll take many hands to haul everything out—we'll bring it back to Honolulu with us, stow it on board the ship, and take it to the States."

"Ho, ho, ho." The sarcasm was Ivy's. "After what us American *how-lees* did to your queen and your country, you want to take your holy relics to the *States?*"

"To the Smithsonian, yes."

"Don't we get to keep any of it?" Lillian asked. "I'd like to wear a feather cloak on stage."

Roselani ignored her. "What the *haoles* did, Ivy, they did almost fifty years ago. The older ones are dead; even the youngest of them may be senile now. And like you said before, they didn't stick us on reservations, or sell us cheap whiskey and turn us into drunks. The Hawaiian race has kept our pride and our

dignity, and some of us are still well-to-do. I'm not worried about the Americans. I'm worried about the Japs."

"Uh-oh," I said. "There's a lot of *that* complaint going around."

"They could invade the Islands any time now," she went on. "And with so many Japs living in Hawai'i to help them, they could take over."

"You and Mr. Brewer have something in common there. Have you talked to him about this?"

"I don't have to, Katy. The Hearst paper, in San Francisco, prints his letters-to-the-editor. And on *that* score, frankly, I agree with him." She backed away and paced the room again. "I'm sure the Japs're gonna mount an invasion of Hawai'i. And if they take over, somebody, sometime, will tell them about this treasure. And if nobody volunteers to show them where it is, they'll round up some of us, and torture us, until somebody *does*. They're ruthless. They cut people's heads off in China! D'you think they'd behave any different in Hawai'i? *Do* you, Katy?"

"No, you may be right there."

"They're a very *patient* race, too, the Japanese. They won't care how long it takes. They'll go after it, and they won't stop until they've got it. Then they'll parade it around for...what's the word?—'propaganda,' and send it back to Tokyo as the spoils of war. That's why I believe everything would be safer in America. When the war's over, we'll bring it all back."

"So-o-o," Ivy said deliberately, "we dig up this stuff that's been hidden for forty years, and collect a reward. How much, d'you think? A thousand bucks?"

"Maybe. A thousand *each*, if we're lucky."

"That'll do!" Ivy nodded, adding—to me—"When was the last time you saw a thousand bucks in one place?"

"Suppose we can't find it?" was my response.

"Oh, Katy," Lillian sighed, "it's an *adventure*. If we don't find it, we haven't lost anything. We'll just keep on playing music. Maybe we'll pick up a gig at the Royal Hawaiian Hotel, the next time we're in Honolulu. By springtime, we could each have almost a thousand saved up. That's enough to—"

"Suppose we're at war by then?"

Lillian wagged her finger at me. "Don't be a spoil-sport! Besides, I know what I'm going to do if we go to war."

"This I gotta hear!" said Ivy.

"I'm gonna join up. The Women's Army Auxilliary's got a band. And you can put all your pay in the bank, or buy War Bonds with it. I mean, in the army, room an' board costs nothing, right? They even do your washing. So you can keep just about all of your dough—"

"Get *her*!" Ivy chuckled. "The boogie-woogie bugle-girl from Company *D-cup*."

"A bugle's just a trumpet without valves, you know."

"Right! Alarm clocks at noon can't wake you up, Lillian, and you're gonna blow *Reveille*?"

"We might *all* end up in uniform," I said quietly.

Ivy leaned back. "That's why I'm sayin', let's grab ourselves a nest egg while we can."

"It still sounds crazy to me."

"Come on, Katy!" Lillian put a hand on my shoulder. "Ivy and I, we've got a few years on you. But we're all goin' out the same way. No rich husbands; not even stage-door Johnnies to scratch us where we itch. Until Bill came along, I hadn't had a boyfriend in months. How about you? Was there anybody steady in New York?" She waited; I shook my head. "I didn't think so. How could there be, with you taking a gig here, gig there, all the time? You know, when they bury us, the only men at our wake'll be the guys who repair our instruments, and they'll be moaning 'cause they're losing our business!"

"I was doing all right—"

"Sure. And we've had a few nice gigs in Frisco. But it's a year and a half now that we've been working there, and we've got no real dough to show for it. I bet you aren't saving much, either."

Ivy picked up the riff. "Us women—all *four* of us—we've spent our best years on the road, playin' music. It's all we know. D'you think any of us could settle down someplace, without stickin' a few shekels in our stocking-tops first?"

"And even if we don't get a reward, *something* good might come of it," said Lillian. "People will read about us digging up the treasure—we'll be famous—and they'll want to thank us, they might even give us gigs: paying gigs, steady gigs."

"And if there *is* a reward," Ivy went on, "and we get some real dough, we could take on some more gals, and work the Sarongs up into a 'big band.' That'd get us top gigs in Honolulu. We could work Frisco steady, too."

I said, "We might even get a spot on the radio with a coast-to-coast hookup."

Ivy grinned. "That's right, Katy. You're in the groove now!"

"I have to admit: I like a little adventure sometimes."

"I know you do. That's why I wanted you for this gig."

"Is that the only reason?"

"You've got muscles," said Roselani. "Ivy figured you wouldn't mind digging in the dirt, and hauling stuff out on your back."

"Or helping you fight off your brother. The first thing you ever asked me was, could I take on somebody *your* size?"

Ivy stuck her right hand out, palm down. Roselani put hers on top of it. Lillian reached over and laid her hand on, too. And Ivy said, "Fish or cut bait, Katy. Are you with us?"

I took all three between both of mine, and though I didn't like having been kept in the dark so long, I pressed our hands together tightly. "Sure. Count me in."

❀

It was nearing eleven o'clock. The ship was unsteady, and the sky—what I could see of it through the little porthole above the sink—was gray down to the horizon. I had to quick-catch my balance once, in the shower-bath, and again while I was getting dressed for our rehearsal with Phillip DeMorro. All the way up to Deck-A, I needed to keep one hand free—my sax and violin cases in the other—so I could grasp railings or brace myself.

The Baronet of Broadway called a cheery *"Entréz!"* when I knocked. He was sitting on the couch, in the salon of his suite,

leafing through a set of handwritten music scores from a leather briefcase. A spinet piano stuck out into the room, back-to-back with a bureau, under an enormous picture-window that faced forward and overlooked the bow.

I stared at the view. I'd expected the waves to be coming *toward* us. But they came from behind, urging the ship up for a moment or two, then easing it back and sliding out from under, to join the others, all gray-capped and whiskered with spray....

"And your 'sisters'...?"

"What?" I needed a couple of beats. "Oh. They're coming," I said. "Am I too early? You said eleven, and I don't like to be late."

"A good habit. Have you a *bad* one to claim, in counter-point?"

"None that I'd tell a song-writer about."

That wasn't an original retort, but he gave me a respectful nod for it and got down to business. "You'll have to forgive me, Miss Green. I think my scores and lead-sheets are in the trunk-room across the hall, where my companion is looking for them. Play your fiddle. Let me hear you solo, before the rest of the band gets here. How about 'Sophisticated Serenade,' in A-flat?"

It was one of his tunes; and though it wasn't one of my showpieces, I gave him his melody against a hastily built harmony line, with double-stops. He smiled when I rounded it up at the end. Then he whistled a few bars of "Fit as a Fiddle"—*not* one of his—and led me into it with a tricked-up, two-finger rendition on the piano keys, like what Chico Marx does in the movies. It's hard to laugh with a violin under your chin, while you're trying to think up a solo to come in with, but I managed to do both.

I heard a door unlatch behind me, embarrassed that the Sarongs hadn't knocked. But it was Bill Apapane in the door-frame—filling nearly *all* of the doorframe—with a bundle of sheet-music under one arm. He wore linen trousers, but his suspenders rode over an undershirt. With a nod and a "Miss Green," to me, he handed Phillip the music sheets. "You only had *these* in the brown trunk. The others aren't in there."

"They must be in the boot of the Chrysler, after all. We'll go down to the cargo deck this afternoon and retrieve them. Thank you, my boy. Have a drink?"

"Yeah. Thanks." Bill opened a black leather box that sat on top of the piano: a traveler's bar, with three square-cornered bottles, a chromed shaker, a set of bartender's tools, and four glasses. He poured himself an inch of clear liquor—gin, maybe—and slugged it right down; then he left the glass on the piano-top and strolled, in his smooth but slightly waddling gait, to the armchair, and plucked the slip-cover off the back-cushion—no—it wasn't a slip-cover. It was his shirt: bright red, and sprinkled with flowers. He buttoned it up, and left with another nod.

Philip called, "Thank you, again!" but didn't look up when Bill closed the door behind him. Instead, he lit a cigarette. "Let's play another tune together, before the Sarongs get here." He vamped in B-flat, and sang a verse of his pretend-cowboy song, "All Alone on the Lone Prair-ie." I came in on the bridge.

Bill had said he was sharing a suite, and I wondered if he had told Lillian with whom, because in the music business, everybody knows that Phillip DeMorro is a man-lover. But he gave no sign of embarrassment, and I gave no sign of concern. In a sense, we stayed on the beat, and were almost all the way through the song when my band-mates showed up.

"Miss Akau! It's an honor to work with you, and I hope this will be only the first of many times. Miss Vernakis! You are by far the most gifted lady trumpet I have ever met, and I have met quite a few. And you must be Miss Powell. Have you considered billing yourself as 'the biggest little band-leader in the forty-eight states'?"

"Hey! Maybe I should!" Ivy beamed.

He handed around some of the music sheets that Bill had retrieved. "Shall we start with 'Quelle Parisienne'?"

❀

By two in the afternoon, with only an hour to spare before I'd be tied up playing music the rest of the day and night, I wanted to

find Bill, and hear his version of the "treasure" story. Part of me wanted to hear about something else, but I wouldn't dare ask.

He was in the Smoking Room when I caught sight of him, and to my surprise, the first thing he said as I approached was, "You seen the waves, this mornin'? Out the front window of the suite? Ohhh. So-o-ome good! Like the *ship* was doin' the surf-ridin'...."

"Yes. I saw them."

There was an awkward silence, which he broke. "So, you goin' tell Lillian 'bout Mr. DeMorro an' me?"

"It's none of my business."

"Damn right!"

"What I do want to know is...uh—"

"—is what's on the Big Island, yeah?" He snorted. "Roselani, she *ho'omalimali* you' friend Ivy."

"She what?"

"Butter her up—tell her what she maybe like hear. What *you* maybe like hear, too, eh?"

"What I 'maybe like hear,' please, is regular English; I'm not used to the Pidgin variety."

"Roselani's got you so focused on the *object*, that you haven't thought about the *subject*."

He'd switched to regular English, all right! I had to squint and ask, "What?"

"Roselani's got you girls so excited about *what's* been hidden, you aren't asking why it's there in the first place."

"What *is* hidden? I've heard two different stories, but they both come down to...uh—"

"'Treasure'? Is that the word she used?"

"Actually, that was Lillian's word."

"So now, Miss Green, you're gonna have to choose. Me and Lillian, or my sister and Ivy?"

"Not so fast! Your sister has led-off a tune I never heard before. Ivy's pounding out some kind of beat to it. Lillian's playing a little riff of her own, inside the chord progression—a riff she says she learned from *you*. And I'm still trying to find the melody!"

He laughed. "You one *akamai wahine*, Miss Green." He didn't let me ponder the meaning before he said, "Smart lady."

"You say it's money, but Roselani says it's statues and feather cloaks and fish hooks."

"And she figures she'll get a reward for finding it. Ivy wants to *believe* there's a reward. She's a tough little shrimp, but she can be led where she wants to go."

"Hey, that shrimp bites!"

"I know about her razor. I know about you, too, Miss Green. Lillian told me what happened last year, in that all-girl band. Don't even *try* your *ju-jitsu* on me. I know how it works, and it *doesn't* work against somebody who's *this* much bigger than you." He slapped his huge belly.

"I'm not looking for a fight, Bill. But I need to know what this is all about."

He leaned back and took a deep breath. "Around the turn of the century, my parents, a few of our relatives, and a bunch of their friends took up a collection, for the queen. Lili'uokalani. Do you know who—?"

"I know who she was."

"And you know she was convicted on trumped-up charges?"

"That's what I've heard."

"Well, my parents' idea was to charter a British steamer, bribe the guards, and get the queen away to London, where Victoria could give her sanctuary. Turns out, the queen didn't like the idea—it sounded too much like 'exile.' Victoria was old—she died a couple of years later, anyway, and Lili'uokalani's own health declined. By the time *she* died, the War was on, so nobody was paying attention to Hawai'i. And my parents succumbed to the Spanish Influenza, right after the War, and never got back to the Big Island to retrieve the money they'd hidden. So, now it belongs to the Hawaiian people, in the name of the queen."

He hadn't moved closer, but I felt increasingly aware of his size. "Suppose there's no money. Suppose it turns out to be...what Roselani says—museum-pieces; old Hawaiian artifacts. She says you'd sell them."

He shrugged. "Yeah. I would sell 'em. Most of 'em, anyway."

I'd expected him to deny that. So I needed an extra moment to ask, "But if these are your people's—" I grabbed at Ivy's phrase "—holy relics, shouldn't they be kept safe, in a museum?"

"Whatever is there, is in the safest possible place right now. Since our parents died, I'm the only one who knows where it is."

"Roselani says she knows how to find it."

"She only knows how to find it, if she gets to where it *is*!"

"Why haven't you dug it up before?"

"Look, Miss Green, my sister and me, we never had much *aloha* for one another. I think it's called 'sibling rivalry.' It doesn't matter how it started, but we never got along. So our parents figured this would bring us together. They never told us anything about it until nineteen-eighteen, which was just before they died. And they took us aside—separately—and gave us each a little...trinket: a memory-aide." He pulled the pocket-watch from his trousers and dangled the gold chain of the fob in my face. A pink seashell about the size of a quarter, with concentric rings like a target, was threaded on the chain through a hole in the center.

"I don't understand."

"You're not supposed to; it's for me. They gave *her* a memory trinket, too, and I know you've seen that one. It's a little box with a feather inside."

"Did you steal it from her, at the Bamboo Hut?"

He shrugged. "Let's say it was my way of telling her that I knew she was going to go after the, uh, 'treasure,' and that she better not go without me—and now, she *won't* go there without me, because here I am, on the ship."

"What does the box mean? And the feather?"

"She's supposed to know that. And I think I figured it out; but I've got the advantage, because she doesn't know where to look."

"Does your seashell charm tell you where?"

"So either we all go," he continued without answering, "or

none of us goes. And if it was still up to me, none of us would be goin' after it, anyway."

"Why?"

"'Cause we dig it up, *everybody*'ll know where it is, and what it is, and then, if the Japs invade Hawai'i, they'll know, too."

"But other people must know the location! What about your family?"

"There's just us left. Roselani sent a radiogram, today, by the way—and don't ask me how I know this. She bought tickets for all four of you, to fly over to the Big Island, and go back to Honolulu on the inter-island steamer, to carry all the stuff she told you she expects to find. Now, I've got to get myself over to the Big Island, too. I've got a friend there—he's a cop. He and I could go retrieve the money together, and the hell with you gals, if I can just get myself over there. I need a plane ticket."

I was still puzzled. "What about the other families who took up the collection—didn't they tell *their* children where it was hidden?"

"No! It had to be a big secret. The fewer the people who knew, the less likely word would get back to the *haole* Annexationists."

"What about your royalty? The would-be king. Roselani says he's...not up to the job."

"Don't underestimate him. With this money the Home Rule Party could be a real political powerhouse." He smiled. "You know, in a way, it'd be better if there really *were* old relics there. He'd gain *mana*."

"'Mah-nah'?"

"It means 'life' and 'power' and 'greatness.' Hawaiians believe there's *mana* in everything around us, but especially in things that are made to be holy: and that's what those sacred artifacts would be. They'd remind us of our past, from before we were conquered. Feather standards, cloaks, *ki'i*—those are very powerful things."

"Touchstones?" I suggested.

"That's a good word. My anthropology professor in college called things like that 'objects of veneration.'"

I suppressed a grin. His erudite vocabulary was still at odds with his massive size and gruff countenance. But I don't often get into highbrow discussions with people I meet, and I was enjoying it immensely. "Did the Hawaiians venerate fish hooks?"

"Those things have magic powers—oh, don't get me wrong: they won't turn lead into gold, or water into wine. They probably don't even help you catch a fish!" He laughed out loud. "The power they have is over *people*. You take a man who's got a shrine to his father's memory in his house. Show him you have a fish hook made from one of his father's bones, and that man will do whatever you say."

"Oh, come on! Back before the missionaries came, perhaps. But not in the modern world."

"You're right: not in that way, today. But there is a kind of power that those things *would* exert, now: the power of propaganda."

"Would there be a...religious revival, too? Would the Hawaiian people go back to worshiping their old gods and—"

"No. We couldn't return to the past literally. If we did, we'd have to have human sacrifices, too."

"I don't think Lili'uokalani would approve of that! Or would she?"

"Hardly!" He chuckled. "She was a devout Christian all her life. She even hedged her bets—joined two different churches in Honolulu. I doubt she ever thought of *ki'i* as religious articles, in the way that relics of the Christian saints are religious. I think she saw them more as political symbols: as proof that Hawai'i was once independent, with a culture all its own, and that it could be independent again."

"But then, why would you sell them? Wouldn't that disperse them, and dilute their, uh...*mana?*"

"Well, like the queen, I'm a realist. We'll never get our country back the way it was before the *haoles* came. We can't fight a war of independence alone, and it'd be touch-and-go even if we

had some other country as an ally. We'll stay an American terri-
tory for the foreseeable future. But now the *haoles* are lobbying
for statehood. And that would be terrible!"

"Why? Because it's so far from Washington, D.C.?"

"No. Because it's so close to California! There are three hun-
dred and fifty thousand people in Hawai'i, but maybe only
twenty thousand, if that, are pure Hawaiians—and we're already
outnumbered by the children of Hawaiians who married outside
the race. If Hawai'i were a state, we'd be completely over-
whelmed by *haoles* from the States! Nobody in a position of
power would have to pay attention to the Hawaiians at all. We
need to expand our Home Rule party, until we represent all of
the *keiki o ka āina*—the children of the land. If the Home Rule
party can elect enough members to the Territorial Legislature,
we'll have a real say-so in the local government. We still
wouldn't be a majority, but at least our voices would be heard—
loud enough to make the *haoles* pay attention to us!"

"And Mr. Kalaukoa, the heir-apparent, would be your leader?"

"Every political party needs a strong leader, to rally the peo-
ple. Why do you think Roosevelt keeps winning elections?"

"What about you? You're pretty well known. You can draw a
crowd, I bet. Maybe you should run for office."

"Maybe I will, when I can't get up on the waves anymore."

After a moment, I said, "Would old relics be safer in America,
in case Japan decides to—"

"Oh, I don't trust the Japs. They'd be crazy to take on the
Americans, and they just might be that crazy! The way I see it:
Hirohito would *like* to have sugar from Hawai'i. But he's *got* to
have oil from the Dutch East Indies, and rubber from British
Malaya. If he's sending out an invasion fleet, it's to go get what
he *needs*, not merely what he *wants*. I do think he'll try to take
Hawai'i, eventually. But first he'll have to fight the British Navy
for Singapore. Besides, it would cost him too much to take
Hawai'i away from the Americans, with all the warships and
planes and servicemen there. Hawai'i's armed to the teeth. How
would the Japs get through our defenses? Plus there's us local

kids—and I'm including the Japs who grew up in Hawai'i. We'd form a Resistance, like the Poles and the Czechs and the French. We'd shoot back. If Japan declares war, it might take a while, but America wins it in the end. That's why it's America that we have to deal with, not Japan. So, like I said, forget about *what's* been hidden, and ask yourself *why*."

"The artifacts, you mean? To, uh, preserve your Hawaiian history."

"No! If that was the intent, they'd have gone to a museum in the first place."

"But they're so valuable!"

"That's it—you've got it."

"Huh?"

"If what's there is *not* cold hard cash—if my parents really hid a collection of old artifacts—then we'll have to turn them into cash, and quick."

"How much do you think they'd be worth?"

He snorted. "Typical *haole* question."

"I'm sorry. But—"

"We won't know, till we see what's there. Mr. Kalaukoa talks about two or three hundred thousand dollars in gold and silver coins, as well as banknotes. There might be bonds, too, and possibly jewelry."

"And if it's not money, but 'objects of veneration'...?"

"Okay." He touched his fingers as he ticked off the items. "Collectors pay fifty, a hundred bucks, for fish hooks that're carved from human bones."

"Roselani said there are hundreds of them there."

"She's only guessing! If there are feather standards and cloaks, too, and if they're still intact, or if they don't need to be totally restored, they'll be worth a few thousand dollars apiece. And as for *ki'i*—assuming they're like the carvings in the Bishop Museum—they'll be big: three, maybe four feet high, with sharks' teeth in the mouth, and mother-of-pearl shells for eyes. Each one of them would be worth ten or twenty thousand."

"So...a hundred thousand dollars, maybe?"

"If everything's sold at once. Twice, maybe three times that, if they're auctioned off in lots. So whether it's money or goods—it's about the same return, either way."

"Won't it be hard to sell things, if war comes?"

"Sure. That's why finding *money* would be a lot better." He grinned and stood up. "Look, Miss Green, mo' bettah I come *with* you, 'cause, believe me: you gals don't want me workin' *against* you."

He made a theatrical, courtly bow—as deeply as his bulk would accommodate—and strolled away.

We stuck to the arrangements we'd worked out earlier, so our sets that night went comfortably well. One couple in Cabin Class, by far the most elegantly dressed, was celebrating their tenth wedding anniversary, and gave us ten dollars for playing "their" song, which was "I'll Get By." We refused to tell Rubbish Mirikami how much they'd tipped, but he gave us a twenty-dollar bill anyway, to play what he said was "his" song: it was "The Japanese Sandman," though when he sang us the first line, he made it "The Japanese *Junk*man."

Up in the First Class Dance Pavilion, a burly crewman approached the bandstand as we were finishing our last set, saying he'd been sent to carry Ivy's bass over to the Brewers' suite, for their party. We followed him through the public rooms, into the cluster of First Class suites on Deck-A. Along the way, whenever the sailor's shirt rode up over his belt, we could see a patch of thick black hair where the small of his back cleaved apart into buttocks. Ivy made lewd gestures that gave Lillian the giggles. If *he* took any notice, he didn't let on. (Roselani feigned interest in the corridor's paneling. Just by coming along, she'd acknowledged it was in our best interest to party together, but damned if she was going to enjoy it.)

Glenn Miller's "String of Pearls" was playing on a portable phonograph in suite four. Bill was hard to miss—and he was talking with the master at arms, Stan O'Malley. Right away, a

steward handed us glasses of pineapple juice laced with plenty of rum. Twenty or so people who'd been in the Lounge earlier were chatting and drinking; half a dozen were huddled around the phonograph and a valise full of records. Ivy went to see what platters the Brewers had.

Lillian made straight for Bill. She gave him a hello-peck, and he introduced her to Stan.

Nan Brewer crossed the room; I nodded, expecting her to smile and pass. But she took my arm. "Thank you for coming, Miss Green. I know it's gauche of me to say this, but Quart arranged this party so that I could sing with you tonight. He does love to hear me perform, and it would mean a lot to him if you would back me up."

The Sarongs had discussed this prospect, already; we could cover just about any standard she was likely to know. "We'd be delighted," I said. "Just name the tune and tell us your key."

"In twenty minutes or so, all right? I believe...*someone* would like to say hello. He's out on the *lāna'i*." She pointed to the balcony.

Her husband and Dr. Boyd were standing by the rail, back-lit by the half moon. The doctor was first to catch sight of me, and motioned me over. With his back to the wind, he poured tobacco flakes from a Bull Durham pouch onto a slip of cigarette paper, twirled it up in his fingers, gave it a lick, and placed it between his lips, all in one very smooth motion. I smiled, thinking he probably did other things smoothly, too. But it was a surprisingly *earthy* way for an otherwise elegant gentleman to smoke. And his source of fire was similarly rugged: one of those new Zippo lighters that snaps open and traps a big flame in a windproof cage.

Our host, meanwhile, was filling a well-used brown meerschaum pipe from a leather tobacco pouch. I thought an aristocrat such as he would use a fancy pipe-lighter. But he was earthy in that way, too: he unscrewed the top of a small canister, pulled out an ordinary kitchen match, and scratched it on the under-

side of the rail, cupping both hands to shield the bowl as he lit up and puffed. Close to his face, the flame gave his pale hair a yellow-orange tinge.

He smiled at me. "Glad you could come tonight. Nan and I would like the Sarongs to play for a party at our house in Crockett, in January."

"I'm sure we could do that, between crossings. Thank you." I was bringing in business! That augered well.

"And now, please excuse us," Nan said, taking her husband's arm. "We need to see if we're running low on anything." They strolled away, so I called out, "Thank you again for inviting us tonight." He smiled, and she waved as they went inside.

The doctor drew deep on his hand-rolled cigarette, letting the wind flick the ash over the rail and away. "I'm glad *you* could come tonight."

"Did I understand you correctly this afternoon?" I asked. "You said the sugar that's grown in Hawai'i and refined in Crockett belongs to Mr. Brewer."

He let a beat go by—long enough for me to worry he might think I was fishing for a rich cousin or nephew. And I was right to worry, although he smiled again. "You meet plenty of fortune-hunters onboard ship, but I cannot for the life of me imagine that you're one of them!"

I flinched, but covered it by saying, "And I stay away from stage-door Johnnies; but I don't peg *you* for one, either." I saw a twinkle in his eye, and said, "I only asked because if we're going to play at someone's house, I like to know what kind of people they are."

"They're rich people."

"Obviously!"

"He's in the family business: C. Brewer and Company."

"You mentioned that last night; but I'm sorry, I don't recognize the name."

"It's the oldest of the Big Five—the five biggest companies in the Territory. They've been in business for more than a hundred years. Quart manages their sugar plantations on the Big Island,

and has his hands full with the unions. Many of the union leaders are Japanese, so he—oh! Good evening, Stan."

Mr. O'Malley had appeared out of nowhere. Well, more likely, I'd been staring too hard at the doctor, and hadn't noticed his arrival. "Evening, Miss Green. Doctor Boyd."

"I was talking with Quart earlier, about the Japanese delegation in Washington," said Swifty. "Is there any news?"

"Nothing that hasn't been in the papers."

"But we won't get any papers for days!" I said.

"Oh, but there is a newspaper on board—it's printed below-decks, every morning," Stan told me. "We get the United Press wire by radio, with the sports scores, too. Heck, we even get Winchell's column!"

I grinned. "So, when he says, 'Good evening, Mr. and Mrs. North America and all the ships at sea'...he means *us*!"

"If you want to hear him, try the radio set in the Lounge, in First. Most nights, you can get Honolulu; and if the weather co-operates, you can pick up the West Coast. And Radio Tokyo, too. We keep our ears open for them, believe me."

"You do?"

"Sure! They tell us more than they ought to. They always play a lot of military music whenever the army's getting into a fight somewhere. And they give out the weather report."

"Are you planning a trip there, Stan? It's cold in the winter. Bring a raincoat."

"Thanks for the tip, Doc. But if American soldiers ever have to get over there in a hurry, we'll be grateful for knowing what the weather's like that day."

"Well, I hope they don't ever have to go there with guns drawn."

I touched the doctor's glass with mine. "No war—here's hoping."

Lillian stuck her head out the door from the cabin. "Hey, Katy! They're bringing in the piano from Mr. DeMorro's suite, next door. C'mon!"

"You go ahead, Miss Green," said Dr. Boyd. "I wish I could

stay, but I can't. I promised to bring sleeping powders to a passenger on Deck-B who suffers from insomnia. And then I have to check on a crewman with the mumps, in the ship's hospital down on Deck-F. So, please excuse me."

I was sorry to see him go.

The crewman who'd carried Ivy's bass earlier was rolling the spinet piano, on casters, from Phillip De Morro's suite into the Brewers' living room. When he'd locked it down and set the bench behind it, the Baronet of Broadway flicked back the tails of his cutaway coat and sat down to perform.

He launched his set with one of his first Broadway hits, from the early years of the Depression, called "We're Down To Our Last Yacht." As his reputation had long made him out to be, he was the best interpreter of his own songs—at least, of the lively, lyrical ones. He played the piano well, too, of course. And up close, in a small room, where he didn't have to project to the back of a theater, he could employ a fine-edged, spare, almost delicate keyboard technique. (There's a Negro bandleader, William Basie, whom jazzmen call "the Count"—*he* plays piano like that.) It was well suited to accompany the dry banter of the Baronet's lyrics, although, of course, not all of his melodies leave everyone breathless. By the time he wound up his set with his poignant ballad, "A Middle-Aged Love Affair," I was reminded of something Darlene Duncan once wrote (she *does* have a good ear, and a knack for catchy phrases). She said Phillip DeMorro's songs were "like cotton candy spun out of talcum powder."

As soon as he had finished, Bill stepped right up alongside the piano, clapping theatrically, like a master of ceremonies. He was wearing a tropical white linen suit that was too big to have come off a rack. And in lieu of the customary white shirt and black bow tie, he sported a Hawaiian-print shirt with bright flowers, its collar open and spread wide over the jacket's peaked lapels.

Bill raised his hands for quiet. "Most of you folks don't know me," he said, "but Mr. DeMorro is a very good friend of mine. And he asked me to do a little song with him—a song I wrote."

Then he reached down, unsnapped a small case, and pulled out a 'ukulele. It's a tiny instrument anyway, but when hugged to his body, it looked like a doll-house miniature. He called over to Phillip, "You ready, brother?"

"As you yourself would say, Bill: 'Geev 'um!'"

Phillip supplied a simple left-hand rhythm from the piano, as Bill vamped an introductory lick: a jaunty, infectious riff, to which I couldn't help beating time with my palm against my thigh.

The song blended English and Hawaiian words into a sort of amorous gazetteer, that linked dozens of girls' names with place names on the "Orchid Isle"—one of the nicknames for the Big Island of Hawai'i. The progression sounded familiar, but I couldn't think from where, because my jaw dropped when I heard Bill's instrumental technique. He didn't use a pick to strum with. Instead, he played whole chords and arpeggios on the 'ukulele's strings with his fingernails. In his breaks, between verses, he played the melody on the higher strings, and enough of the chord below to support it. He embellished the notes with the tips of his left fingers, too, much like the way classical guitarists play or like what we violinists call *pizzicato*. It's a very difficult technique to master.

Even so, I was not prepared for what happened next. Phillip hit a few fresh bars of intro, brought his right hand in, and the two of them played both "A Middle-Aged Love Affair" *and* Bill's "Orchid Isle" song simultaneously!

No wonder the chord progression had seemed familiar! It supported *both*. The classical, conservatory word for what they did together is "counterpoint." On Tin Pan Alley, though, a song with two different melodies played to the same accompaniment is called a "double-song." (Irving Berlin is very fond of them; the easiest one he wrote is "Play a Simple Melody." But as any composer will tell you, pulling off the trick is far from simple.)

There was a smattering of "*whews*" and "*wows*" when the songs ended, and some of the applauding guests even rose from their chairs.

While the waiters refilled glasses, DeMorro relinquished the piano bench to Roselani. Lillian and I got our instruments out of their cases, and Ivy brought over her bass. We were still on pitch, and fortunately, the piano was too. Nan Brewer strolled over, and whispered something to Roselani, who nodded.

"Water and whiskey," Ivy called back to her. And when Nan squinted questioningly, Ivy explained: *"What're* we playin', and *whis' key* is it in?"

"'Yours Till Dawn' in E-flat," she said.

We knew *that* song, all right! It was by Ted Nywatt. Ivy and Lillian and I had played it a few dozen times in his band, the Ultra Belles, last year.... I suddenly realized I was holding my breath. I let it out and swallowed hard, just as Roselini started the intro and I swung into my violin part.

Nan came in on cue, and on pitch. She took all her phrasing comfortably, and didn't rush. She really could sing! Ivy was agape, and caught my eyes with hers, in silent agreement. Nan looked at the people around the room. She knew what she was doing. When she finished the number, Lillian rushed to congratulate her, and probably would have hugged her, if Ivy hadn't stepped up first with a hearty handshake. Lillian settled for giving her a big smile.

I said, "That was terrific!"

"I've done this before."

"I can tell. Where were your gigs?"

"I never had any, really. Only amateur shows and spoofs in college. But I do know quite a few musicians, who've given me tips on breath-control and phrasing. I met them at work."

"Where do you work?" Ivy asked.

"Oh, I don't work anymore, since I married Quart. But I was the social director at the Royal Hawaiian Hotel."

Ivy lifted her chin a bit closer to Nan. "Do you have an inside track with the hotel's social director *now*? We might be looking for gigs after Christmas."

"I'll send her a radiogram. At the least, she'll audition you."

"That's all we need! Thanks, Mrs. Brewer."

"Miss Powell," she said with a nod, in lieu of "you're welcome" or "good-bye," and strolled away toward the sideboard, where Quart was waiting. He opened his arms and gave her a big hug.

Lillian beamed. "The Royal Hawaiian—wouldn't *that* be a great gig?"

Roselani nodded. "We could get it. But they'd have to kick out the band that's there now, and they know me. They're really *Bill's* friends, though, and they won't like it if we dip our fingers in their *poi*-bowl."

"We haven't even tried out for the gig," Ivy rebuked her, "and you're worried some big *kanaka* might pound you into *poi*!"

"Pound *you*! Squash you outa your shell, *ōʻpae*!"

"What kinda pie is an 'oh-pie'?"

"*Ōʻpae* is a little shrimp."

"Jeez!" Ivy lofted her face as near up to Roselani's as she could. "I've got a dozen riffs on being short that are funnier and dirtier than 'little shrimp.' You want to hear 'em?"

"No. I'm sorry. Forget it."

"Damn right." Ivy settled on her heels, saw I was staring, and took another pineapple-rum cocktail from a steward's tray.

<center>❁</center>

By two-thirty, I was feeling the cocktails in my head, and needed fresh air. I stepped out of the suite and wandered along the corridor, until I found the door to the deck outside. There wasn't much of a breeze; the wind and waves were coming from behind us, as they had done that morning, and we were still—as I'd heard Mr. Brewer express it earlier—"running before the weather." Not having the wind in my face, or hearing it buffet my ears, seemed to cancel out the sense of forward motion that I'd expected to feel on deck. And the near-calm was disconcertingly quiet.

The air wasn't as cold as it had been the previous nights, either, since we were heading south, as well as west. So I slid my shawl off my shoulders and settled into one of the deck-chairs beside the door.

"We had to ask *Katy* to break the ice with DeMorro, so he'd sit in with us." It was Ivy's voice, from somewhere nearby, but behind a riveted steel partition that hid my chair, and kept me from seeing them, too.

"She's the only one of you that hasn't got a dirty mouth." That was Bill.

"You never even *hinted* to Lillian that you knew him. He hires musicians every day of the year. Didn't you think he might—?"

"It was only since a party, last year. Friend of a friend, really. Know what I mean? I told Phillip I could catch the boat down in L.A., after I picked up my new surfboard. He always takes a suite with an extra bed."

"Eh?" That wasn't Ivy—it was Roselani.

"He knew I was writing a song, that—"

"You never—!"

"I talkin' story here, sister. You mind?"

"That song about the Orchid Isle? You sayin' you went *write* 'em?"

"An' what? You the only one in the family got rhythm? Okay, I'm not so good as you. But I wrote one verse last year, and I sang it to him at that party where I met him, an' he wen' tell me: if I ever get more verses, he like put melody to 'em. So, I sent him a wire, with the verses, last weekend—"

"Only after you knew *we* were sailin' for Hawai'i. It *wasn't* about goin' home for Christmas, was it? Or about Lillian!" Ivy demanded, "The next time you see DeMorro, you gotta give us a plug."

"Naah, you never gonna do that, eh brother? You gettin' too many favors off of him already."

"Will you, at least, tell Lillian that you *didn't* come aboard to diddle her?"

"That's none of your business, Ivy."

"It sure *is*! Lillian's my best friend, and you're taking advantage of her."

"Bill's good at 'takin' advantage.'"

"Go to hell, sister. You too, Ivy!"

"We'll see who's goin' t' hell when I get my razor—"

"No *huhu*, Ivy. Let's go. Bill's goin' to hell *already*! For what he's doin' with the *māhū*, eh brother?"

Ivy asked, "What's a 'mah-hoo'?"

Roselani left that unanswered; I heard footsteps, then a door opening and closing, and I was left in my deck-chair in silence.

But not for long. Barely half a minute later I heard Lillian's voice, close by, although the steel partition still screened my chair from view. "You stinker!" She practically spat it out.

"Aw!"

"I'm really mad at you, Bill."

With so little wind on deck, I could hear them perfectly. But I drew my feet up, hoping they wouldn't see me.

"Your 'roommate' is the goddamn Baronet of *Boys*-way!"

"*Ku'u ipo*, honey! You think I don' know he's *māhū*. Lotta guys in show business are *māhū*."

"'*Māhū* or no *māhū*, I'm *huhu*! If he's payin' your fare, then you're givin' him the time."

"No! He was payin' for the suite, anyway." Then he whispered, "Do you know how much it is? A thousand, one way! But it's no more dough if you put two or three in a suite. So, when I—"

"Whoa! I am *not* going to play in that *trio*!"

"I didn't mean—"

"I never thought I'd have a reason to ask, Bill, but I'm askin' now: Do you like it that way?"

He waited a moment. "I never had a reason to ask, either, but I'm askin' *you* now: You never put out?"

"What?"

"You know what I mean. You never…done it—to get somethin' off somebody?"

"Are you saying—?"

"You *never*?"

She let a couple of beats go by. "Well…not 'never,' but—"

"See? How you figure I go stayin' in First Class? Like I said, he's a friend of mine, and he has a suite with an extra bed—"

"And you're sleepin' in it? *Alone?*"

"Listen—this is more important. Where'd Roselani get the dough to take you to the Big Island?" he asked.

"Hey—I'm still waiting for you to tell me—"

"She saved up? Is that what she said?"

"Yeah. From playing the Treasure Island Fair, and six months at the Bamboo Hut. Are you gonna tell me about DeMorro?"

"Ask Roselani who she—"

"I'm askin' *you.* Everybody knows *he's* a fairy. Are you a fairy, too?"

"Ask her about the airplane fare over to the Big Island, and the steamer tickets back to Honolulu. *Somebody* had to buy them—which is like puttin' a down-payment on the 'treasure' Roselani thinks she's gonna find."

"I want to know about you and *him*! Not her."

"Jeez, Lillian, when you get somethin' in your teeth you don't let go."

There was a moment's silence, then they both giggled, until she finally said, "This is important, Bill. I have to know—wait! Where're you going? Turn around!"

"I gotta meet somebody."

"It's three in the morning!"

"It's about the.... I can maybe get a ticket on your plane, and go with you to the Big Island."

"Who're you meeting? Some high-flyin' boy in the Army Air Corps? I thought it was only *sailors* who liked to—"

"Make Roselani tell you, before you get on the plane—"

"The hell with her. Are you one, or aren't you?"

"I'm tryin' to tell you: Be careful—"

"You just told me." She wheeled around and—I suppose it had to happen—caught sight of me in the deck-chair. "Oh, great! Katy Green—sees all, hears all, knows all. You gonna *tell* all, Katy?"

I shook my head.

There was a long silence. Bill tried to give Lillian a kiss, but she turned her head aside. "Say nighty-night to your roommate

for me! Tell him it was a lovely party. I had a swell time." She stepped away from him, and headed for the door, her sandals squeaking.

Bill turned toward me. "Like I tried to tell her: whoever paid for your tickets…watch out for them. Good night, Miss Green." Then he walked away down the deck toward the stern and vanished in the dark.

I wasn't ready to go back to my cabin. I actually wanted another drink, to steel myself for what seemed a certainty: that the Sarongs would break up when we returned to San Francisco—maybe even in Honolulu! I'd be out of work again, all too soon, and would have to scrounge up a gig for New Year's Eve to earn my train-fare back to New York.

I returned to the party, and frankly, I was glad to see that neither Bill nor Lillian had come back. Roselani had apparently left, too. But Ivy was sitting on the piano bench with Phillip, leading a knot of guests in evening clothes through the chorus of his ballad, "Two Strangers in Rome." I joined in. Nobody's likely to hire me as a canary, but I can carry a tune well enough at a party.

I stayed there, singing, till four or so, because it brought back a flood of sentimental memories—though perhaps they arose from the spiked pineapple juice that I kept drinking more of.

At home, my family liked to gather and sing around the piano while Mother played. Her favorites were sad "parlor" songs, like "Only a Bird in a Gilded Cage," and "Melancholy." My father went in for "animal" songs, like the "Grizzly Bear" and the "Turkey Trot," that were all the rage to dance to in our childhood years, before the War. Tim, being the youngest, wanted nonsense, like "A Capital Ship," and tongue-twisters, like "My Baby's Due at Two-to-Two Today." And as I wanted to show our parents how mature I was, I called for sophisticated tunes like "Nola" or "Too Much Mustard."

Of course, we didn't sing any of those old chestnuts on the *Lurline;* we sang the hits of our own, modern time. But I was still remembering songs from my childhood days when I finally—and unsteadily—began to make my way down the stairs to

Deck-E, toward my cabin. I was whistling "Ballin' the Jack" and sort of dancing to it, though I was a rather tipsy Terpsichore by then. It's rare for me to get so high, but I was through with work for the night—maybe even through for the month ahead! In any case, no longer having to be on my best behavior in First Class company, I was enjoying the rare sensation of being a thick-tongued drunk. My brother always managed to tread on my toe when we danced, and for a moment I thought I ought to turn around, go up to the Sun Deck, and send him a radiogram in jest. Or maybe a *singing* telegram, of "Ballin' the Jack," which I proceeded to sing aloud: "That's what I call bal—"

A heavy thud echoed in the stairwell, from somewhere below. I shut up and winced, embarrassed, hoping no one had heard me. When I reached the Cabin Class Foyer, on Deck-D, what looked like a huge pile of laundry lay half-in and half-out of the stair landing. It was white, with red mixed in. But then it trembled, and the red part lifted off the floor. Two dark eyes and a mouth opened. *"Doctor!"*

It was Bill.

My head cleared enough for me to realize he needed help. I dropped down, as fast as my tight sarong would let me, and knelt beside him. He lay prone, but raised his head again, and looked straight at me. His face was gashed open from left temple to right cheek, and his nose had been knocked askew—broken, no doubt. His chin and throat, his floral shirt and white linen jacket were stained with blood that puddled beneath him.

In my mind's eye, I was paging through my Red Cross first-aid handbook, when he gripped my arm.

"Let go, Bill! It's Katy Green. I'm going to get the—"

He pulled me closer, but what he said turned into a gurgle.

"Please! Bill—don't talk." I was sure the first-aid book said, *Keep the victim still.* I pulled the tail of his jacket up and blotted it against the back of his head. He was bleeding there, too. "I'm going to stand up, go down the hall—" I pointed toward the dispensary "—and fetch the doctor."

When I lifted his fingers from my arm, he relaxed the fist,

touched my head, and twirled two thick fingers around a lock of my hair. He wouldn't let go, as he struggled for breath.

I shook free, and said, "I'm getting the doctor." I've never been the screaming type, but I brought my voice all the way up from my solar plexus and shouted, *"Help! Doctor Boyd! Come here, Doctor!"*

A cabin door opened, but it wasn't his. "Please," I called, as a head stuck out. "Get the doctor!"

"Miss Green?" It was Danny Boy Ohara. He was barefoot and bare-chested, wearing only trousers. Then he saw Bill. "Holy cow!"

"Rouse Doctor Boyd. Hurry!"

"Right!" He trotted across the hall and pounded the doctor's door with both fists.

I heard it open. "Over here! This man's hurt."

Swifty stared down the corridor. He was in pyjamas and a silk robe. "Oh! Uh…is he conscious?"

"Just barely."

"Okay. Don't move him. And don't let him exert himself, or try to talk. I'll bring a stretcher." He ducked back inside.

Danny Boy called into his own room, "Hey, Mouse! Give us a hand!" Then he came over and squatted on his heels beside Bill.

Bill rolled his eyes. "You a Jap doctor?" He clenched his right fist, waved it close to Danny Boy's nose, and seemed to chuckle, but he gurgled and choked instead.

"I said, 'Keep him quiet.'" Swifty had arrived with a canvas stretcher. I slipped my end under Bill's forehead, and the three of us rolled him over, onto the stretcher, on his back. I cushioned the back of his head with the tail of his jacket; my fingers got bloody, and I wiped them on the canvas. A damp red stain remained on the carpet of the stair landing.

Mouse arrived, in a woolen bathrobe, and peered down at Bill's face.

Bill managed to whisper something that sounded like a name, but I didn't recognize it. Finally, he mumbled something that I did understand: he said, "Hey, whassa-matta you?"

Mouse said, "Okay, I'll play. Whassa-matta me? Whassa-matta *you?*"

"*You* whassa matta!" Bill replied, and then gurgled again what sounded like a name.

"Keep him quiet, remember?"

I touched his shoulder. "Shhh! Be still."

"Ooh, is he heavy!" Mouse complained.

It took all four of us—Danny Boy and me on one end of the stretcher, Mouse and the doctor on the other—to lift Bill, carry him feet-first into the dispensary, and hoist him onto the examining table.

Immediately, the good-humored Swifty turned into *Doctor Boyd*, one of those brusque, authoritarian medical men who've given surgeons a bad name. Yanking on a pair of rubber gloves, and taking sterile instruments from his autoclave, he barked out orders: "Miss Green, wash your hands—you have blood on them. I need you to go wake my nurse. She's in four-forty-five, down the far corridor, toward the stern. And where's his sister? Do you know? I'll want *her* here, if I have to operate. Get the nurse first, then the sister. And you men—go find Mr. O'Malley, the master at arms, and tell him to come here right away. All of you—fan out! Now! Go!"

It didn't take long to wake the nurse.

But Roselani wasn't in our cabin. I had to go all the way up to Deck-A, where I found her drinking with Nan Brewer, in the Men's Club Room. I motioned her aside, and whispered what had happened.

She looked back at Nan, said, "Somebody broke a 'ukulele string. I've got to go fix it. See you tomorrow night," and walked out casually, on my arm.

But she broke into a run as soon as the Club Room door had closed behind us, and called, "He's gotten into another goddamn scrap!" over her shoulder on the way downstairs. She was so fleshy that I'd imagined she never exercised. So as we reached

the dispensary, I was surprised she wasn't panting when she yelled, "Bill, what did you do now?" through the open door.

The doctor was untying his surgical mask, and placing his instruments back into the autoclave. The nurse closed the door behind us.

Stan O'Malley was there, too. He said, "Your brother is dead, Miss Akau. I'm sorry."

"How?"

"Damage to his brain, from bleeding inside his skull. He sustained a blow to the head," said the doctor, "and a severe facial wound. He was discovered at the foot of the stairs, so he may have fallen. And he probably aggravated his injuries by trying to get here on his own."

Roselani bent down close to Bill's face. "You so big, you always figure nothin' goin' hurt you. So now, the one time you get hurt, what you do? You make 'em worse. 'S like you...you went-go kill yourself, brother!" She stopped and breathed heavily for a moment—it was the panting she'd denied herself, before. She pulled back a couple of inches, but kept her gaze on Bill while she said, "Doctor, please don't tell me this all came from falling down stairs. He had perfect balance: he was a surf-rider."

"No, Miss Akau," said the nurse. "Doctor was trying to..."

"Spare my feelings?"

"Yes." She was a tall, skinny woman in her forties, and a true professional: she had gotten to the dispensary without pausing to remove the curlers and snood that she'd been wearing in bed.

Roselani pointed to Bill's wounds. "Did he say what happened?"

Swifty pulled off his gloves and dropped them into a metal canister. "No. He lost consciousness here on the table. Most likely, he got into a fight."

"Doctor started a transfusion," said the nurse. "He was stanching the wounds when I arrived to assist. Doctor asked me to administer a stimulant to the heart, which I did. But the gentleman did not respond, and I recorded that he expired at four-seventeen A.M."

Stan nodded to her. "Miss Lanahan, please let them know on Deck-F."

She picked up the desk phone and gave the ship's operator a number.

Roselani asked, "Who's she calling?"

"There's a cold-locker on Deck-F," said Stan, "that's reserved for...circumstances like this. Your brother will be kept there until we tie up in Honolulu."

Swifty extended his hand. "You may want...I'm sorry. These were in his pockets." He gave her a stateroom key, a monogrammed handkerchief, and the watch Bill carried, with a seashell on the chain.

"This is the doctor's office," Nurse Lanahan said into the phone. "I'm sorry to disturb you. We need you to come here to pick up...yes, that's right. Immediately. Thank you." She replaced the handset and looked up. "Shall I stay, Doctor?"

"No, Miss Lanahan, you don't have to."

"Thank you, sir. Good night. And Miss Akau, I'm really very sorry." She pulled the belt of her robe tight, and walked out.

The master at arms asked the doctor, "Did he say anything before he expired?"

"No. But Danny Boy Ohara and his friend Mouse Ichiro were nearby. They helped Miss Green and me bring him in here. Perhaps he—"

"*You* were here, Miss Green?

"Yes, Mr. O'Malley. It was I who found him. Where the stairwell opens into the foyer, out there—" I pointed in its direction. "And he did say something."

"Yeah?" Roselani demanded.

"What'd he say?" asked Mr. O'Malley.

"When he saw me, he called out for help. And then, when the other fellows came, he said...I don't know. A name, I think. It sounded like John Kemp or Kent. Something like that. Could that be the man he fought with?"

He shrugged. "I've got the full passenger- and crew-list in my office. If there's anyone aboard with a name like that, I'll find him.

"Try other names, too," I said. "It might have been Jan or Jack or Joe. I'm really not sure."

Roselani wheeled around. "Maybe he said 'Jap'!"

"Yes, in fact, he did! But before that, when we were all leaning over him. He asked Danny Boy if he was a doctor—'a Jap doctor.' I heard that clearly."

"Anything else?"

"Well, it's funny—not really, of course—but when we were carrying him down here to the dispensary, he and Mouse started up a routine of patter, like a couple of burlesque comics. I was trying to keep him quiet, and give him first-aid. I didn't have a bandage; I used his linen jacket."

Swifty touched my arm. "You did the right thing, Miss Green. But you needn't stay any longer—nor you, Miss Akau. The Line has rules and procedures covering fatalities aboard ship. Among other things, I have to perform an autopsy, and that will take a while."

Mr. O'Malley added, "There's a lot of paperwork, too, for the Doc and me to fill out. You two go get some rest. Miss Akau, anything you have to sign can wait until morning."

"Thank you."

"And Miss Green, I'll want to see *you* in the morning, too. You'll need to tell me your story again, so I can write it down. Meantime, try to remember everything you saw and heard—especially that name, if you can."

"Of course."

"Your hand, Miss Green…" The doctor touched my arm, slid his hand down to my wrist, and turned it over. "You still have a little blood—"

"Oh? I washed, before I—"

"You'd better disinfect it." He pointed to a bar of brown soap on a shelf above the sink. Then he reached into a small cabinet, pulled out a pill-bottle, and asked Roselani, "Will you be able to sleep? Would you like a sedative?"

"Uh…yeah. I could use it."

He shook four tablets into a paper envelope. "Take two now,

and the other two, if you still need them, tomorrow night. Miss Green?"

"No, thank you. I'll be all right."

Roselani said, "Thanks, Doctor. Good night." She headed out the door, and I followed.

But Stan called, "Please don't tell anyone what happened—not yet. It may become public knowledge later, but for now—"

"Sure," said Roselani.

I took her elbow, outside the door; but when we reached the stairwell, she shook off my hand. "You gotta go tell the girls. I need to be alone in our cabin for a while. I'm sorry. Give me an hour, eh?"

"Of course!" I would have liked to sleep it all off. But I was really the right one to break it to Lillian. And it couldn't wait.

The party in the suite had ended; and the public rooms on Deck-A were all dark. The Cabin Class Lounge and Smoking Room had also closed, hours before; but I found Lillian on the Deck-C Promenade, where we first got onto the ship. She was in a teak deck-chair beside the double-door, sharing a pint bottle of scotch with Rubbish, who was sprawled in a similar chair, a few feet away. He'd pulled his necktie off, and his starched collar, unbuttoned at the front, flapped around his neck.

"Rubbish here's a man who doesn't sleep," Lillian declared to me.

He grinned and said, "Why sleep when you can drink?"

She nodded and hoisted the bottle. "I'll drink to that!"

He enjoyed the sight of her out-thrust chest for a moment, then smiled at me. I took it to mean he would prefer me to leave.

Lillian held out the bottle to me, but I shook my head. She capped it, and slid it across the deck to Rubbish, who scooped it up.

"May I talk to you for a second?" I wanted to sound nonchalant, but I was panting, having foolishly dashed first to where I'd found Roselani, and checked the upper decks, before coming down to Cabin Class, which would have been closer to begin

with. I did not feel either warmly drunk or keenly energized anymore. I was moving slowly, and I was out of rhythm with the ship's roll.

Lillian could tell I'd had more booze than usual. She really was quick on the uptake, even if she didn't always get right what she got fast. She hoisted herself out of the chair and stood, a little wobbly at first, alongside me at the rail.

I'd more or less rehearsed this, on the way. "Bill got into a fight, a little while ago. A real brawl. And he—"

"Lost, I hope! It'd serve him right. What happened? Did that fairy hit him with his purse?"

"Bill...was badly hurt. He died on the operating table."

She nodded. "Thank you, Katy. Now, go back and tell the big galoot I am not in a forgiving mood. He can *not* cheat on me—especially not with a *man*. And if he thinks the three of us 're gonna play a *trio*—!"

"I'm sorry. Bill really is dead."

She squinted. "He is?"

"Yes. I found him—" I suddenly realized how near, and pointed inside "—right down that stairway, on Deck-D. We got him into the doctor's office, but...it was too late."

She gripped the rail. "What happened?"

I told her what I knew. Rubbish, tired of waiting, strolled over and caught the tail-end of the story. I didn't care. He'd hear it from his friends, soon enough. He extended a hand to Lillian, and drew himself close enough to offer wordless consolation. And for the first time since I'd seen them in each other's company, he was looking at her eyes, and not her bosom.

She let go of his hand and said, "G'night, Rubbish. C'mon, Katy, we gotta tell Big Chief Sarong," and walked with me all the way to 531.

"Hey, Ivy!" Lillian flicked on the light. "Ivy!"

Her bed-clothes stirred. "Don't ask me if you should break up with Bill again. Get some sleep."

"Katy says Bill's dead."

"Katy's drunk. Go to sleep."

I sat down on her bunk. "Ivy, wake up. Bill *is* dead. He got into a fight with somebody, and got so badly hurt that it killed him."

"Somebody killed him?"

"It wasn't an accident."

"Where's Roselani?"

"Next door. She needs to be alone. Can I bunk out here, on the day-bed? We'll all go in and see her in the daylight."

"Sure."

"Thanks." I untied my sarong, rinsed my mouth in their little sink, pulled the coverlet over me for a blanket, and curled up, facing the wall. In a couple of minutes, everything caught up with me, and I sank, at last, into a foggy sleep.

At one point, though, I had a dream. Someone was cutting my face with their hand—no—with diamond rings on all five fingers, that sparkled like embers rising from a flame.

I woke with a start. I'd forgotten to take off my watch. And with my left arm tucked under my head, the winding stem had scratched my cheek. I checked the radium dial—five twenty-five. I unbuckled it, wound it up, stuck it under the bed, and slipped back into the dark, grateful—for the first time—for the numbing hum of the engines beneath me, that obscured my thoughts and ferried me down into what passed for sleep.

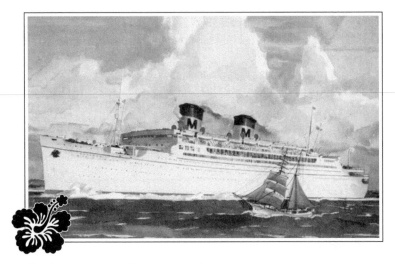

# Monday, December 1

IVY MUST HAVE SEEN MY EYES OPEN. "We've been waiting for you," she said. "It's a quarter to ten."

I retrieved my watch, knotted up my sarong again, and led the way. The door to 533 wasn't locked, and Roselani was awake—but neither reading nor resting nor anything else, just sitting in the little chair in the middle of the room.

I asked, "How are you feeling?"

She looked at Ivy. "I'll make the gig, don't worry."

"No. Listen!" Ivy shot back. "You wanna sit out tonight, it's okay. We'll understand. He was your brother! That's terrible."

"I know how I'd feel if *my* brother—"

"Thank you, Katy. But I've come to terms with it. With him."

Her bed was as taut as the maid had left it. Had she been in the chair all along? Or had she gone somewhere else on the ship? I felt queasy, though it was surely from the headache I'd been ignoring. I went straight to my toilet-kit, brushed my teeth, and swallowed three aspirin tablets. I needed a shower-bath, too.

Ivy was saying, "Honest, Roselani, it's okay. I'm stickin' to the union rules. They say you can have sick-time off."

"I'm not sick."

"We've got plenty of material. We can reprise our Ultra Belles' arrangements. Don't wor—"

"Oh, Roselani!" Lillian touched her hand. "It's *my* fault! I called him a fairy—a *māhū!* He must've gone crazy, and picked a fight with somebody, just to prove he *wasn't!*"

"No cryin', Lillian! Here." Ivy tipped Luckies out of her pack for them all, and struck a light.

"Hey—three on a match," said Lillian.

"Nope," Ivy retorted. "No bad luck now. All our bad luck is past us. There's only good luck ahead. Right? Right, Katy?"

I raised my aspirin bottle. "Here's to good luck!"

They gave back, "Good luck!" in unison.

Ivy leaned against the door. "So, we still goin' on this treasure-hunt?"

"Aw! I wanted so badly for Bill to come, too."

Roselani spun around and jabbed a finger at Lillian. "Bill was *never* comin'! Get that through you' head!"

<p style="text-align:center">❁</p>

The office of the master at arms was down on Deck-F, which was off-limits to passengers. His door was open, and he called, "Good morning, Miss Green," and waved me into an armchair across from his desk. "Were you able to sleep?"

"Yes, thank you." I didn't tell him how poorly, nor that I was now wishing I'd accepted one of the doctor's sedatives.

He took up a note-pad. "Are you any clearer now about what you heard? What was the name Bill Apapane said when he saw you? Whatever it was, I'm guessing that it's important."

"It sounded like John or Jan, and Kemp or Kent."

"Well, as you might expect, I've looked through the passenger- and crew-lists already. But I want you to take a look yourself before we talk about it. Power of suggestion—you understand?" He handed me two carbon-copied pages of typing, and a red pencil.

I settled back in my chair. The passengers' names were

alphabetized, and there were no J's, so I made a tick beside Kemperer, Sidney and Kampinski, Thomas. Under the C's, though, I found a Camp, Jonathan. In the crew's roster, there were no K or C names that sounded right; but there was a Quing, June and—under the J's—a Janus, Karel. Seeing that, I went back to the passenger list and red-ticked St. Johns, Cornelius, too.

He took back the sheets, glanced, nodded, and grinned. "We can drop Mr. Kampinski: he's a regular traveler with us, seventy-six years old, and needs help walking."

"Does he use crutches? A man could swing a—"

"He's too feeble, believe me. And Mrs. Quing is a chamber-maid: middle-aged, Chinese, and slightly deaf; she's been with the Matson Line since nineteen twenty-two."

"Not a likely killer."

"Right. I'll go talk to Mr. Camp and Mr. St. Johns. I already know about Mr., uh, Janus, except he pronounces it 'Yan-oosh.' I make a point of meeting all the foreigners in the crew before we sail, in case I have to—you know—weed out any undesirables. His working-papers say he was a steward on the Dollar Line and the Grace Line, but this is his first job with Matson. He's the bar-tender in the Cabin Class Verandah. He's a Jew with a Czecho-Slovakian passport. But there's no such country anymore, and Jews aren't exactly welcome in Europe these days. So he's got no home to go home to. I saw him in his quarters, here on Deck-F, this morning."

"What did you decide? Is he a refugee, or an international spy?"

"Says he's a mathematics teacher, doing this until he can find work in a college."

"Does he have some connection with Bill?"

"A lot of people on board do."

"Well, he was a big guy—hard to miss."

"And famous. Besides, he's taken the *Lurline* a dozen times, at least. Several of the crew know him well. Janus, not so well, but he saw him on the Sun Deck, about three in the morning."

That could have been right after his row with Lillian. I had resolved not to mention her, though, since I didn't want her to be grilled—at least, not for a while. "Was he alone?" I asked.

"Naah! He was with one of those Japs we were talking about: the ones coming home from their football game."

"They seem like very nice fellows. A lot like football fans everywhere!"

"And if you ask me, they're good Americans, too. Maybe even better than some *A-me-ri-cans* around here, if you take my meaning."

I nodded.

"Though I don't care much for the one called Danny Boy. When you're Irish, like me, just 'cause a Jap can be named Ohara doesn't give him the right to…well, it's just not funny. But anyhow, Bill could've gone anywhere on the ship, even into Cabin Class, from First. Plenty of guys in the crew learned to surf-ride because of him; and most of us have *seen* him ride in Hawai'i. He never had to buy a drink. Never had to hustle up a date, either. He always had a…girlfriend on board."

"Really?" Uh-oh. Did she—or he—know about Bill and Lillian? I had resolved not to mention it unless he asked. "A regular passenger? One of the crew?"

"That's all I'm going to say, Miss Green. You want the ship's gossip? Go have your hair done. But I will say that he could've easily walked through from First Class to Cabin. The Line isn't very strict nowadays about keeping them apart, as long as nobody takes advantage—you know, like pay for Cabin, but sleep in First someplace. The crewman at the gate must have waved him through."

"There was no crewman there on duty when I found Bill. That's why I had to yell so loud for help. Where was the crewman?"

"And *who* was he? I'll check the duty-roster. Thanks, Miss Green. That could be important. Uh, we don't have to be so formal anymore. If I can call you Katy, you can call me Stan."

I said, "Thank you," but I wasn't keen on the idea. He had a

disconcerting habit of glancing at my legs, instead of my face, whenever he talked to me. And he'd definitely given me a leer when I'd first met him. But maybe I was extra-sensitive, what with all the wolves I meet in the music business. Asking to be on a first-name basis may not have been a come-on, after all. So I decided to take it as a gesture of acceptance and friendship, and therefore I felt emboldened enough to ask, "May I read Dr. Boyd's autopsy report?"

He leaned back. "Why?"

"I'd like to know…what he died from."

"It's not nice reading for a lady. Besides, I'm conducting an internal investigation for the Matson Line. The death's recorded in the captain's log, and the entertainers can't see that, either. You heard the Doc last night: Bill was cut and banged up, hard enough to kill him. Now, tell me again: was it 'Jack Kent'?"

"Something like that."

"Why do you think Bill said the name?"

"He may have thought I knew who it was."

"Maybe he thought *you* were who it was."

I shrugged. "I don't think he recognized me. I had to tell him my name. Maybe he was hoping that if he could just tell some-body, the doctor…me! That I could track down his killer."

He laughed out loud. "Like he thought he could wander all over the ship, too, after his head was stove in."

"Bill must have *thought* I could."

"Oh, yeah? Why?"

"I had…been involved with something like this last year in California, and he knew it."

"Something like *this*? Look, Miss Green, I'm sure you mean well. But I think you've got a wild streak in you. And you're *lōlō* if you imagine that—"

"What's 'lo-lo'?"

"Means crazy—or stupid—in Hawaiian. Like *loco* in Spanish. I'm sorry, but you're in no position to do anything more than what you tried to do—administer first-aid. You don't seriously expect you can do like you said: 'track down his killer.' How

d'you figure on doing that? You gonna look out from the band-stand and see somebody and point and say, 'Hey—you!'?"

"No. I—"

"Just leave it to me and my crew, and don't worry anymore about it. Thing like this is a shock, even if you do know first-aid. You're still excited from it. Let it wear off. Ask the Doc for a pill or something, if you want."

"I have to stay alert to play."

"Fine. You go play. I'll check and double-check everybody on your list…" (I waited for the *but*, and he didn't disappoint me.) "But you're a material witness, and your job is to answer questions, not ask them. Now, tell me: Who benefits from killing Bill Apapane?"

"I have no idea."

"What about his sister. Did they get along?"

I had to say, "No."

"I won't look at her too hard, until I've gone through every-body else that it might have been. But she *could* have done it—right? She's a big *wahine*, she could've hit him with something."

I had to say, "Conceivably."

"Did he have anything to do with, uh…any of you girls?"

(He did ask.) "With Lillian, the trumpet player. She and Bill have been…seeing each other, for a couple of weeks. She's pret-ty upset."

"I met her last night. She's a little loony, isn't she?" I nodded. "D'you think *she* could have…?"

"No."

"Okay. I'll wait on talking to her."

"Thank you."

"Any more Apapane siblings? Kids?"

"You said he had a girlfriend on board…."

He ignored that. "Maybe there's a wife. Or an ex-wife?"

"I think there's only his sister."

He nodded. "The family are old Hawaiian *ali'i*. Is there any-thing she stands to inherit? A *kuleana*? That means family land, a homestead. Some old auntie's house someplace, maybe. Did he

own anything valuable that he could pass on to *somebody*? Does he even have a will?"

I had resolved all along not to tell him about the "treasure" with which Bill and Roselani were obsessed. It was still too fantastic for me. Most likely, it was a family legend they'd picked up as children, that had grown, and gotten more amazing, with every passing year. I simply could not believe that in this modern age, there was really any "buried treasure" left to find.

So, what I told Stan was only what I knew to be true. "I met *her* less than a week ago; and I just met *him* on Saturday morning, when he came aboard in Los Angeles."

"Even so, you say she didn't like him, and the feeling was mutual?" I nodded. "Family don't kill family except for darn good reasons. Like an inheritance."

"Maybe somebody on board had a grudge."

"That's a fair guess. A guy with a lot of friends can have a lot of enemies, too."

"Was there anyone who didn't like him? Anyone with a quick temper?"

I'd meant: among the crew. But he said, "All those Japs are hot-headed, except for Mouse Ichiro. Danny Boy Ohara's even got a record!"

"A police record?"

"Assault and battery. Back when he was in high school, in Pearl City. I was on the Honolulu force then, and Danny Boy was a boxer: a bantam-weight contender. He got up to number-three ranking on O'ahu."

"I'd guessed he was a boxer, from his physique."

"He had a nasty trick of going into a roughneck bar and letting some drunk who didn't recognize him pick a fight with him. Then he'd beat the guy up. Well, boxers are not allowed to do that, because their hands can be construed as lethal weapons. One time, he put the other guy in the hospital. The guy brought charges, and Danny Boy drew sixty days. Had to give up the ring after that, too. He might still have a mean streak."

"But why would he pick a fight with a fellow like Bill, who so totally outweighed him?"

"Guys do funny things when they're drunk. What about the captain? Where was he at four A.M.?"

I had to say, "I don't know. Only Danny Boy and Mouse came out to help."

"Not Rubbish, either?"

"No. He was with...my friend Lillian on deck. Is there anything else I can tell you?"

"I don't know yet. But listen: I take back what I said before. Maybe you *can* help me, after all. A lotta girls know first-aid, but you know how to use it and still keep your female emotions in check. Just don't try to smoke out the killer by yourself. If he could do what he did to Bill, you don't want to get anywhere near him. Keep your eyes and ears open, and tell me whatever you see and hear, and I'll keep you on my team."

"All right, I will. Thank you."

"You're what they call an *akamai wahine*—a smart lady."

"Thank you, again."

"Here's where it stands with the captain: There's him and me, you ladies in the band, and the four Japs who bunk across the hall from the doctor. I've gotta tell Mr. DeMorro, since Bill was sharing his suite—" he said that without any innuendo. Maybe he didn't know? "—and I wouldn't be surprised if Mr. and Mrs. Brewer find out; they're *akamai*, too. So, as long as we're the only ones who know what happened—"

"That's 'only' thirteen people! Plus the crewmen who took Bill's body away, and the ones who know where it is now—"

"Well, be thankful it wasn't the middle of the day when everybody's awake, or there'd be hundreds. People like to sleep late on a ship. So, here's the captain's instruction: If anyone wonders where Mr. Apapane has gone to, we're going to say that he fell down the stairs last night, sustained a concussion, and is recuperating in the ship's hospital." I nodded, but he could tell I wasn't happy about having to lie. "Would you rather we put an obituary in the ship's newspaper and raise a toast to his memory at the captain's gala *lū'au* tomorrow night?"

"No, but—"

"A death aboard ship is never good news. And the Matson

Line is your employer. *Our* employer, Miss Green. The doctor's, too. So we're all obligated to play by their rules. Me, I'm expect-ed to provide whatever information their lawyers in Frisco may be able to use later, to prove that what happened wasn't the fault of the Matson Line."

"That they weren't negligent."

"You got it. We make sure nobody let a carpet come un-tacked and tripped him up, or something. But I know—and obviously, you know, too—that this wasn't an accident. So, if you hear anything new, or remember anything more, just pick up any phone on the ship, ask for my office, and leave me a mes-sage if I'm not here."

"All right. I will." I stood up.

"If—" He motioned for me to stop. "If you run into the guy that did this, your first-aid may not help. You could get hurt. So be *akamai*. Not *lōlō*. If there's an emergency, get away from it, find a phone, and ask the operator to ring me on extension one. That'll send every page on duty out to find me, wherever I am, day or night. But that's only for a real emergency."

"I understand." Again, I made for the door, and again he held up one hand.

"I'd like to have somebody in the brig for this, by the time we dock in Honolulu on Wednesday. So when I say I'll listen to anything you turn up, I mean it."

<p style="text-align:center">❀</p>

"I *hate* it!" Swifty slapped the table in the Writing Room, rattling his teacup and saucer.

I had just slid into the seat beside his, and said, "Good morn-ing." Now, I had to ask, "Hate what?"

"When they die on the table. When I can't save them."

"You did your best."

"He shouldn't have tried to get to me on his own."

"He probably didn't realize how badly hurt he was. He was a big man, and a surf-rider. I'm sure you've seen athletes who've been hurt but don't realize it. Or people who've been in an acci-

dent, and yet they're walking around. My father was a doctor. He taught me first-aid—"

"He taught you well."

"I've given aid to accident victims; but it's disconcerting when it's someone you know."

He clenched his jaw and nodded, then signaled to the steward to bring me tea. I prefer coffee, but I didn't say so. "How's your hand?" He took hold of it, and held it far longer than necessary to see that I'd cleaned off last night's blood. Indeed, he started rubbing the center of my palm gently, with his thumb. It was very relaxing, though anyone who walked into this public room might think we were holding hands. That kept me from feeling romantic in return. "This wasn't how I expected to broach the subject," he said quietly, "but I hope we'll have more opportunities to spend time together."

"I need to apologize, first, for—"

"You mustn't feel guilty! You did everything you could."

"No! For something else. Do you remember, the other night, what Mr. Brewer said about the Japanese in Hawai'i? How they'd form a fifth-column? Well, I don't hold with talk like that. It offends me to hear anybody's patriotism called into question. But I couldn't challenge him. I had to walk away. So I'm sorry if I left you with a false impression. I don't approve of what he said. Really, I don't. It's human nature to be uncomfortable around strangers, but it's not all right to be prejudiced against them."

He smiled. "We agree on that, absolutely. But you did leave me there, all alone, to make the case."

I shrugged. "I'm sorry. I had to. The help mustn't argue with the host."

He tucked his thumbs behind the lapels of his white uniform, leaned back, and drawled, "We-ell, Miss Katy, I'm jes' a hired-hand on this here dude ranch, too. Eh-ee-*yup!*" We both laughed, then he said, "*May* I call you Katy?"

"Do you want me to call you Swifty?"

"Unless you like Hobart better?"

"I like Swifty."

"I like Katy." He was looking right into my eyes—making a pass, of course. It's always flattering when a good-looking man gives you the eye without the wink, and the line without the leer. I wanted to say something to prolong the moment, but I had too many questions. My eyes wandered—and his eyes followed mine—down to his left hand, where there was no ring, not even a paler stripe around his suntanned finger.

He understood. "I'm a widower. My wife died two years ago."

"I'm sorry."

"That's when I sold my practice. I traveled for a while, and took this job so I could keep on traveling. Becoming a ship's doctor was also a way to get away from…remembering. I'm easily distracted aboard ship, and I can specialize here, in a terribly important branch of medicine."

"Really?"

"Treating the ailments of the upper *clabsses*." We both laughed. "Have you ever noticed," he went on, "rich people are the same the world over, no matter what color or race they are. They pal around only with one another, and look down on the rest of us."

"Are you a socialist?"

"I'm a nationalist. I'd like to see all the races live in their own lands. Have you heard of a Hindu lawyer called Mohandas Gandhi? He's trying to get the English out of India."

"Yes, I've read about him. I like what he's doing."

"Gandhi says India should be for the Indians. I agree. I say Africa for the Negroes, Arabia for the Arabs, Palestine for the Jews, Asia for the Asiatics."

It seemed only fair to ask, "How about Hawai'i for the Hawaiians?"

"Why not? But America will never give it back without a fight. We're no angels, you know. We don't *call* the Philippines a colony, but we run it that way. I don't blame Hawaiians for feeling stateless; but there's a lot of *that* ailment going around, today."

"What about China for the Chinese? With the Japanese troops in Nanking and—"

"Oh, *they're* no angels, either! But they've put a Chinaman back on the throne in Manchuria. And they've brought real economic progress to Formosa and Korea. Now they're helping Siam to take back territories that England and France *stole* from the Siamese, a century ago. If there's ever a war for possession of the Dutch East Indies, I think the Indonesian people will side with Japan against Holland. We may not like it, but is it really America's business?"

I shrugged. I hadn't expected him to echo what I'd heard about Hawai'i; and I didn't know enough about the situation in Asia. So I let the thread drop.

"What bothers me," I said, "is when an educated man like Mr. Brewer disparages a whole race of people for something that their ancestral country may be doing now. Especially when they have no connection to it anymore. My landlady's German, but she's no Nazi. And everybody in America knows Italians who aren't Fascists. I'm sure there are Japanese who aren't war-mongerers, too."

"Of course!"

"I think it's ironic, how much you all have in common: you and Mr. Brewer and those four men—all of you, rooting for your alma mater at the Big Game, year after year.... I suppose Mr. Brewer lost a lot bigger bet to you than the price of a Cabin Class ticket."

"Not *much* more. A ship's doctor can't afford an eighty-five-foot seagoing yacht, like Quart can. But enough about him. I've known him since prep-school, Katy, and down deep, he's really a good egg. And a sincere patriot, though perhaps overzealous sometimes." He took out his tobacco pouch and a packet of papers.

"Let me roll one."

"Didn't you say you don't smoke?"

"For *you!* Let me try to make you one. My brother showed me how, years ago. I want to see if I can still do it."

He chuckled, and passed me the kit. It was my way of letting him know that I liked him, without actually saying so. If I'm

interested in a man who smokes, rolling one is my version of losing at Ping-Pong.

Alas, I'd volunteered too soon. I remembered the basic idea, but simply could not get my fingers to do what I thought they ought to be doing.

So he said, "Follow me, here, Katy. Monkey see, monkey do!" The he-monkey chattered, too, in falsetto.

The she-monkey replied with a smile and a chuckle.

He rolled one in front of me, step by step, and I mimicked each movement. I managed to get everything right, until the critical tuck-and-roll. My tobacco pile kept lumping up at the ends, leaving the middle almost empty. But Swifty kept "doing" and I kept 'seeing,' and eventually I managed to roll a fair semblance of a cigarette, if a rather loose one. He tucked his own into the breast-pocket of his uniform shirt, put mine to his lips, and gave me a very warm smile as he held his Zippo up to my poor creation.

It burned unevenly down one side, but he didn't call attention to it. He tilted his head up and exhaled. "Would you mind if I say something blunt, Katy?"

"I hope not."

"I'm impressed," he said, "that you know how to keep your head in an emergency. And that you're not squeamish."

"Thank you. Umm…would *you* mind if *I* said something blunt?"

"I won't mind."

"I need your help—professionally."

"Are you ill?"

"No! It's…Please, will you tell me what you found in your autopsy?"

He arched his eyebrows. "Definitely not squeamish."

"Will you—?"

"It's in my report."

"Mr. O'Malley won't show it to me. There's some rule against it. Will you tell me what you wrote?"

"Yes. Finding Mr. Apapane is what put your name in the

report. And *that's* why the Line's rule-book says you can't read it. But in *my* rule-book, you're entitled to know the outcome. I trust you won't tell Stan that you heard it from me."

I didn't want to be in the report! It took me a beat to catch up. "I won't tell anyone."

He extinguished my sloppy cigarette, lit up his perfect one, took a deep drag from it, and sat back.

"I don't usually have to make so detailed a report. Most of the people who die on a ship come aboard with whatever kills them: heart-conditions, you name it. They're taking that 'one last trip' they've always wanted. But concussion and shock is what killed Bill: the sudden drop in blood pressure, resulting from the trauma of a severe blow to the back of the head, and bleeding inside his skull."

"There was a cut on his face, too."

"That came first. One stroke, from his chin to his forehead—" he drew his finger up my face to mimic it "—knocking a tooth loose, and breaking his nose."

"From what? A knife?"

"I'd say it was bigger, and not so sharp. A dull cane knife, probably. It's broader than a *machete*, and has a little barb for snagging sugarcane after you cut it."

"That's not something a sailor might have."

"But something that any crewman—or passenger—could fit in his luggage. Whatever it was, I think Bill was fighting with a man for possession of it. Do you know anything about fighting?"

"I know a little *ju-jitsu*. Enough to keep a wolf at bay, the two-legged kind."

"You fight the battle of the sexes with *ju-jitsu?*"

I laughed along with him.

"Well, in *this* fight, the cut might not have been a deliberate attack. But the other blow—the one that dented his skull—that came from *behind*, right about here—" he touched the back of my head "—and did the real damage. He certainly could have lived with the broken nose and the cut on his face, though he'd have needed reconstructive surgery."

"What cracked his skull? A baseball bat?"

"Not round like a pipe. Flat."

"An oar from one of the lifeboats?"

"Could be. I didn't think of something wooden, because there were no splinters. I thought of the broad side of that cane knife."

"An oar wouldn't have broken."

"That's true. But the lifeboats are up on the Sun Deck, and you found him on Deck-D. Getting down those stairs would certainly have exhausted all his strength."

I nodded. "So, I'm picturing Bill in a fight with somebody up there. His tooth, his face, his nose…that must have hurt. So he'd stop and maybe feel his mouth…leaving the killer a steady target at the back of the head. And *still* he was able to walk—stagger—down four flights of stairs."

"What a terrible irony! If he'd stayed put on the Sun Deck, he wouldn't have broken so many more blood vessels in his head. A crewman on watch would have come along and found him."

"He must have been in pain, though. And he knew he needed help."

"I have to say, it was a brave thing in one way: he was a champion in a sport where you fall down a lot, yet you keep going back out against the waves. He was big, besides, and I bet he was not accustomed to losing a fight. But he shouldn't have bet on his own strength this time. I like your suggestion of an oar. I'll mention it to Stan. He can have the boats checked. Though if I had a bloody oar in my hand, I wouldn't put it back. I'd throw it overboard."

"Then, when they count the oars, they'll find one missing."

He nodded, sighing away the last of his smoke. "If only Bill had stayed put, and called for help! I…I might have been able to…Damn!" He stubbed out the cigarette. "What's the point?" He looked away, then at me.

I understood.

A page broke the moment, stepping up to our table, and handing him a note. "For you, Doctor."

He said, "Excuse me a second," as he read it. "Sorry, Miss Green. I have to go. Duty calls."

"An 'upper-clahss' ailment?"

"Sunburn." Then he drawled, "Be seein' ya when the hired-hands get off-a work, this evenin', ma'am," touched his forehead in lieu of a ten-gallon hat, and strode away.

<center>�֍</center>

Ivy was the hairdresser's only customer. (The Line knew their entertainers had to look top-notch; we were entitled to one free treatment per crossing.) Her chair-back was all the way down, and her head rested in the sink. She looked up and waved me in. She didn't pretend it wasn't a dye job—nothing embarrassed her.

The hairdresser was a woman somewhere past fifty, whose neat smock could not conceal a stomach. "You must be Miss Green! Miss Powell has been telling me all about you girls. And oh! Now I see. You are *so lucky!*"

I squinted. "What?"

"You aren't going gray."

"Yet!" Ivy called up from the sink.

"Would you like me to trim your bangs? I can take you at one-thirty."

"No, thank you."

"I was so sorry to hear about Mr. Apapane. What a shock for your friend. The poor girl must be devastated. It's terrible, having someone you—well, someone *that* close to you—die in the middle of the night. It's a tragedy."

I was mortified. Ivy must have told her. I kicked myself for not saying earlier that we shouldn't. So I said, "Ivy, you know that song: 'Remember to Forget'? We need to go over our parts."

Ivy went "Huh?" and then, "*Oh!*" when she caught my drift.

But the hairdresser kept jabbering, while her fingers worked the excess dye out of Ivy's hair and down the drain. "And how awful for his sister, too! That beautiful Hawaiian girl—oh, I just

love her singing, don't you? I saw her at the Treasure Island Fair, you know, and told all my friends."

"I'll be back in my cabin, Ivy."

"Give her an hour at least, Miss Green. She'll be under the dryer."

"Plenty of time to think about your part in that song!"

"Umm" came from the sink, as I turned to go.

"I'm Gloria," the hairdresser said.

I turned back reluctantly.

"*You're* the girl who found Bill!"

I gave her a nod.

"And to think I've heard about Bill *twice*, today! From Miriam first. Poor Miriam! Oh, my goodness! What she must have thought! No wonder she—"

"Is *that* who she was?" Ivy asked.

"Who are you talking about?" I added.

"Our manicurist. She was telling us about Billy Apapane. She always called him Billy. Of course, she'd have been told. Word gets around from the boys in the—well, we call it 'the ice box,' but it *isn't*, really. It's where they, um…"

"Keep the bodies cold," Ivy finished.

I was only half-glad to know Ivy hadn't spilled the beans *first*. "How does Miriam know Bill?"

"Well, she and Billy used to spend a lot of time together, when he was making this crossing four or five times a year. It was kind of a joke, among the crew. You know: like a sailor has a girl in every port. Not meaning to speak ill of the dead, you understand, but it was the talk of the Line that Billy had a girl on every ship. Oh, he was quite a ladies' man, and if I were a few years younger, believe me, I'd have tried my darndest to sit in his lap. He hasn't taken the *Lurline* in such a long time, though. A few years, now. And I suppose Miriam got tired of waiting for him. She got married, last spring. Right here on board, since they both work on the ship: her and Frank—that's her husband, now. Frank Todd. But you probably haven't met him, I don't think, unless you've had to go get something out of your trunk

down in the hold." She pointed down with a wet finger. "He's the fellow with the clip-board, on the Cargo Deck, that knows where everybody's luggage is stowed. Come to think of it, nobody's actually been killed on this ship since 'thirty-five, and that was in a knife fight in the crew's quarters. First time since then. How did he die? Have you any idea?"

"No."

"Well, be sure to tell Mr. O'Malley, if you do. Have you met him? But of course you have. I certainly hope he catches the man who did this! Do you know *anything*, Miss Green?"

"Nobody knows anything, really." I leaned over the sink and whistled a few bars of "Remember to Forget." I didn't say goodbye to Gloria. If news of Bill's killing was all over the *Lurline*, Stan might well blame me.

So I just turned and walked out. You can do that, you know: disregard the presence of people like waiters and maids and hairdressers. We never had a maid at home, so I didn't learn this until I was out on my own. They know they're only there to work. So, maybe that's why they're so quick to pick up any opportunity you give them to join in your conversation, like a friend instead of a servant.

But it dawned on me, walking back to my cabin: Were we musicians any different?

<div align="center">❀</div>

To get over the last of the hangover I'd woken up with, I needed either a nap, or three more aspirin tablets, or both. But I felt sour in the stomach, so I skipped the aspirins, and gave myself a rest for two hours. Roselani hadn't come back, so I ran scales on sax and fiddle for another hour, and worked up some fresh solos, too.

I was back in the groove around nightfall. But the Sarongs weren't playing our best. We took our tea-dance numbers a bit slower than we should have; and (I shouldn't say this, but) we "phoned in" our pre-dinner instrumental sets in the First Class Foyer.

We didn't hit our stride until our set in the Cabin Class

Lounge. Danny Boy Ohara, Jingo Mirikami—Tad, in civilian clothes, and his cousin Rubbish sat in a corner banquette. They were shaking their fists—no! they were playing scissors-paper-rock, the loser to pay for their beers.

Swifty Boyd was there, too, sharing a table with Nurse Lanahan, Stan O'Malley, the radioman Les Grogan, and (*uh-oh*) Gloria, the hairdresser. Across the room, the San Jose and Willamette college football teams were there, too, wearing their letter-sweaters; and so were a dozen handsome, dark-skinned men in matching white blazers: a school swimming team, perhaps.

Swifty caught my eye at the end of the set. He pointed off in the distance, toward the Dance Pavilion. So I was motivated to play my best when we got up there, at nine-thirty. But I wasn't the only one. Lillian was surprisingly perky, leading me to suspect that something I'd seen, earlier that day, was true.

When I'd left Ivy at the hairdresser's, I went first to 531 to tell Lillian not to talk about Bill, and walked in without knocking (well, damn it, *she* does it). Lillian was crushing a pill into a little square of paper in her hand. She looked up. "New toothpowder! See?" She touched a finger to the powder, and rubbed her teeth with it.

But toothpowder comes in a can. I figured it was cocaine. The more you take, the less you eat—she'd been losing weight—and you can get just as coked up rubbing the stuff into your gums as you can by sniffing it.

It was possible that Roselani had taken some, too—at least, this once. She'd shaken off the lethargy that had slowed us down earlier. She always led off our songs, and we had to follow her beat, so if she was a little sluggish… But now, she was—if anything—a little fast. That was okay. Faster means more concentration, so no time for bad thoughts. I didn't need cocaine to swing into my solos with plenty of pep, and as long as they stayed on the beat, I'd have no complaints.

❀

"We've been getting better and better, all night," Ivy said, as we finished the first of our two sets in the Dance Pavilion. "And that might have been the best we've played on this trip, so far."

Ivy was a mystery to me: nothing seemed to faze her. Maybe she drank as much as she did to keep from feeling too much. Maybe she took cocaine, too: she was so callous and insensitive, and it can certainly get some people acting that way. But she was so quick and sharp all the time that cocaine would probably rev her up like a propeller and send her spinning away.

Swifty came over. I put my saxophone down on its stand and joined him at the side of the music platform.

"I wish you could be out here on the dance-floor, with me, instead of on stage," he said.

"It'd be a neat trick, Mr. Astaire."

"If anyone can do it, Miss Rogers, it's you." He twirled once around, on his spit-shined black pumps, made a mock-bow, extended a hand—which I took, with a smile—and led me down off the platform. It was blatantly but good-heartedly theatrical, and I was charmed. I saw Ivy catch Lillian's eye, and jerk a "Get her!" thumb at us. We paused at the bar, where he bought me a glass of pink champagne, then held the French doors open for me.

We stepped outside, but I failed to keep some of the champagne from sloshing onto the teak deck. "These glasses are too shallow!" he declared, and poured some of his drink into mine, to make up for the loss.

"Don't look at me like that, Doctor."

"Swifty. And I shouldn't look at you like...what?"

"Like you want to sip this champagne from my slipper."

That led to a quiet moment, and a bit of worry, on my part at least, that I'd said something too soon.

But he said, "You'll like the Alexander Young."

"What?"

"The hotel in Honolulu. It's where the Line puts us up: the officers and the social staff. It's right downtown, not far from the

ship. You can walk there. But they have a roof-garden, and on a balmy night, you get all of *this*—" he drew his arm across the moonlit horizon "—plus the lights of the city, and the scent of flowers, in place of stars and seawater."

"There's a lot to like about stars and seawater, though."

"We could dance there."

It sounded wonderful; but I didn't want him to expect me. "Ivy has all our vouchers. But I think, on this trip, we're staying someplace else that Roselani knows about. I guess she's stayed there before. I don't know where it is, though."

All of which was true.

# Tuesday, December 2

A CHART POSTED IN THE FOYER showed the ship's track across the Pacific with a red ribbon that a crewman extended every four hours. By nine o'clock Tuesday morning, we were closing in on the Tropic of Cancer.

Up on the Sun Deck, the sea and the breeze were both soft, and the ship gave only its native roll and thrust, oblivious to the tiny waves lapping our sides. And inside the tennis-net, four of the dark men I'd seen last night were playing doubles; the others stood outside, cheering them on. They were all in their twenties, broad-shouldered, and well worth the looking at....

"Thank you, Miss Green," someone said, quite close to my ear. It was Stan O'Malley.

"You're welcome. For what?"

"You made us work for nothing." Before I could even flinch, he grinned, and said, "I can't find a John Kemp or Jack Kent, and none of the other names you came up with have any connection to Bill Apapane."

"Maybe Bill was delirious, and what he said didn't mean anything."

"I guess so."

"Did you learn where the crewman was, who—"

"Yeah. Turns out, there was no one on the gate, and it was un-locked. Crews up and down the Matson Line are getting letters from Uncle Sam, so we're running short-handed. Keeping First and Cabin apart on Deck-D just isn't a priority, these days. The man was needed on watch, above-decks. Which reminds me—" he spread his arms out "—no oars are missing, up here. We checked all the boats before dawn today."

"I'm sorry. It seemed like a good idea."

"Don't be sorry. The Doc didn't think of it, either, and I *should* have. But it got me to thinking. Those fellows you're watching—" He pointed to the tennis players. "They're canoe-paddlers, from the Outrigger Canoe Club in Waikīkī. They took first place in a tournament in Santa Monica last week. Wherever the team goes, they bring their own paddles. Ever see a Hawaiian canoe paddle?"

"No."

"It's heavier than an oar, and it's got a round blade that's big-ger than a dinner-plate. As long as they're all up here, I want to go below and look at their paddles. Want to join me?"

A tour of other cabins wasn't my idea of sightseeing, but I accepted so I could stay in his orbit and learn whatever I could. Besides, if I were to somehow give him a suggestion that paid off, he might just let me read that report and maybe even take my name out. Like Ivy bragging to Roselani that I knew "jujube," people always get things wrong about me; and it was an official report about that killing in my Gramma's home town that got me arrested there.

"Miss Green!"

"What? Sorry. I was watching them volley."

"You're keeping something from me, Miss Green. Gloria told me—"

"I didn't tell her!"

"I know that. It was Miss Powell. I could see, last night, that she'd had her hair done."

"I should have warned Ivy not to—"

"Gloria can draw anybody out, if there's something in it for her. And there is."

I squinted.

"She's been an extra set of eyes and ears for me many times."

I shouldn't have been surprised that the master at arms would have (what else to call them?) spies on board. "Does she have an idea of who killed Bill?"

"She wants me to question the manicurist, Miriam Todd, since Mr. Apapane and your band-mate, Miss Vernakis, had been keeping company. She might be jealous, even though she's married."

"More likely, I'd think her new *husband* would be the jealous one, if he thought Bill still had designs on his wife. Is he a Jack or a John or a—"

"Frank Todd."

"Oh."

"Don't let it drop, though. Frank's not a small man, but the guys that work under him—the stevedores and freight-handlers—they're a lot bigger. And they're always complaining that they supply all the horse-power, while he's in the saddle. So they call him 'the jockey,' behind his back."

"'Jock-ey'—John-Kemp. That's a stretch."

"But it's possible."

"Does he have a temper?"

"Some, but not *that* much. If he hears somebody say 'jockey,' he'll give the boy extra duty or more hauling and lifting on his next shift. That's about all. But I want to give him the once-over, anyway. He's the boss of the crew in the hold, which makes him more important to the running of the ship than you might think."

"How so?"

"He tells the boys where to stow everything that comes aboard with the passengers, and he makes sure it's all tied down. It's *his* responsibility, if any of that cargo was to shift. If an auto-mobile or a tractor or something heavy was to break loose, especially in rough weather, we'd have a serious emergency

below the waterline. So, I'd like to know if Frank Todd's running amok."

"Could he have gone after Bill? To defend his wife's honor or something?"

"Why don't you ask him?"

"What?"

"We have to go down to his hold, to see those paddles. Think up something to say that'll tease it out of him. I'll protect you, if he gets violent."

We had been watching an especially long volley, and I was enjoying the display of well-toned muscles. The paddlers were all big across the shoulders—last night, I'd thought they were swimmers—but some, who were especially barrel-chested, were also bandy-legged. Stan, however, was looking at their faces, probably assessing whether he knew any of them from his old police days, and if he did, on which side of the law.

Just as their second set ended, Danny Boy emerged from the radio shack ahead, his daily round of equipment-checking apparently accomplished. He waved at me, but didn't stop to chat.

Stan gave him a quick glance. "He's still got the cocky walk of a boxer, doesn't he? I wish he'd screw up again. I'd toss him in the brig so fast—"

"Aren't you still mad 'cause he's an 'Ohara' who isn't Irish?"

"Yeah, I guess I shouldn't hold that against him."

We watched the tennis players' third set. When they finished, the winners actually jumped over the net with their hands out to shake with the losers. It drew a round of applause from their friends on the sidelines, and from me, too.

One of the crew approached Stan and pulled him aside to talk. When Stan returned, he said, "I have to see somebody about another matter. Meet me on Deck-D, Cabin Class Foyer, in half an hour, and we'll go look at those paddles."

I thanked him, and stayed to watch one more match. I wondered if Swifty Boyd played tennis. I can play well enough to lose to a man, if I have to.

❀

"Hey, Miss Powell! Miss Green!" It was Danny Boy's voice, but we didn't see him until we glanced down. Ivy and I were on Deck-A, looking over the stern; he and Tad Mirikami were in swim-trunks beside the Cabin Class swimming pool, below us on the fantail. But they bounded up the narrow stairs, two at a time, and strode over.

"Is there anybody you'd like to talk to on the telephone today?" Danny Boy was asking Ivy first.

"Nope. My family's in Michigan, but they don't like me much. My big brother still lives at home, in Traverse City, but him and me: we're like cats-and-dogs."

"How about you, Miss Green?"

"I'd like to talk to *my* brother. Or my mother, or my Gramma."

"Where are they?"

"Mother's in Syracuse, in upstate New York, where I grew up. Gramma's in Lithia Springs."

"Where's that?"

"About fifty miles east. We used to spend our summers there. And Tim's teaching at Hamilton College—not too far from either of them."

"That's enough to go on. I should be able to raise a ham in New York *somewhere* upstate. If I find one who's local, in one of those places, I'll ask him to relay our traffic over a land-line."

Ivy lit up a Lucky. "What are you talking about?"

Tad jerked his thumb at his friend. "This guy can fix you up with a free phone call, ship-to-shore, even to…" he looked at me "…what was that little burg?"

"Lithia Springs."

Ivy snorted. "Are there really springs there?"

"Oh, yes. The town was a health-spa, before the War, like Saratoga, except most people went there for the horse races, and stopped coming to Lithia Springs, which had only the funny-tasting water. My grandmother used to run one of the bath-houses; most of them are closed now."

"Is she your only grandparent?" Tad asked.

"Umm," I nodded. "Mother's mother."

"There's just *my* grandmother, too: my father's mother, though. She's in Japan. She went back in 'twenty-eight after my grandfather died, stayed there, and married a man who's a lot like my grandfather was. They'd both been plantation workers for thirty years—only he was in Peru, instead of Hawai'i. He saved up his pay, moved back to Hiroshima—that's where they'd both come from—and opened an import-export business. We get postcards and presents from them. He's never talked Spanish again, and she won't talk English anymore."

Danny Boy grinned. "That's the 'Japan' Japanese for you: real *nihonteki*! They're living like they never left."

"What a charming story, though," I said.

"Very romantic!" Ivy put in, though I couldn't tell if she was being sarcastic."

"It's a problem for my pop, though," Tad went on. "My mom won't let him go visit his mother, because he won't be let back into the U.S. if he leaves. He's still a Japanese citizen."

"Yeah. Immigration laws are tough on...on a lot of people."

"It depends on which 'lot' you're in, Miss Powell," said Danny Boy.

I half expected her to crack wise, but she only nodded. I didn't say more, either. I'm not comfortable talking about race and prejudice with people who aren't like me.

"But speaking of Japan, Miss Green, remember that Japanese guy that Les Grogan heard on the radio the other day? Well, he's still transmitting."

I asked, "What is he saying?" at the same moment that Tad asked, "What's he saying?" and we all laughed.

"Les gave me the earphones," said Danny Boy, "while I was checking my 'scope this morning, and I got all the words this time. What he's saying is: 'The cherry tree needs pruning when the summer wind is from the south, and when the autumn east wind brings rain. Listen to Radio Tokyo for the latest weather report.' He's saying it over and over. Cherry trees are a big deal in Japan."

"In Washington, D.C., too," said Tad. "They were a gift from the old emperor, a few years back."

"I've seen them in bloom."

"Me, too," said Ivy.

"I guess he wants to be sure we know how to care for them. Anyhow, Les made a note of it in the radio log. He still doesn't know exactly where the guy is transmitting from. But this is the funny part: there's a ham Les talks to, up in Dutch Harbor in the Aleutian Islands."

"That's in Alaska, isn't it?"

"Right, Miss Powell. And *he's* heard the pitch for Radio Tokyo and how to grow cherries, too. Japanese whalers put in at Dutch Harbor, so he knows a few of the words. It could be some kid, fooling around with a grown-up's radio-set. But Les is worried that it might be a military thing: some secret Japanese operation that they're disguising by transmitting over the ham bands."

"*You're* very excited," Ivy said.

"Sure!"

"How could you tell if it was a 'military thing'?" Tad asked.

"First, we've got to find where it's coming from, and Les can't spend all his time listening; he's got to work. So he asked me to try raising other hams around the Pacific, and get them to tune their rigs in on the signal. The guy in Alaska thinks it's coming from Formosa. Les thinks it's coming from Hawai'i. If a third ham can tell us where *he* hears it coming from, then we might be able to triangulate its position. Of course, whatever we find, we'll tell the captain and Mr. O'Malley. I'd sure like to do something like that—something patriotic—to show them where our hearts are. If it got into the newspaper, maybe it'd carry enough weight with somebody, somewhere, that they'd let your father go see his mother, Jingo, and come back home again."

"Wouldn't that be something!"

Ivy looked down at the deck. "So, Danny Boy, you'll be spending the rest of the trip in the radio shack, huh?"

"Nope. I'll be in my cabin."

"Your cabin?"

"I have a portable rig. For those ship-to-shore calls. You

didn't think I could commandeer the *ship's* rigs, did you? I always take it on my trips; I built it myself. Wanna see? Come knock on my door."

Ivy smiled at him. "Okay."

"It only weighs twenty-six pounds—"

"The antenna's a spool of wire that he dangles out of the porthole!" Tad put in.

"Of course, that's not the most efficient array," Danny Boy went on. "It'd be better to do it like that—" He pointed up at the antenna wire that was stretched the length of the ship, between the masts of the freight-hauling cranes. "But even being thirty feet or so off the water, where Deck-D is, works well enough out on the ocean."

I grinned. "Do you really think there's a spy ring or something?"

"Only one way to find out. What do *you* think, Miss Powell?"

She waited a couple of beats. "I was thinking about what you heard the guy say, over the radio. Cherries are big business where I come from in Michigan—you see orchards all over Traverse City. And the trees don't get pruned in the summer or the fall. They get pruned when they're dormant—in the winter."

❀

Stan was already on the stair landing at Deck-D. "You found him right here, is that right? Like this?" He used his hands to suggest how Bill lay. "Prone—on his stomach?"

I motioned him to shift more to the left, and not so far into the foyer. "Only his feet were inside. Until he looked up at me, I...I thought it was a pile of laundry. I was going to step over it."

"Then he said what it was you heard?"

"Not right away. He called for help first. Then, after I yelled, and Danny Boy went for the doctor—that's when he said 'John Kemp' or whatever it was. He said it twice, I think."

"What did he say after that?"

"Umm, when Danny Boy came back, Bill said, 'You a Jap

doctor?'—he was asking, in Pidgin English, I guess, if he was a Japanese doctor. Then, as we were carrying him—"

"Show me."

I led him along the foyer, halfway to the doctor's office. "About *here*, he and Mouse got into that 'What's the matter with you—?'"

"'Whassa-matta you.' And Mouse gave him the reply? He said, 'Whassa-matta *me*? *You* whassa matta.' Is that right?"

"Um-hmm."

"Okay. Let's go." He started down the stairs, and I followed. There was no carpeting below Deck-D: the stair treads were an open metal grillwork. At Deck-E, there was a sign warning that, from there on down, the Aft Stairwell we were in was off-limits to passengers, unless accompanied by a member of the crew. Stan was kind enough to play tour-guide, though, as we went deeper into the ship.

"Deck-F is where the crew live; and you were on Deck-F yesterday, when you came to my office. It's just ahead of the Forward Stairwell."

"Yes. I remember."

"The ship's hospital's on Deck-F, so it doesn't frighten any-body who's just visiting the dispensary. And the cold-locker that we use for a morgue: it's on Deck-F, too. We're taking the last two flights down, to the bottom of the stairs: that'll be the Car-go Deck, which is where we're going. There's another set of stairs, from there, that leads down into the engine room; but we're not going that far."

"Ouch!" I had stubbed my toe on a tube that ran under the base of the stairs and through the steel walls that enclosed the stairwell. "What is that? A water pipe?" It was a foot or so in diameter, and a second one ran parallel to it.

"Those are fuel lines."

"Where's all the coal?"

He chuckled. "Were you expecting a gang of men shoveling coal into boilers? Like the lady in that play by Mr. O'Neill—what's it called? *The Hairy Ape*? You ever see that?"

"Yes. So, I guess I *was* expecting that."

"Nobody burns coal anymore! Modern vessels run on diesel oil. There are eight big tanks, up and down the length of the ship. We'll be walking aft between two of them, to get to the cargo hold. As the oil gets used up, and the tanks get emptied, one of the engineers pumps the rest of the oil all around to keep the levels constant, which keeps the ship in trim. You'll see those pipes everywhere down here. Watch your step."

All the way down, warm air had been rising. At the Cargo Deck, the air was actually hot, and more than a little damp, with wafts of petroleum fumes—the diesel oil, probably—that left grime on the steel walls.

Two well-riveted arches, the size of garage doors, but with rounded corners, stood across from one another at the base of the stairs. At the top of each, I could see the steel watertight doors that could isolate any leak in the hull, and keep the rest of the ship dry.

I knew about watertight doors. I was only five years old when the *Titanic* sank, but Father saved all the newspaper accounts in a scrapbook, and I read them when I was twelve. That may have been the start of what Mother calls my "morbid curiosity," but ever since, I'd wanted to see a real watertight door. And an iceberg, too, of course.

From turning and turning down the stairs, mainly watching my feet, I was disoriented, and grateful for the signpost at the bottom that labeled one way out FORE, and the other AFT. Stan waved me aft, and I stepped over the threshold of the watertight door into a narrow passageway between (as Stan had said) two oil tanks. The walls were barely a dozen feet apart, but the oil pipes along the deck shrank the walkway to only half that.

About fifty feet on, through another watertight door, we got into the hold: an open space, two decks high. The oil pipes were routed around the perimeter, almost to the sides of the ship, and protected from any breakaway cargo by a stiff wire fence.

The first things I saw in the cargo hold were cars: a blue Ford roadster and two coupés—a DeSoto and a Cord. And a red

1939 Packard convertible that put me in mind of the time in New York when I had to cling for my life to the running-board of a yellow one. The standout auto, though, was a black Chrysler Airstream sedan, polished to a glistening shine. Didn't Phillip DeMorro say something about a Chrysler? I'd ask him, later, if this black beauty was his.

A man with a clip-board sat at a small desk beside the far doorway; he stood up as we approached. "Afternoon, Mr. O'Malley!"

"You got my message? To see the Outrigger Canoe Club's gear?"

"Yes, sir." He was shorter than I, and rail-thin; and his uniform clung tight, hinting at muscles under his jacket. He wasn't small, like a real jockey, but he gained an inch by brushing his thick brown hair up into a high pompadour, and another inch by way of elevator-shoes. I suppressed a smile. For his wife to go from a man as big as Bill to one so much smaller, must have been quite an adjustment, if you take my meaning.

"Mr. Todd, this is Miss Green. She's in the dance band: the Swingin' Sarongs. I told her she could come along."

"We can't find one of our instruments," I said, launching into the tale Stan had asked me to concoct. "It must have gotten sent down here, with a 'not-wanted-on-voyage' sticker on the case, that it shouldn't have had. Would you mind if I poke around and look for it?"

"I'll check the manifest. But I can't let you wander all over. You'd better just follow us. I had the boys shift out a path through the cargo, to get to those paddles. Would've moved more away, but the reserves and the draft are taking a lot of my crew lately, and I'm short-handed this trip. Sing out, if you see your...what is it?"

"A 'ukulele."

"Huh?" He gave me an exasperated look. "Why would you stow a little thing like that down in the hold, anyway?" He glanced at Stan, who responded with a shrug. So he sneered, and said, "Women! They can't ever find what they leave some-

place! It's why they always take so long to get ready, especially when you're running late."

Instead of letting that roll off my back, I decided to use it as a lever. "You sound like a married man. Are you married, Mr. Todd?"

"Wha' d' *you* think?"

"I think I'd be grateful, if that were my wife's only fault."

He stopped and gave me a grin. "It is, you know. It's the only thing I'd change if I could. Anyhow, you can look around here, Miss Green. This is the best I can do for now. If your 'ukulele's someplace else in this hold, we won't find it till we unload everything in Honolulu tomorrow. Check back with me, though, if it doesn't show up."

"I appreciate that. Thank you, Mr. Todd."

"These here are what Mr. O'Malley came to see." He gestured toward a long bundle lying on the deck, wrapped in canvas and secured with ropes.

Stan went through the motions of untying the knots, opening the canvas flaps, and exposing the paddles, each of which he dutifully lifted out and examined. But I could tell from his expression that we were at a dead-end.

"Something wrong with the paddles, Mr. O'Malley? 'Cause I know who handled 'em last."

"I guess not. They asked me to look them over. One of the fellas in the club thought he saw them bump against the side of the hatch, when they were being hoisted into the hold, and—"

"No, sir! We handled 'em like babies! I was watching, the whole time. And you know I don't let my boys get away with any f—any foul-ups. 'Scuse my language, Miss Green. I make sure my boys are real careful."

"I can see you're right. Thank you."

He led us back along the "path" that had been cleared for us. "Anything new on what happened to Bill Apapane?"

Stan didn't flinch. "Nothing, so far."

"He and my wife—well, you know—they used to be real close, back a couple of years."

"How is she taking it?" I asked, as though I had a right to.

"She cried for him, and I can't blame her. I guess a man's supposed to be jealous, and get angry, if his wife's old boyfriend shows up. But he wasn't the marrying kind, and she knew it. 'S funny, though: he showed up on Saturday, right after we left L.A., and got his nails trimmed, just like he used to. She told me she couldn't keep from laughing, afterward, 'cause he's gotten so big, since…since before. I didn't see him myself this trip, but she reckons he'd put on fifty pounds, and wondered if he could still compete, carrying so much weight. But I guess he could—or he was gonna. He brought a new surf-riding board with him. It's down here, too. Came aboard in L.A., strapped to the top of this Airstream." He was close enough to tap the Chrysler's hood twice with his hand.

"I don't know who's gonna claim the surfboard now," he continued. "His sister, I guess. Or Mr. DeMorro, maybe. It's his car. Wanna see the board? It's a real beauty!" He stepped behind the Chrysler and lifted a bundle up from the deck. "Some of the boys must've been looking at it, and didn't strap it back on top of the car, like they're supposed to. I'm puttin' them on report!"

He tipped the bundle up on end; it stood almost twice as tall as he—ten feet high, at least. The canvas bag was mottled with reddish-brown dirt stains and greenish oil-smears; a rope circled the bottom, tied in a slip-knot. Mr. Todd undid the knot and lifted the bag partway up, exposing what resembled a fish's fin on the bottom, and a design painted on the top that…"Oh!" I pointed to it. "That's a swastika!"

"Yeah," Todd chuckled, "but it's not from the Nazis. We noticed it, too, 'cause the bag doesn't tie up all the way. The skeg—that's what they call this fin, here—it sticks out too far. Anyhow, when Bill came down here, Saturday, we asked him why he's got a swastika on his board. Turns out, it's an ancient good-luck symbol, that the Nazis stole from India or someplace."

"Stole it—that figures!" Stan declared.

"But *see?* This one's different: it lines up straight and square.

The Nazi swastika is tipped on an angle, like a diamond. Bill said these good-luck swastikas always brought *him* good luck. But now the company that makes 'em—you can see the name, right here, under the swastika: Pacific Home Systems—they've stopped putting swastikas on 'em, on account of people have been complaining. Anyhow, Bill said this was the very last swastika-board they're ever gonna make, and that they gave it to him for good luck, for old-time's sake. I think maybe they wanted to get rid of it anyway. A swastika's kind of embarrassing these days, don't you think? Want to see the rest of the board? I can pull the whole thing out of the bag—"

"Naah. Unless Miss Green…?"

"No. Thank you. That's all right. And I don't see the 'ukulele anywhere. So we must have left it backstage, in the Dance Pavilion. I'm sorry we bothered you."

"It was no trouble. We don't get many visitors down here."

❀

The sun was high, but a crosswind chilled my bare arms—the first time all day I'd felt cold. A steward walked by, offering blue blankets embroidered with the yellow Matson M, so I took one and looked for an empty deck-chair.

I was not surprised to see, across the way, that Swifty Boyd was having a cup of bouillon, his feet outstretched in a deck-chair beside the Cabin Class swimming pool. But alongside him, Ivy and Lillian and Roselani were doing the same!

Ivy waved me over. "This is the life, Katy, I swear. This is why people get on big boats. Nothin' to do but sit on your rump, kick off your shoes, put your dogs up, and sip hot soup while the ocean rolls along. You gotta try it!"

Roselani nodded. "Try one of the Doc's sedatives, too."

"Veronal," he said.

A steward had come up with a tray of bouillon. It wasn't hot enough, but it had plenty of chicken flavor to assuage my hunger. I'd had a sweet roll and only one cup of coffee for breakfast, and I hadn't learned anything new in the hold, so I'd been feel-

ing a little cranky. But now, with my feet up, shoes off, a big blanket over my shoulders, I was free to relax, to wonder—and be pleasantly surprised to *be* wondering—if ships' doctors may bring their wives along....

"Before you came," Lillian broke through, "Doctor Boyd was telling us how the *haoles*...what was it, again?"

"I was saying that if it hadn't been Captain Cook, it would have been some other *haole* explorer who'd have reached the Islands. Somebody from one of the seafaring nations would have tried crossing the ocean in these latitudes: a Spaniard, or a Portuguese, even."

Ivy looked at Roselani. "An American could've discovered Hawai'i."

"*We* discovered it! You *haoles* took it away from us!"

"No *huhu!*" Lillian tucked in.

"What's important," he told us all, with more than a bit of the bossy "doctor" in his voice, "is that the Hawaiians had a native country that's no longer theirs."

"It was stolen!"

"In some ways, yes, Miss Akau. But the greatest of your race's misfortunes was to have had no champion when the Annexationists made their first move against your queen. You'd agree, would you not, that you could never have held the Islands on your own, in a war for possession."

Roselani waited a couple of beats, then she pulled the little sandalwood box out of a pocket in her cardigan sweater. She slid the top back, and held it out to him.

"D'you know what is an ō'ō bird, Doctor? It's all black, except for this one yellow feather—" she touched her throat "—right here. Used to be so many ō'ō birds in the forest, we could weave a yellow feather cape from plucking just this one feather. You see, we didn't kill the ō'ō bird; we always set him free, to go make us another yellow feather. *We* didn' ever kill them. But nobody's seen one since the queen's time."

"That's so sad!" Lillian chimed in.

"When Captain Cook showed up," Roselani went on, "the

Hawaiian race was half a million people. Now, maybe only ten, twenty thousand. Pretty soon, nobody's gonna see one of *us*, since *our* time."

Ivy leaned over. "You could've had kids."

"Not with Clyde!"

"How come?" That was Lillian.

Ivy made a rude gesture. "Is he…?"

"No! He's half-Chinese, that's why. And too many *keiki*s are *hapa*, nowadays."

"Children who are half one race, and half another," Swifty translated.

"If Hawaiians don't have Hawaiian kids," Roselani went on, while she pocketed the box, "then there won't be any of *us* left, one day. Like the *ō'ō* bird. And a lotta Hawaiian babies up and die young. Do you know, Ivy, we don't celebrate when babies are born. We wait until they make it to their first birthday. Then we make a *lū'au*. But lately, we don't make enough pure Hawaiians to keep on making *lū'au*s for, 'cause there's a plague of *haole* diseases on us. You ever get the measles?" She waited while we all nodded. "You get well in a week. Some *haole* gives *us* the measles, and we die from it. One of our kings died from the measles. You *haole*s gotta stop killin' us!"

"Get her!" Ivy jerked a thumb at Roselani. "You figure that veronal's wearing off, Doc?"

"You've all been touched by Bill's death," he said. "And a little veronal can help you get over the worst of the bad feelings. Feel free to come around to my office and ask, if you'd like some more."

"Right now," said Ivy, "we gotta go back downstairs. I've got something important to tell you girls."

I was worried that she'd called the meeting to disband the Sarongs. But she had *good* news: Phillip DeMorro had arranged to perform with us that evening. But it would not be announced ahead of time; he wanted to spring it on his fellow passengers, as a surprise. So, he'd arranged for us to rehearse in the Dance Pavilion, which would normally be closed in mid-day.

Punctual again, he was there ahead of us, spinning up the piano-stool—he stood a head shorter than Roselani. The tunes he'd picked were among his best-known, which was not surprising, and his music-sheets, though well-used, were easy to read.

We expected, and so were not surprised, that Phillip would want to ad lib, occasionally—he was the soloist, after all, and we were just (as even female accompanists are called) "side men." But whenever he departed from the score, it was always in a predictable way. And his favorite way of ending a song turned out to be the way we usually ended requests: stretching out one of the conspicuous melody notes in the next-to-last measure, and then, on cue, resuming the original tempo, and giving the last full measure a dramatic flourish.

After an hour, I was feeling hungry, and I couldn't have been the only one. But Phillip—bless his heart!—had sent word to the *maître d'hôtel* in the First Class Dining Saloon, and just as we were ready to take a break, a steward rolled in a cart with five luncheon plates and a big pot of coffee.

<p style="text-align:center">❄</p>

With half an hour to kill before our tea dance set, I wanted to be out of doors in the sun. I went to the Cabin Class pool, but—again—I had no time to swim. I like to swim, but I'd hardly gone all year. There was that three-night gig last summer at Asbury Park on the Jersey shore, where I'd bought those white lace-up sandals; but you can't do much real swimming when you have to elbow your way through a couple of thousand people on the sand just to reach the water. I hadn't gotten wet on the crossing, either, and my visions of swimming at Waikīkī Beach were going to stay visions, for at least two more weeks. I was not looking forward to tramping around some sweaty jungle on Roselani's treasure-hunt. I promised myself I would take a dip every day on the way back, even if I had to do it early in the mornings. Well…before noon, anyway.

Danny Boy and Mouse were in deck-chairs on the far side of the pool. I waved, and they gave me a glance, but didn't invite

me over. Instead, Danny Boy tipped his head up and at an angle, as if to say, "Look up there."

I did. On Deck-A above, Stan and Swifty were at the rail, watching the pool, and when I smiled, Swifty waved for me to come join them.

"I hear we have a musical treat in store for us tonight," said Stan, when I got there.

"He hears *everything*," Swifty explained.

"I'm sorry we can't do it in Cabin Class, too. I know those fellows—" I gestured downward "—would get a kick out of it."

Swifty grinned. "It's one of the perquisites of the upper *clahss*."

But Stan *harrumphed*, and gestured toward the men below. "What's that Danny Boy got to be so cocky about? He hasn't fought a round in years. Unless it was him that picked a fight with Bill Apapane."

"Do you think it *was*?" I asked. "Why would he? He's an important man aboard the ship."

"Says who?"

"Says the radio operator, Mr. Grogan. He told me Danny Boy's, uh…'scope' I think he called it, is a critical piece of equipment. I've never seen anything like it. There's this funny green lamp, and if you stare at it, you'll think you're being hypnotized."

Stan's eyes narrowed. "How do you know all this?"

"Danny Boy took me up to the radio shack—" I pointed toward it "—the second day out. He and Mr. Grogan are old buddies. They've talked for years, over their ham radio sets."

"And Les Grogan let you in? He *knows* civilians aren't supposed to get anywhere near our radios. And that includes you!" Stan turned away, gave us a hasty "Excuse me," and strode off.

❀

"Miss Green!" I was passing the beauty parlor on my way to dinner, when Gloria called out my name, and added, "I heard they caught him!"

I joined her at her door. "Caught who?"

"The boy who killed Billy Apapane. Would you like me to trim your bangs now?"

"Uh, okay." I did want to hear what she'd heard, so I sat down.

"It was one of the Japs: one of those college chums on his way back from the football game. That's what they said."

"Who are 'they'?"

"Well, Miriam Todd, actually. She came by, maybe twenty minutes ago, to tell me the good news. It seems that Mr. O'Malley went to interrogate the little Jap about something, and found him talking into a secret radio set—can you imagine that? He was smuggling a *radio* on board. And it wasn't a radio set like you have, to listen to 'Hawai'i Calls.' It was a...you know...wha'd'you call it?"

"A transmitter?"

"That's it! A transmitter. Hidden in a suitcase. He'd been sending signals—I bet they were messages in secret code. Mr. O'Malley thinks he was talking to the Jap army or navy...something sinister like that. Isn't it wonderful? It's like in those Mr. Moto movies, except that *this* Jap's a spy instead of a policeman."

A spy wouldn't have offered to make phone calls for Ivy and me on a secret radio set. But I was in no position to contradict Stan O'Malley's action.

"Tell me, Miss Green, are you making a play for the doctor?"

"What?"

"Well, I thought I'd ask. He had his eye on *you*, last night."

"Did he say anything?"

"He said you play real good. He's a widower, you know."

"Oh?"

"He was married to a Japanese girl. She was a doctor, too. They met over there. Had a medical practice together, in Tokyo. But she took ill herself, a couple of years ago, and died. So he went back to California—I heard this from Mrs. Brewer, you see—and the doctor bumped into his old friend, Mr. Brewer, at that big football game they have. Hadn't seen each other

in ten years. Mr. Brewer invites the doctor onto his yacht, and one thing leads to another, 'cause Mr. Brewer knows a fellow at M-a-t-s-o-n.... Mmm?"

"Yes. And here he is, on board."

"And that's some figure he cuts! He's the best-looking doctor this old tub's ever had. You should have seen the one before him. What a geezer! Gave me this cream for my hands—you know how your hands get all..."

I had stopped listening. I was entertaining romantic thoughts about the doctor. He was, indeed, very attractive. He led a glamorous life. And he was smart. I don't meet many really intelligent men. Sharp and funny, yes. Intellectual, no. Doctor Boyd was all those things. I was starting to entertain thoughts of him in...*that* way, too, if you take my meaning. He'd certainly know his way around a woman's body, and wouldn't be all fumbles....

I looked at my watch. "Wow. I have to go to dinner. Thank you for the news. And the trim."

"Tell me, if you hear anything more about that Jap spy!" she called, as I headed for my cabin.

<p style="text-align:center">❀</p>

My sarong and my "tropical" white sandals both tied on securely, I was passing through the Cabin Class Foyer, en route to our set, when I saw Mouse and Rubbish on the port-side sofa—the one nearest their cabin—smoking cigars. Rubbish waved me over and said, "Something awful has happened. Danny Boy has been arrested. Care to sit, Miss Green?"

Checking my watch, I saw I could spare a few minutes, so I perched on the sofa's arm, tucking the flap of my sarong under my hip. "I heard something about it. What happened?"

"I wasn't there," said Mouse, "but apparently Mr. O'Malley found Danny Boy talking on his radio rig—it's the one he built himself, that he always packs on a crossing. And I don't know what to do now with his stuff. Do I take it with me, when we get to Honolulu? Or leave it for the cops to go through?"

"Where is Danny Boy now?"

Rubbish snorted, "In the brig!"

His cousin Tad came along, and sniffed theatrically. "All this smoke—I thought the ship was on fire. Hello, Miss Green. Did they tell you about Danny Boy?"

"Yes."

He looked at the others. "How the heck we gonna get him out of this mess? I've got my service pistol. I could bust him out!"

"I bet you would, too," said Rubbish, "if they wouldn't court-martial you for it!"

They all chuckled. Mouse shifted aside, to make room on the sofa. But Tad held a hand up. "I'll stand. Thanks." Then he sighed, and said to me, "You wouldn't think it to look at him now, but when we were kids, Danny Boy was always getting into fights."

"The first time I saw him," I said, "I thought he looked like a bantam-weight boxer."

"Good call, Miss Green! He and I were on the boxing team at Stanford."

Rubbish reached up and gave him a friendly poke in the arm. "That's why you joined the army, Jingo: so you could hit people and not have to take the consequences."

Tad returned the poke. "You were the biggest scrapper of us all. Remember when we tried to call you Fatso?"

"D'you know who I think killed the big *kanaka*?" Rubbish waited for us to shrug. "That *māhū*, DeMorro. It wouldn't've been a real fight. I figure they were horsing around, and one of them got rough, and then the other one got rough, and…somebody hit somebody a little too hard."

"That doesn't sound like horsing around to me," said Tad.

"And 'a little too hard,'" Mouse mocked, "wouldn't crack the big guy's head open from behind." He touched my elbow. "Did Bill…say anything? Besides getting me started on 'Whassa-matta you'?"

"What *is* that, anyway? A burlesque routine? Vaudeville?"

"It's the oldest joke in Hawai'i."

"It had whiskers," Rubbish added, "before we were born."

There was a silent moment; Rubbish shook his head. "I'm worried about Danny Boy."

"We all are," said Mouse.

"I don't think he killed Bill. Or got into a fight with him."

"Of course not. That's why it's so frustrating," said Tad. "There was no reason for Mr. O'Malley to toss him in the brig. He takes that radio set on every crossing. His friend, the radio-man, ought to know that, and say so. Besides, Danny Boy was *helping* Mr. Grogan with something, over the radio."

Mouse perked up. "Yeah? What was it?"

"I don't know. But that's what he told me."

Me, too—though I didn't say so. I said, "I don't think he killed Bill Apapane, either. And I'm glad that Danny Boy has friends on board who can help him."

"Here's to friendship," said Rubbish, hoisting his cigar as if he were toasting with a glass.

"To friendship!" They replied, almost in unison.

Tad said, "Hey, Rubbish. You've got a lawyer. Why don't we send him a radiogram, and see what he can do for Danny Boy?"

"Good idea!"

"And on that note, I've got to go play music." I slid off the sofa arm and stood as Rubbish rose; he and Tad headed for their cabin. But Mouse beckoned me to lean down, and whispered, "Danny Boy *could* have gotten into a fight. The fact is, some-times he…goes crazy."

I joined him on the couch.

"Don't get me wrong," he continued. "He's my friend, and I love him like a brother. Nobody can twiddle the dials on a radio set like he can; and what he does for the phone company…well, let's just say they don't want to lose him! But when he's *off*-duty, or away from home on a trip like this, and he's had a few beers, he…uh, he's been known to get a little hasty with his fists."

"Does he pick fights?"

"He has. Rubbish and I had to bail him out of jail once, after he started a ruckus in a bar and sent a man to the hospital. Another time, we were at a nightclub, downtown on Hotel

Street, and he was giving some girl a line about taking her to Frisco with him. She brushed him off, and we thought that was that. Only she had a boyfriend, who caught up with us later, outside. Danny Boy liked getting into fist-fights, but this guy hit him with a brick. It kind of scrambled his brains. He had to take a couple of days off work." Mouse looked me square in the eye. "So, Sunday night, with Bill Apapane...that could have been an accident: the *kanaka* could've been groggy and bumped into something, and fallen down. But if Mr. O'Malley thinks Danny Boy *killed* him...well, I wish I could say he couldn't have done it. But I just don't know for sure."

"I've given first-aid at accidents, Mouse, and I've seen... people who've been killed. Murdered, even."

"Really?"

"Yes. And if it was murder—"

"Don't go telling anybody that!"

"Who would I tell?"

He snorted. "The girls in your band. The swells, up in First Class. Let Mr. O'Malley be the Sam Spade of the *Lurline*. He'll figure out what happened, and break the news in his own way. And if he decides to keep it under wraps, then you better do the same. Mr. O'Malley knows how to handle things like this."

"He can *handle* it, I'm sure, but the fact is—"

"The *fact*, Miss Green, is that if there's any question about how Bill Apapane died, the Matson Line's gonna crack down on...well, on *us!*"

"Because you're Japanese?"

"We're all from Hawai'i, but that'll make no diff'—not to them. Nobody likes Japs, these days. We're the bogey-men of the world. When we get to port, I wouldn't be surprised if the Honolulu cops gave all of us the third-degree. They could come after you and your girlfriends, too, for palling around with us. They might even keep you stuck on board, and you'll spend your two free days in Hawai'i looking out through a porthole."

"At least, I wouldn't have to put zinc cream on my nose!" I

said that with a grin, and he shrugged, accepting it as the con-
versation-stopper I'd intended. I gave him a nod, in lieu of say-
ing good-bye.

"If I were you, though," he added, "when we get to Honolulu,
I'd get off the ship as quick as I could."

<p style="text-align:center">❀</p>

On our break, I wanted to leave the Verandah, to watch the
phosphorescent wake. But Nan Brewer, under the palms in one
of the wicker chairs, made a come-over wave, and tapped the
arm of the chair beside her.

When I approached, she gave me a smile, so I said, "Any time
you want to sing with us, just say so. You're very good."

"Thank you. You had a very tight arrangement for the song I
did at the party."

"Oh, yes. I know the composer, too: Ted Nywatt. Ivy and
Lillian and I toured with his band, last year. Where was that
college glee club you sang in? Were you at Cal? Or Stanford?"

"Please! Every time we take this trip—and we take it every
November—I have to listen to Quart and Swifty toss the old
pigskin around. Every punt, every play, every scrimmage of Big
Game, the whole trip back to Hawai'i. Cal beats Stanford one
year. Stanford beats Cal the next. Who the hell cares? But to an-
swer your question, like the 'three little maids,' I went to a 'ladies'
seminary'—Mills College, in Oakland."

"Where you evidently sang Gilbert and Sullivan."

She smiled. "Pitti-Sing in *The Mikado*, and Phoebe in *Yeomen of
the Guard*."

That was news. They're not the leading ladies; they're the
*soubrettes*: the funny girls, the saucy girls—very much the type
who, in real life, would be social director of a glamorous hotel.
"Have you considered going back on the stage, or—?"

"No! I couldn't. I'm very happy now, being Mrs. Quart
Brewer."

"He's lucky to be married to someone so talented."

She smiled at the compliment, but let a beat go by. "You're

not from the West, are you, Miss Green? You grew up back East some place. Am I right?" I nodded. "I noticed that it troubled you when Quart started in on the Japanese. I do *not* share his prejudice against them, and I hope you will overlook it. The sugar companies are having labor trouble these days, and the Japanese workers are the most aggressive union-men. I know something about labor relations, from working at a big hotel. The Japanese instinctively cooperate, and once they decide on a course of action, they all work together. They're compulsively polite, too, but they never stop fighting until they get what they want or they're dead."

"Mr. Brewer doesn't seem to hate the Hawaiians, or anyone else."

"He has a grudging respect for the Hawaiians. He was born in 'oh-three, ten years after the queen was deposed. Do you know about that?"

"Yes." I thought for a moment. "Was his family involved with that?"

She nodded. "Quart's father, Mr. Brewer the Third, was one of the men responsible; and he lobbied hard for annexation afterward, in Washington. Your Miss Akau can give you the Hawaiians' point of view, if she hasn't already."

"She has."

"Well, there is a *haole* side of the story. And if you're going with her over to the Big Island—oh, don't look so surprised that I know."

"How—"

"It was bound to happen, one of these days. War is in the air. It's only natural that the Apapanes would want to unearth the family's cache."

"So it *is* money they buried!"

"No. Not cash money. C-a-c-h-e. A cache of rifles and small arms. Ammunition, too, no doubt."

"What?"

"Didn't she tell you what she's going after?"

"She didn't say guns."

"I'm a navy officer's daughter, Miss Green, and I know enough about ordnance to ask you: please, try to dissuade Miss Akau from doing this. Ammunition—anything explosive—that's been buried for years, the wrappings may have deteriorated; they'll be very dangerous to handle. My father says the navy is prepared to send a team of munitions experts, if she will simply tell them where to look."

"I don't understand. She said—"

"She promised you a lark, didn't she? A gay adventure, something out of a storybook? A treasure-hunt?"

"Gilbert and Sullivan in sarongs, and a 'regular royal queen.'"

"Lili'uokalani! I swear—the way the Hawaiians adore that woman, it's like a cult! You'd think she was Mary, Queen of Scots. Look, here's the *American* side of the story. The queen was doing everything she could to make herself an absolute monarch, and the hell with the legislature. So they said the hell with *her*, and did what was best for *all* of the people, not just for her particular race. Frankly, I'm not sorry it happened, or that it happened the way it did. She had it coming. My grandfather was one of the marines who kept the queen at bay, in 'ninety-three, and a year later, he was wounded on the front-lines, putting down the armed insurrection that *she* was responsible for. His son, my father, became a naval officer, and he's been at Pearl Harbor for more than twenty years now. He's second-in-command under Admiral Kimmel. Officers' families have a good life in Hawai'i, and we owe it all to annexation. You'll be pleased to know, however, that for Quart and myself, all that is history. In Hawai'i, the *haole*s and the Hawaiians—the *ali'i*, especially—are great friends. Quart even plays golf with...well, there's no other way to put it...with the man who would be king, if history had taken a different turn. Henry Kalaukoa is his name."

"I've heard of him."

"Considering that their families were on opposite sides of the annexation issue, he and Quart are remarkably good friends. They met at Punahou School, of course."

"Doctor Boyd went there, too."

"Yes, although he wasn't born in Hawai'i. His parents were missionaries in South America and Indochina." Aha! That explained his anticolonial sympathies. "What's important is the guns. You must either leave them where they are, or allow the navy's demolition experts to remove them from their hiding place."

"Why do you say the Apapanes buried guns? I've heard it was something quite different."

"Money, you said?"

I nodded.

But she shook her head. "After the queen was sentenced, the Hawaiians prepared to launch a full-scale uprising, storm the palace, kill the guards, and turn it into a fort. This would be coordinated with Hawaiians on the other islands, who would shoot all the *haole*s in the government, so they could put their queen back on the throne."

"And do you think Roselani's planning to do something like that *now*?"

"Her brother certainly was! He was a hot-head, but extremely popular—a dangerous combination. He had a lot of friends who'd do anything he told them to. If he put guns in their hands, they'd storm the legislature and hold the Territory for ransom."

That didn't jibe with what Bill had said. It was possible that she was making all this up. But it was also possible that she wasn't.

"The Hawaiians," she went on, "hid guns and ammunition on each of the Islands. There were two caches on O'ahu: one at the foot of Diamond Head, and the other in the queen's garden. That's one of the key reasons she was convicted; nobody had to trump up charges. The caches on Kaua'i and Maui came to light after the queen died, in 'seventeen. But the cache on the Big Island was never produced. Everyone knows the Apapanes were responsible for hiding it—she was the queen's secretary; he was her factotum on the Big Island. Since they're dead now, the assumption has always been that they told their children where it is. So it's up to you, Miss Green, and your friends—you must try

to talk Miss Akau out of this foolish and dangerous excursion. At the least, you must not help her retrieve those weapons. The Hawaiians cannot possibly take back the Islands from the United States. A great many people will be hurt in the attempt; some will surely be killed. And it's her own race, more than any other, that will bear the brunt."

She sank back in her chair. For a woman so otherwise reserved in manner, she was adamant and agitated. This was no idle cocktail chatter; and despite her attitude toward the Apapanes, it was possible that Roselani—and Bill, for that matter—had been lying about the nature of the treasure.

# Wednesday, December 3

THE BRIG WAS DOWN ON Deck-F and—not surprisingly—right next door to Stan O'Malley's office. I went there before breakfast, intending to ask his permission, but the door was closed. So I showed the young crewman my ship's pass anyway.

"This is for going through the gate into First, Miss."

"Oh? I'm sorry. I was told, since I play in the band, that I could go all over the ship with it." Not true, but worth a try.

"What's your connection to the prisoner?"

"We went to different schools together."

"Oh. Well...uh—"

"He *is* allowed to have visitors, isn't he?"

"Yes, miss."

"So it's okay."

"Uh, I'll...have to leave the door open, in case..."

"Sure. That's fine. Thank you."

He unlocked the brig.

"Miss Green! Wow." Danny Boy looked up from the ship's newspaper. "Thank you for coming."

"Are you all right?"

"In one way, I'm actually better-off. I don't have to smell

Rubbish's cigars, and—" he stretched out his arms "—I don't have a roommate anymore. I've got a whole stateroom to myself! Of course, this one's an *inside* cabin—I always book the outside, so I can trail my antenna out the porthole. Do you think I should speak to the purser about this? See if I can swap with somebody—like maybe the guy who *really did this!*"

"You'll be cleared, I'm sure."

"Rubbish sent a radiogram to his attorney. They're getting a bail-bondsman to meet the ship in Honolulu today." He smiled as he said it, but then he turned away, swung back around, and thudded a fist against the outside wall. "That *stinker!*"

"Hey, you!" the crewman called from the doorway. "Don't break anything."

"Sorry!"

"Who's a stinker?" I asked Danny Boy.

"Apapane! Why the hell did he try to reach the Doc by himself?" He waited a whole measure. "I used to be in the ring, so I know how to fight. And I'm under suspicion, because I have a radio set. But Mr. O'Malley thinks I picked a fight with Bill Apapane—*me*—take on a guy who outweighed me by what? Two hundred? Besides, he *started* it!"

"You don't mean—"

"I do. I *did*...sort of fight with him."

"No! When? Where?"

"Up on the Sun Deck. Les had the 'dog-watch' that night, midnight to four A.M., and wanted some company. I left the radio shack a little after three. I saw him over by the rail, near one of the boats. That girl in your band wasn't around. Nobody was. I'd never met him, so I went over and introduced myself, said I'd seen him ride, and asked if he was going to enter a competition in the next couple of weeks. It was a perfectly ordinary and appropriate thing to ask, but apparently he didn't think so. He made a fist—and I was taken aback. But then he shook it three times, and I realized it was Jan-Ken-Po, and he was challenging me."

"To what?"

"That's what *we* call it. What do *you* call it?"

"I don't understand."

"Oh, you must've done this, since you were a kid. You put out a fist for a rock, palm down for paper, and two fingers for scissors."

"Oh, that! 'Scissors-paper-rock.' What did *you* call it?"

"Jan-Ken-Po."

"Is that Japanese?"

"I don't know. Chinese? Korean, maybe? *Everybody* calls it Jan-Ken-Po in Hawai'i. Anyhow, he put out 'rock,' and I put out 'paper.' So I won. Now, I wasn't really gonna punch him one in the bicep, you know. I was gonna stop short. But when I didn't, he gave *me* one! And it wasn't a little tap. Then he told me to get off the deck, and I said, 'Hey! It's a free country,' and he said something that I'd grown up hearing a thousand times, which I won't repeat—"

"It must have made you angry."

"Oh, no! We call *his* people names, too. You grow up in Hawai'i, those things roll off your back. You want to keep a cool head—that's the main thing, over there. Cool head, main thing."

"Like, no *huhu*?"

He chuckled. "Same difference!"

"And you were playing...what's it, again?"

"Jan-Ken-Po."

I chuckled.

"*Jan-Ken-Po?*" That was Stan O'Malley's voice. I spun around. He stood in the doorway. "No wonder we couldn't find any John Kemp!"

"Maybe *that's* what I heard, after all," I said by way of apology.

"Yeah," Danny Boy added. "Mouse challenges everybody to Jan-Ken-Po. And when Bill saw *him*, he must've—"

"I'm disappointed in you, Miss Green."

"I'm sorry. I'd never heard it *called* that, before. If I had, I'm sure I'd—"

He looked away. "I want to hear about this fight you got into, Danny Boy."

"I wouldn't say fight, exactly."

"You did say fight. I heard you through the door!"

Danny Boy shrugged, and sat down in the brig's one chair.

"Okay. When I didn't walk away, like he told me to, he swung and connected. Right here. See?" He unbuttoned his shirt and pulled it open by the collar. A black-and-blue mark, more than two inches wide, lay where the skin over the shoulder-blade is thin.

"Does it still hurt?" I asked.

"Sure!"

"Did you hit him back?" That was Stan.

"Are you crazy? There was nobody around. He could've picked me up with one hand, and tossed me over the rail. I wasn't gonna wait around for that. I took off, and went down-stairs."

"Whoever killed him didn't have to be big or strong. He was hit with something hard, like a club or a canoe-paddle."

"Anybody can swing a club, Mr. O'Malley. Even a woman."

"But the doctor says Bill was fighting with someone first. That's how he got so banged up."

"Okay. You know something about fighting, don't you, Mr. O'Malley?"

"*I'm* asking the questions."

"Sure. But tell me this: how were Bill's hands?"

Stan paused a beat or two. "They weren't bruised."

"What does that mean?" I asked.

"If you're in a bare-knuckle brawl," said Danny Boy, "and your hands don't get bruised or scraped, then you didn't land any punches. The other guy must have sucker-punched him—hit him when he wasn't looking."

Stan nodded. But he said, "Suppose one of your buddies saw Bill punch you, and misunderstood—didn't know you were playing. Mouse Ichiro must have a cane-knife with him, don't you think? He works with cane all the time. Maybe, after you went away, he caught up with Bill and figured he'd teach him a lesson about being a bully."

"It crossed my mind. But Mouse would never let me take the rap for him."

❁

After coffee and a couple of boiled eggs, I went up on deck and had one of those moments—I'd had several already—when I have to stop and realize how far away I had gone, catch my breath, and marvel anew at how enormous was the Pacific Ocean. This time, what compelled my attention was a band of clouds that lay still on the horizon ahead, and didn't shift with the wind. How extraordinary the skill of those ancient mariners—Hawaiians and *haoles* alike—to have known that where the clouds don't move, land sits underneath.

O'ahu itself appeared an hour later, close enough that I could distinguish steep green hills, and rows of houses clustered in the valleys between. It was bigger than I'd expected, although most likely, my sense of scale for land had atrophied over four days on the open sea.

We rounded the high bluff they call Diamond Head, and sailed west along the coast, toward the harbor. O'ahu did not resemble a Hollywood island: there were no ramshackle trading posts, like in *Rain*, and no native villages, like in *King Kong*. The town grew more crowded, the closer we got to the harbor. Plenty of ships were moored, but the port of Honolulu was small compared to San Francisco, and tiny compared to New York. Nor were any of the buildings there worthy of the name skyscraper. We tied up beside a campanile called the Aloha Tower, the only thing in town that stood taller than the *Lurline's* funnels. Even along the main streets that ran up into town from the dock, palms and flowering trees loomed over the office buildings and hotels.

It was barely nine A.M. when we pulled in, but the day was already hot and humid. The sidewalks were crowded. Men in white linen suits and women in gay silk dresses strolled to work, though no one seemed in any great hurry.

But *we* were.

Roselani had gone to the ship's mercantile store that morning, and bought us each a pair of rubber-soled deck shoes. We were to pack only a small overnight bag apiece, with one change of clothes, and a toilet-kit. And she hustled us off the ship as soon as the gangway was hooked onto the Deck-C Promenade. We followed her down, past the crowds of greeters and families, and out onto the street, where she waved us into a taxi at a curbside stand.

The driver grinned, and maybe leered a bit—seeing four *wahines* of such different sizes. He had something in his mouth, too, which he replenished from a small paper bag and chewed on.

"Is that gum?" Lillian asked. "Can you spare a stick?"

"Crack-seed," he said, and passed her the bag.

Roselani said, "Dried, salted plum," took one, showed it to us, and added, "Chinese candy," before popping it in her mouth. Lillian declined, but Ivy tried it, and so did I. Sweet and savory competed for attention, and although the flavor grew more intriguing as I gnawed the dry fruit away from the pit, I can't say it was ever delicious.

All the way from Matson's pier to the airport, I'd been waiting to see the island turn into something like the publicity photos that the tourist boosters pump out. Where were the lush rain-forests, exotic blooms, beatific folk...?

The view from the road was not at all scenic, unless your idea of a tropical paradise includes gas-tanks, warehouses, freight yards, and junkyards. It may have been the dustiest, dreariest, most thoroughly industrialized corridor in town. Every city has such a district, to keep itself running, but I was surprised they let tourists see it. For three miles, nearly every building was roofed and walled with nailed-on sheets of corrugated tin. Clods of reddish dirt filled the spaces where the streets weren't paved over, and the skinny trees and bushes that managed to survive along the parched road boasted hardly any flowers. Even the palms had been stripped of fruit, and it was small comfort to learn from our driver that it was done to keep people from being struck by falling coconuts.

A cloyingly sweet aroma wreathed the enormous Dole pineapple cannery as we passed it. But the folks who were stepping off the streetcars and heading inside for their shifts looked no different—nor happier—than factory-workers anywhere. As for sight-seeing, the only monument worth noting on our route was a tall water-tower above the cannery, whose tank was dressed up to look like a pineapple. "You lucky you seein' that tank now. Gotta cut 'im down soon, now," said our driver. "The pineapple ripe!"

I figured that was the *second*-oldest joke in Hawai'i.

The terminal for Inter-Island Airways was a wide, stucco-clad building furnished in the modern style. Ticket-agents worked behind a streamlined black desk banded with shiny metal stripes, and passengers waited for their planes in sleek chrome chairs with black leather cushions. Through tall windows we could see the planes that were parked outside, and the runways beyond them, toward the ocean, where they took off and landed.

Roselani went straight to the desk, and came back with four tickets and a brochure about the airline. A wide banner above the boarding exit declared that Inter-Island Airways had the WORLD'S FASTEST AMPHIBIANS—EQUALLY AT HOME ON LAND OR WATER. They meant planes, not jumping frogs. A sign beside the ticketing desk promoted a round-trip fare to Hilo for $47.30 that included a sightseeing bus trip to the volcano—which, alas, we would not be taking.

We'd arrived three-quarters of an hour early for our flight. Ivy and Lillian browsed the souvenir stand, trying on picture-hats made from palm fronds, and sniffing potted flowers—billed as A TROPICAL HIGHLIGHT FOR YOUR HOME GARDEN—that were wrapped up in cellophane. Roselani, however, spent most of the waiting time in a phone booth.

A loudspeaker called our Hilo flight, and we filed out onto the field to mount a staircase that had been wheeled up to the plane. It stood on three wheels: one under the tail, and two that unfolded from either side of the fuselage, beneath the wing—one long wing held up on struts. And from each side depended

an engine and a float. Since it could operate on the water, the door into the cabin was actually a hatch on top, and we descended a ladder to go inside.

Eight seats with round portholes were ranged along each wall of the cabin. A hostess in uniform directed me to the first seat on the left. Roselani took the one across the aisle, saying, "You'll have the best view of every island we pass, except the Big Island; but when we get over to it, I'll switch with you."

"Thanks."

Ivy took the seat behind me, saying, "D'you think we'll be the only passengers?"

"No, silly!" Lillian replied, taking the seat across from her. "Didn't you see the honeymooners in the gift-shop? Look." She pointed toward the back of the plane, where two young couples were settling themselves in. They may well have been newly-weds, since each pair held hands across the aisle. Our pilot and co-pilot came aboard next, nodding hellos to the passengers.

Nan Brewer came down the ladder. I hadn't noticed her in the waiting-room—nor Mouse Ichiro, either, who followed her down. They took the hindmost seats. Mouse called, "Hello again, ladies," down the aisle. "Sightseeing?"

I answered first. "Yes. You, too?"

"Oh, no! I've just had my annual vacation. It's back to work, for me. Besides—" he added, with a jerk of his thumb and a theatrical whisper "—the boss's wife is watching!"

She gave us a little wave.

Lillian called back to Mouse, "Do you work in Hilo?"

"Mostly in California, in Crockett. But my field lab and test-plantings are at Onomea Sugar Company, near Hilo—half an hour's ride up the coast, by train." He stood and walked up to our seats. "Have you ever seen sugar cane growing?"

"No."

"Well, you'll be seeing a lot of it soon. From the air, you'll think it's grass," he said, "like an enormous lawn. And it *is* a kind of grass. But when you get up close, it looks more like bamboo. Each stalk can grow eight or ten feet tall."

"What do you do, exactly?"

"I develop new fertilizers, to give us the greatest yield of sugar per ton of cane."

"When you come back to Hawai'i in a couple of weeks," Mrs. Brewer called up to us, "you might want to take the inter-island steamship instead of the plane. It's an overnight trip."

"We *are* going back on the steamer," said Ivy.

"And we'll be out on the water today, too," Lillian declared, "on a fishing boat!"

"Going fishing!" Roselani tucked in.

Mouse looked around at the rest of us, smiled, and said "If you'd like me to tell you what you're seeing from the plane, just ask," as he headed back to his seat.

The ground-crew wheeled the staircase away, the pilot started the engines, we buckled our safety-belts, and the plane rolled out onto the runway.

I'd been up in the air only once before, when I was a teenager. A barn-storming act came to Syracuse, offering ten-minute rides for ten dollars. I pulled the cork out of my mechanical nickel-bank, which got me six-fifty. But I was a tomboy at that age, and Father was delighted that I was willing to take the risk! He made up the difference. Mother still shudders at the memory.

The view out the porthole was spectacular. The sun was high. Every valley on each island stood out; the foamy crests of waves glistened white below. Roselani and I switched seats over the Big Island, and right away I saw something as big as a cloud and even whiter. Snow! On the mountain top.

"Mauna Kea—white mountain," she said. "If it's not raining in Hilo, you'll see it from the bay."

And it *wasn't* raining. A jitney-bus that had a top, but no windows or side-curtains, drove us down off the plateau on which Hilo's airfield lay. It let us off on a wide crescent beach, stretching across the entire bay front. And there, again, was Mauna Kea, with a snowline and white peaks. By contrast, the beach sand under my feet was—so help me—*black*. I picked up a handful: it wasn't like the oily muck of river-mud in New Orleans, nor

like the sooty grit of the channel between Staten Island and Jersey. It was coarse, like fresh-ground pepper, but shiny—more like fine crystals than pebbles.

Close behind the beach, a pair of railroad tracks and a busy commercial avenue ran toward the center of town, with stores, houses, and small office buildings along the way. But unlike any other small town I'd ever seen, palms, bananas, and trees covered with thick green vines grew out of every patch of ground.

Canoes, most with outrigger floats attached, were hauled up in several places along the shore, and beside each lay the native version of an anchor: a rock about the size of a basketball, with a hole drilled through it and a rope tied through the hole.

A dozen fishing boats were tied up at a dock that ran along one bank of an estuary that emptied into Hilo Bay. The night's catch had already been sold; men were sweeping ice and offal into the water beside the auction shed, while trucks and bicycles hauled away the fish.

Roselani pointed out her ex-husband's boat. It was only about forty feet long, but it had been built to challenge the sea head-on, with a bow rearing up high off the water, sharply pointed, to punch through big waves; and a stern long and low and flat, for hauling nets into the cockpit. The vessel's name, KA LEO, was painted across the transom, along with HILO, its home port.

I stepped onto a short plank and into the cockpit. Above the deck, a wheelhouse was roofed-over and windowed, with a small flag-mast sticking up from it, topped with a lightbulb. Inside the wheelhouse, a ladder dropped down into the cabin, where two pairs of bunk-beds lined the sides, with a table between them. A sink and drainboard stood on one side of the cabin, across from a closet with three ventilation holes—most likely, a toilet.

At a clanking noise below, I looked straight down and craned my neck toward the stern, under the cockpit, where the engine was mounted. A man hunched over it sideways, twisting some-

thing with a long monkey-wrench, looked up as I called down, "Hello."

"What's your name?"

"Katy Green. I'm glad to—"

"Where's 'Lani?"

"Huh?"

"Roselani."

"Oh." I swiveled around. They'd all come aboard; I beckoned her over.

She peered down, glanced at the wrench, and gave a snort of disgust. "Like I always sayin', Clyde: you got somethin' loose."

He chuckled. "And what? You no more ask me, 'How's-it?' Eh, Lani?"

She waited a second. "How's-it, Chang?"

"'S okay. Sorry to hear 'bout Bill. Thanks, eh, for th' call." He continued to apply torque with the wrench to whatever it was. "So, uh, how he went? You shoot him, Lani?"

"Shoot *you*, you—"

"Eh, no *buhu*, yeah?" He stood up, swung out of the engine compartment, and hauled himself up the ladder. Passing Rose-lani, he smiled at me, Ivy, and Lillian, and touched his forehead as if he were tipping his hat. He said his full name—Clyde Chang Akau—and each of us introduced ourselves.

Lillian asked, "Do we call you 'Chang', or—?"

"Jus' Clyde. Stow your gear below." He turned to Roselani. "Okay. You charterin' my boat. Where we goin?"

She looked around, as if to be sure no one on another boat was listening. "Onomea."

"All of you?"

"Yeah, all of us."

"Okay." He took a pair of binoculars from beside the wheel, and went to look at something beyond the stern, out to sea.

He was smaller and more fine-boned than Roselani—she had said he was half Chinese. But like her, and like Bill, he walked with his whole body at once, neither leaning forward nor swag-gering. Standing still, shoulders back, binoculars to his eyes, he

was poised like a dancer breathing between moves, or like someone accustomed to being in the public eye, or perhaps merely like the longtime captain of a small boat. Lines weren't prominent in his face, but gray hairs had overtaken the black.

Whatever he was checking out apparently satisfied him. He swung around, strode under the wheelhouse roof, and told us, "There's yellow rain-slickers in the lockers, under the bunks. Anybody falls over the side, get a life-preserver from under the seat, throw it in—but don't hit 'em. Now, if I say, 'Slip the bow and stern lines'—any of you know what that means?"

"Yeah, I do," said Ivy. "My pop has a boat on the lake." I've always said she could swear like a sailor, but I never knew she'd been a swabbie!

"Good. Hop onto the dock and stand by to cast off."

Clyde tapped the glass over the compass, checked the gauges, pulled out the choke-knob, and pressed a button. Beneath our feet, the engine sputtered, caught, and settled into a steady *potato-potato* beat.

Ivy slid the ropes off their cleats on the dock and tossed them onto the boat, then carried the last one under her arm as she stepped off the dock and into the cockpit, with a final kick to push us off. Clyde pushed the choke back in and swung the bow around toward the mouth of the bay.

I had seen the island from the air, and gotten at least some idea of how big it was, and how much was covered with the grass-like cane. In my mind's eye, I was still hoping for a Hollywood island of sandy beaches—*white* sand, like the Jersey shore, but fringed with palms. In fact, the shoreline north of Hilo Bay—whatever wasn't green with plants—was all rocks and cliffs, sharp-edged, dark and rough as broken slabs of chocolate.

I'd expected the sea close to shore to be practically transparent, like in Florida, and that I'd see fish in myriad colors over the side. I'd even read somewhere that dolphins swim ahead of small boats in the tropics, splashing back and forth across the bow to lead you into open water. The "blue Pacific" here was blue, all right, but so deep it was impenetrably dark. And it wasn't

dolphins, or even fish, that crossed our bow, but dense mats of brown debris, like wilted grass-clippings dumped from the bag of some gigantic lawnmower.

"Cane trash," said Clyde, steering around them. "It's what's left after they chop up the stalks and boil out the sugar. The mills flush it down to the ocean, and it'll foul our propeller if we get into it; so let me know if you see any straight ahead."

"Sure."

I looked out to sea, and had another of those moments of being suddenly and intensely struck by the reality of the biggest ocean in the world. Aboard the *Lurline*, those moments began on a high note of awe, then sagged down the scale, making me feel weak and untethered, almost helpless, as if I were adrift, nearly three thousand miles from California, and even farther to anywhere else. It was a discomforting experience, even on a modern, six-hundred-foot liner, with plenty of lifeboats, and radios to call for help. But here, and only a few hundred yards from land, a mere forty feet of wood and a gas engine lay between me and the deep, and I had to fight down a palpable anxiety.

I turned back to look at the coastline: a series of rocky headlands, each topped with windbreaking trees and sugar cane; and between the headlands were deep gulches—a dozen or so, large and small—most of them wet from rain, and lined with thin waterfalls that trickled down steep cliffs.

Clyde chuckled and said, "Okay, Lani. You gonna tell me, now, why we goin' to Onomea Bay?"

"Like I tol' you," she snapped back, "*Bill* knew where. What I know is what to do when we *get* there. But now I know what Bill knew."

Lillian looked up. "You didn't have a séance, did you? That night you stayed in the cabin alone?"

"It was on his watch-chain!"

"Huh?"

Roselani pulled Bill's watch from a pocket in her Bermuda shorts, and swung the seashell around on the chain. "They call this *puka* shell. 'Puka' means a hole through-and-through.

Onomea Bay has an arch cut by the sea, and that's a hole through-and-through. Besides, it's close enough to Hilo, where our folks lived. You can drive a truck there in an hour or two."

"And Quart Brewer's been growing sugar right on top of that bay, all this time," Clyde said with a grin. "He lookin' for it, too?"

"His missus was on the plane with us."

"Yeah? *She* stay lookin' or what?"

Roselani shrugged. "She knows we're goin' after it."

"But she thinks it's guns there," I put in, "left over from when your parents tried to set the queen free."

Clyde chuckled. "Dumb *haoles*."

Roselani stayed mum.

"What *about* that?" I asked her. "Was all that talk about statues and feather cloaks just a—"

"You gonna give me a hard time, Katy? I'll throw you—"

"Whoa!" Ivy yelled. "No *huhu*."

"Yeah. No *huhu*, Lani. Save it for Mrs. Brewer."

"Could she follow us?" I asked Clyde. "I saw her get into a taxi at the airfield."

Lillian insisted, "She doesn't know where we're going, unless somebody told her!"

Clyde shook his head. "She doesn't have to know. She can take a pair of binoculars and watch us from the train." He pointed at the railroad line inland. It didn't run along the shore. There didn't seem to be a shoreline, anyway: just cliffs and steep slopes—nothing flat enough to accommodate tracks, not even a strip of beach. Instead, trestle bridges spanned the valleys between the headlands. And so far, all those headlands had been tree-topped promontories jutting into the ocean. But now I saw one that was different. It looked (so help me) like a doughnut that's been dunked and stood up on the saucer, nibbled side down.

"Onomea Arch," said Clyde, throttling down the engine and edging us in toward shore.

The arch and its headland formed the northern side of a circular bay, perhaps half a mile across. The tops of those rocky

slopes and inhospitable cliffs rose a few hundred feet over the water. The sea's edge, below them, was a thin line of stones, brush, and small trees.

"If anybody's gonna come down from on top," said Roselani, "the only trail from the plantation is over there—" She pointed across the bay to the scraped-away edges of a zigzag trail in the hillside. "Give them an hour to get to the trail-head—we'll hear them if they're driving cars or trucks—and another hour after that to get down."

"Good!" That was Ivy. "Maybe we'll be here and gone before they reach the place."

"Oh, we'll be here," said Clyde. "But we won't be gone. When they show up, we'll have to...deal with them."

Roselani nodded. "I'm willing to give the Brewers a couple of things. They can donate them to the Bishop Museum while we take the rest to the Smithsonian. We'll all look like heroes. Are you all with me on that?"

"I'm glad to hear you say it," I told her.

"Hey!" That was Ivy. "Don't count your chickens. How the hell are we gonna haul it all out of wherever it is—a hole, right?—and get it onto the boat?"

"Is it heavy?" Lillian asked.

Roselani shrugged. "I don't know."

"What *do* you know?" Ivy demanded.

"I know what my parents told me. Every family brought something to our house, and one night, my parents and a couple of their friends hauled everything in horse-carts to a cave somewhere in the bay here."

"Hey! That little box of yours, with the feather—" Ivy said. "It's got a carving on the top. Does it show where the treasure is?"

"No. It's just a...oh, what's the word?—a reliquary. The feather was taken from one of the cloaks. It's there to remind us that—like the ōʻō bird—the Hawaiian people could go extinct, too. I...I'm supposed to say a prayer, after, and leave the feather for remembrance."

"That's very sweet," Lillian said quietly.

I brushed my hands together and said, "Okay. I'm ready. Where do we dig?"

"I don't know.

"You don' know where we 'sposed to start lookin'," Clyde repeated, "an' we got three, four hours, most, 'fore dark, to go get 'em?"

"I wasn't even born when they did this. I do remember my parents saying it took three horse-carts to transport it all."

Ivy made a whinnying sound. "Is everybody feelin' their oats?"

"Where we're going—" Roselani nudged her arm. "It's supposed to be on *this* side of the arch. So, look for a rock."

"A rock?" Ivy exclaimed. "I hope you know *which*!"

Clyde demanded, "An' what, Lani? Gotta turn over every rock on the beach?"

"I hope not."

"I think," said Lillian, "that we're looking for a pet...a pet what-d'you-call-it? A carving."

"A petroglyph?"

"Yeah. Like the one on that little box."

"No! It's just an old design," Roselani insisted.

Clyde snatched it up, brought it close to his eyes, and handed it back. "There are petroglyphs just like this all over. Every island's got 'em. It's how the Hawaiians made a family tree. Those three figures, largest to smallest—that's the grandfather, the father in the middle, and the son."

Lillian nodded. "That's what Bill told me. And that it's a traditional design."

"It looks like a totem-pole," I said.

"Or like circus acrobats," Ivy put in. "See 'em? Standing on the shoulders of—"

"No!" said Roselani. "Chang's right. It's grandfather-father-son."

There was quiet for a moment. "How big is this rock supposed to be?" Ivy asked.

Roselani shrugged. "I have no idea. If it isn't big enough to be seen from the boat, we'll have to go ashore to look for it."

"People *collect* petroglyphs," Clyde said. "If there was a really obvious rock with a carving on it, somebody's sure to have noticed it before now, and hauled it away. Miss Powell—"

"Yeah?"

"—I'll need you in the bow when we go in. Watch for rocks, and wave me around them. Hold on to the bow-anchor. You'll be dropping that first. Then I'll swing us around, and we can drop the stern-anchor."

"So we'll end up stern in."

"Right!"

The arch was the biggest thing in sight now. Its hole was maybe sixty feet in diameter, the promontory another sixty feet higher and a few hundred feet wide. There was no way to motor through the arch: stones and dirt and scrub grasses formed a rough beach at its base. (Like the crumbled bits of that soggy doughnut on the saucer.)

Clyde reversed the engine and slowed us down. "Let go!"

Ivy tossed the anchor out. It didn't take much chain along before it reached bottom and held firm. Our end of the boat, with its long, low deck, swung around, past the arch, and toward the adjacent shore. Clyde left the wheel, tossed another anchor off the stern, and cut the engine as soon as he got back.

The shoreline was a ledge of smooth black rocks and pebbles, and white chunks of coral. Where patches of brown dirt and rocks had tumbled down, the ledge sprouted wispy grasses. Thin saplings with mottled bark grew all the way up the face of the promontory, bearing dun-yellow fruits, many of which had fallen and broken open, exposing the pink of their insides that had fermented, pungent and cloying. By now, I had only to ask with my eyes for Roselani to answer, "Guava." She took up the binoculars that lay on the console beside the ship's wheel, scanning along the water's edge and up the sides of the promontories. "Can't see anything. We gotta go ashore."

Since Ivy was the only other experienced sailor, Clyde told

her to stay aboard in case of emergency. Lillian, who'd previously balked when the rest of us changed into slacks, finally acknowledged that her dress was a hindrance; she ducked below and emerged in Bermuda shorts.

There was no dinghy (or lifeboat!) so no way to get ashore except to wade in. But the deck at the stern was low and close to the water, for hauling in nets. The water was waist-deep, and cold; the rocks were slippery under my feet. I was grateful for the rubber-soled shoes.

We divided ourselves up, and fanned out to scour the shoreline under the arch and on either side of it, and as far up the cliffs as we could see on tiptoe. But after an hour, it was clear that there was no one special rock waiting for us to say, "Open, sesame."

"Can I ask a question?" I asked. "Are we...trespassing?"

"Nope!" Clyde shot right back.

"It's the Brewer company's land up there," Roselani said, pointing to the ridgetops. "But we're not trespassing if we stay on the ocean side of the high-water mark."

Clyde squatted down on his haunches, pushed a few small stones around with the tip of his finger, and said, "'S not here."

Roselani flopped onto a smooth rock beside him. "It *has* to be here."

"Maybe we shouldn't be looking for it, after all," I mused. "Maybe it should stay hidden."

"Too late for that," she replied. "Mrs. Brewer, or somebody workin' for her husband, knows we sailed up here. If they get hold of these things, it'll be over my dead body!"

"The Brewers," I said calmly, "were born in Hawai'i, too."

Roselani spun around. "Eh, *baole* girl! Shut up."

"How will you keep them from making a claim?" I waited a beat for her to answer, but she didn't. So I said, "Let's go over this again. What, exactly, are we looking for?"

She turned toward me. "Eh—you simple, or what? I tol' you 'ready. Hilo-side of the Onomea Arch. That's all I know. Except, I'm supposed to bring the box, too."

"And leave the feather as…an offering, a remembrance."

"Yeah."

"Why did your parents divide up the clues?" Lillian asked. "Why keep you *both* in the dark?"

"They expected us to work *together*."

"Too late for that," Clyde said. He wiggled his fingers at the box, said, "Lemme see," and she passed it over. He slid off the cover, touched the feather, then tapped the inside edges with the nail of his index finger.

Roselani puffed, half-spitting in frustration. "You think I haven't done that? There's no secret compartment."

He glanced up. "Maybe we should look higher up the hill."

"*You* start climbin', Chang."

I took the idea seriously, though, and said, "It might be worth a try. Would they have left everything right down here, close to the water, where there'd be storms and tides? Look at these boulders—" I pointed to the largest on the shore. "They must've fallen, some time. Anything smaller could easily shift around in a storm, or break loose and fall into the water. Maybe what we're looking for *is* higher up the cliff."

"How high?" Lillian asked.

I shrugged. "Maybe the carving on the box is telling us to stand on each other's shoulders—to go up the height of three men."

"Hawaiian men are tall," said Clyde. "Over six feet, easy. Figure three times six feet. Try look fifteen, twenty feet up."

Roselani peered through the binoculars again. "Nothing over here…nothing on this side of the arch."

"Try look *inside* the arch," Clyde suggested.

"Okay…looking up inside the…son of a gun!" She pointed into the arch, above our heads, where a clump of green leaves, yellow fruit, and mottled branches was especially thick. "How'd all that guava get in there? No way fruit and seeds could fall down from the top and then get *up* inside the arch! Somebody had to plant it."

"I goin' get a cane-knife." Clyde waded back out to the boat,

calling to Ivy to take it out from under one of the cockpit seats, along with a second coil of rope. She handed both to him. He undid his belt as he waded back to shore, threading it through a leather thong that ran through a hole in the cane-knife's handle, and rebuckled the belt.

The arch was like a tunnel, twenty feet long, running north-and-south. So, standing inside it was like standing under a bridge, or inside one of the overpasses in Central Park, only larger: the twenty-foot-long sides arced inward and met about sixty feet up.

Clyde called, "Somebody'll have to go up with me. I'll take the south side of the rock. Who wants to climb the north?"

He was looking at me—I was clearly the most athletic of us girls. I shrugged and raised my hand.

"Wait here," he said. "I better go up first." He called back to Ivy to secure the other end of the rope somewhere on deck, which she did. Then he tied his end around his waist, took hold of the lowest-hanging guava saplings, with their mottled bark, and hauled himself up until he found a foothold in the curved wall, on an outcropped rock.

Only then did I realize he was barefoot! His feet were enormous, and thickly calloused—probably tougher than any sandal. He climbed to the edge of the patch where the vegetation was thickest, and called down, "I see a rock underneath! Maybe three feet wide. Gotta clear the brush. Miss Green, come on up. Gimme a hand."

I climbed, in much the same way as he had done. The wall wasn't as steep as it looked from below, but once the arch started curving inward, I was forced to use the guava saplings to hold on to and stand on. And whenever I touched them, overripe fruit shook loose, dropped to the ground, and shattered open. If *I* fell, of course, *my* pink insides would burst, too!

When I reached a spot about twenty feet up, on a small outcrop that was big enough for both my feet, Clyde held on to a branch with his left hand, untied the cane-knife from his belt with his right, and began striking at the mottled guava branches

and trunks. Eventually, he cleared enough away to reveal that the rock was even bigger than he'd thought: almost *four* feet across, and had bits of moss clinging to it.

"Check that side, Miss Green. Does it look like it was *put* here?"

Holding on to a sapling with my right hand, I edged close to the rock. The flat layers that comprised it did not line up with the layers of the surrounding wall of rock and earth. I edged up a couple of more inches, so I could see the top of it, and I ran my hand over it, just to be sure. "*Ha, ha, ha!*"

"What is it?"

"There's a bump on it, with a hole that goes right through the bump—like the arch itself! Or like one of those stone canoe-anchors I saw, back at Hilo Bay!"

"Okay!" he called down. "They came from up on top, and lowered everything down with ropes."

"It must have taken two people, at least, maybe more," I added, "one from the north end and one from the south. They swung themselves into the opening, here, filled the hole up, and then pounded this rock into place, to seal it."

Clyde undid the rope from around his waist, held on to it a few feet back from the end, and tossed it to me. On his second toss, I caught hold of it, and—though it took six attempts—I stuffed the tip-end into the top of the hole in the rock, and pulled it through from the bottom.

"Fo'get the knot," he called. "Jus' ride 'em down."

"*Ride* it?"

"Hang on to th' rope, and jump."

My first thought was, "The hell I will!" But it wasn't too far, and indeed, friction kept it from running through too fast. I actually got a thrill, working my way down—backwards, half-stepping, half-jumping—until Lillian took the rope from me, patted my cheek, and said, "Weren't you worried? The rock might have pulled right out on top of you!"

That took a second to register. *She was right!* But I was so exhilarated that I laughed it off. "Well, don't *you* stand underneath!"

"I won't." She stepped away, crossing gingerly over the guava-encrusted beach stones, as though she were playing hopscotch.

Clyde called down, "Miss Green—make a knot that'll cinch tight on the rock. Then go walk the rope out to th' boat. *Miss Powell!*"

"Yeah?"

"D'you know what is a block-an'-tackle?"

"It's a pulley and a rope."

"All right! Up in the forepeak. Go get, yeah? An' hook up the rope. In the cockpit, you see th' winch?"

"A motorized winch?"

"Right. There's a handle, and a button fo' press 'em."

"Okay. I see it."

"Good. Make fast the line, and we goin' yank that rock outa that arch."

She chirped, "Aye aye, skipper," and jumped to do it.

When the rope was secured, he yelled to me, "Stand aside!" and then, toward the boat, "Geev 'um, Miss Powell. Haul away!"

The engine whined, and the rope grew taut. At first, it pulled the *Ka Leo* toward shore, but once the boat was stopped by its anchor-chains, the rope grew taut. Actually, it tightened and slacked, again and again; each rebound making a noise like *thunngg*. I chuckled, and shouted out, "Ivy! You're playing a really big bass now!"

"Twelve-bar blues in E! I called it!" she shouted back.

Suddenly Clyde yelled, "Stop!"

Ivy threw the winch into neutral. The rope slackened and drooped. The *Ka Leo* bobbed in the water.

"We better loosen the dirt around it. Miss Green, can you dig with something?"

"Uh, sure." I tore off a guava branch, a little less than an inch thick, and climbed back up to where I'd stood before. He did the same, and we edged along our respective sides of the rock, poking at the dirt around it. He climbed down a couple of feet,

and scraped the underside, then he edged away and called over his shoulder, "Haul away, Miss Powell!"

Ivy put the winch in gear again.

With a slight shudder, the rock lost its footing, and yielded to the tug of the *Ka Leo*. Glancing off an outcrop just beneath, it flew over Lillian's and Roselani's heads, out of the arch's tunnel, and plunged into the water a foot or so off the stony ledge.

Clyde slid over toward the unplugged hole. For the first time in almost an hour, he could stand on both feet—taking advantage of an outcrop beneath the hole. But he was still too far below it to see inside.

I could see only the opening. Clyde motioned for me to get closer, so if I couldn't *get* in, at least I'd be able to *look* in. I worked my way up again, over to where I'd hung on to attach the rope, and edged sideways until I could peer inside....

(I have a confession to make. For all my skeptical carping about this "treasure-hunt," when I finally got to look in the hole, I was really hoping it'd be—you know—Ali Baba's cave full of *treasure*.)

But that's not what I saw inside. It wasn't gold and jewels, or money, or statues, or feather cloaks. It wasn't even guns and ammunition. It was a stack of logs.

"Firewood!" I called out. "Maybe as much as a cord of logs. I can't see behind them. It's too dark inside."

"Can you clear the logs away?"

"The closest ones, maybe."

"Try it."

I stuck my arm in, and jiggled the nearest one loose. But three on top of it shuddered down and tumbled out, just missing my head—I gasped, "Sorry!"—as they dropped the twenty feet to the ground below.

"Let's go down and make a plan," he said, then looked down at Roselani. "What about the firewood?"

"Nobody ever said."

"Maybe you were supposed make a *signal* fire with the wood," I suggested.

"Inside the arch?" Lillian asked.

I pointed. "On top, more likely."

"Sure." Roselani nodded. "You can see this headland all the way from Hilo, and on up the Hāmākua Coast for another thirty miles."

"But I thought it was supposed to be a secret."

"Until *now*, Lillian," said Roselani. "Once we got here, we'd need help to haul everything away in boats or trucks. My parents probably expected people to come help—and they *would* come, if they saw a fire here."

"Are we going to make a fire?"

"Lillian!"

"I was only asking!"

Clyde reached the ground, and called, "Come ashore, Miss Powell, an' bring the lantern, yeah? No twilight in Hawai'i," he added for our benefit. "Comes sunset, it gets dark in a hurry."

Ivy retrieved the lantern from the cabin, and held it over her head as she waded in—the water came nearly up to her shoulders—and set it down beside Clyde. "Here's what I think," she suggested. "Take the rope up again, only this time, loop it over one of those little tree-trunks above the hole. Then we can *all* get up there, holding on to the rope."

"Good thinking!"

"I've got another idea, too," she said. "After we've tossed the firewood out, we can tie on one of your fish-nets from the boat, load the stuff from the back of the hole into the net, and lower everything down gently, with the winch."

Clyde gave her a big smile.

"Uh, I'm not going to climb up there," said Lillian. "I'm scared of heights."

Roselani nodded. "Okay. You and me, we'll stay here, and toss the logs aside as they come down. Or stack 'em up, if you like. Just don't stand where you could get hit. And keep *this* area clear, right under the hole, so we can rig the net, after."

But the hole was too small; only Ivy could fit inside. Clyde

remained below; I got back up to where he'd perched before, while Ivy took my route up, hoisted herself onto the little ledge, and went inside, head-first.

"The floor's level, but the ceiling's too low, even for me!" she called. "I can't straighten up." Nonetheless, she managed to pull out a few logs at a time, and I pushed each one over the outcrop to make it fall straight down, though only about half of them did that. The rest bounced off the rocks and into the water. Whoever was closest below picked up each log that hit the beach and tossed it onto a pile against the cliff.

"This is crazy!" Ivy declared, after she had cleared the first few feet into the cave. "There's enough wood in there for a bonfire."

"Let me see." I stretched and peered. There was still half a cord or so inside, branches neatly hacked off, and the logs stacked cross-wise, so they wouldn't rot. "What's so crazy?"

"There's thick ones and thin ones in the same pile."

"Just like the Sarongs!"

She inclined her head and smirked. "And none of the big logs are split."

"Hey!" That was Clyde. "We're waiting! Everything okay?"

"Keep 'em comin'!" Lillian yelled.

Ivy went back to it, but not without muttering, "What a waste of time—all this scut-work. I need a breather."

She joined me at the mouth of the cave, and sat down on the edge with her legs dangling over.

"Coffee break?" That was Roselani.

"Gimme a minute!" Ivy retorted.

"Somebody could come, any minute!"

Ivy tilted her head. "I don't hear anything. Are there trucks up on top?" They looked up, but none of us heard anything

Ivy scuttled, crab-wise, back into the hole. But after almost half an hour she declared, "That's the last one," and came and sat on the edge again.

"How about the treasure?" Lillian called up.

Roselani added, "What's in back?"

Ivy panted, mopping her brow and neck with her shirtsleeve. "Nothing."

"What're you saying?" Roselani demanded.

She waved her hands toward the logs, afloat and ashore. "That's everything."

"Nothing further back?" said Clyde.

Ivy leaned over and fluffed brown clouds out of her hair. "Just a lotta *dirt*! And tree-roots."

"Okay. Come on down. Both of you."

Only when we'd reached the bottom did I realize how tired I was. My hands and feet tingled, from having had to grip and hold positions for too long. And my back was strained from twisting around to steer all that wood down. I sat with my back to the cliff, knees bent, and closed my eyes.

I heard Lillian say, "Is it too late to go see the volcano?"

Clyde ignored her and glared at Roselani. "There must be another hole!"

"This is it. Don't look at me!"

"Why not? You got it wrong, obviously."

"I know what I was told. *You're* the one who said, 'Go up three lengths of a man'! Hey, Lillian! D'you want the box back?"

I opened my eyes. The box missed Lillian by a couple of feet, and landed on a rock, knocking its lid off and cracking the mucilage. The feather wafted out, toward the water, and Lillian swiped at it four or five times until she'd caught it in her fist. She held it to her chest, panting, then slid it into a cup of her brassiere. "Maybe Bill knew something that he never got to tell us, because he's dead."

"Shut up!" Roselani said it in a half whisper, close to her face.

"Is that all you can say?"

"*Shhh!* Listen."

I froze. We all did.

It was a truck motor, growing louder, gears shifting—making the engine run faster. It was coming downhill. We looked up. Headlights flickered at the top of the cliff. Suddenly, the motor was cut, and a couple of doors slammed.

"They're gonna come down the 'z-trail,'" said Roselani.

Ivy looked around. "Let's get out of here."

Clyde shrugged. "Cannot. Too dark to see the rocks. We stay sleepin' here, go Hilo in th' morning. You girls wade out, take the bunks. I stayin' ashore, just in case.... "

"I'm hungry," said Ivy. "Have you got any food on the boat?"

"Now *there's* a good idea," I said. "Let's have something to eat, and decide what we're going to do when they reach us."

Clyde shrugged. "One *akule*—that's a fish—in the ice-chest. Got *poi*, in a calabash, and some bananas."

"Is there a frying pan?" Lillian asked cheerfully.

"Yeah," he replied, "but the kerosene stove never work."

"So what?" Lillian said.

"So what?" Ivy taunted her. "You're gonna eat raw fish?"

"We have all this wood. We'll make a fire. I'll cook."

Roselani looked around and complained, "There's no tinder."

Lillian picked up a log. "It's been in a hole, out of the rain, all these years. It should be dry enough."

Clyde added, "Got kerosene in the lantern."

Roselani waded out and back, retrieving the frying pan, the fish, the *poi*—in a hollowed-out gourd—a hand of bananas, and a bottle of Coca-Cola. The rest of us made a ring of large beach-stones, and laid in a couple of the smaller logs. Ivy dribbled kerosene onto them. Clyde struck a match on a bare rock, cupped it against the breeze, and squatted down to touch the flame to the damp spots on the logs. The kerosene caught right away: smoky yellow flames danced over the logs. The sticks were dry enough for the bark to crackle and sputter, but the wood beneath did not catch fire, and when the kerosene was consumed, not even smoke remained.

Roselani huffed, "Like I said: no tinder!"

I stood up. "Hang on. I was a Girl Scout."

Roselani cackled. "That figures!"

I snatched up the dead twigs from the guava branches we'd hacked down earlier, and broke them into bits with my fingers. They burned well enough, but try as we might, the firewood did

not catch. Clyde insisted on keeping his last three matches in their screw-top safe, just in case.

By then, we could see two lights (only two? I'd expected more) moving down the z-trail; they threw no long beams—lanterns, probably.

Roselani glanced up, decided that trouble hadn't come close enough yet, and went back to complaining. "Like I told you before: this is the rainy side of the island. It's hard to find really dry wood over here. And—" she waved the Coke at Clyde "—I couldn't find a bottle-opener on your boat, either."

"Aw, gimme that!" Ivy grabbed the bottle, stuck the top in her mouth, and pried off the cap with her teeth! I shuddered. Clyde, however, laughed out loud, and congratulated her with a hearty clap on the back.

The *akule* was only about the size of a trout, and had to be shared among five people. Clyde shaved off the scales, skinned and boned it with a pocket knife, and rinsed the fillets in the water. "Fish and *poi!*" he called out. He broke off a chunk of *akule*, dipped it into the calabash with his fingers, and—like Jack Horner—pulled it out with a plum-size blob of *poi*. I grinned, until he tossed the fillet to me, and I realized I'd have to do as he did. Well, I'd eaten clams and oysters on the half shell. I was game for raw fish. I pinched off a piece from the tail end, scooped up a little *poi* on the tips of my fingers, and put it all in my mouth.

I guess I liked it, because after I'd passed the fillet to Ivy, I wished I'd taken a bigger bite. Ivy rolled her eyes up, took the plunge, and—though I didn't believe her—said, "Ummm!" Lillian needed half a minute to overcome her squeamishness, and nibble a little of each. Clyde grabbed half a dozen guavas and passed them around. He ate the skin, flesh, seeds, and all, so I did, too.

"Is there some *other* place," I asked, "that might have been—"

"Maybe we just didn't get our bearings straight," Lillian suggested.

"Suppose it was low tide, or high tide, when they picked out

the hole," said Ivy. "Only it's the opposite tide now, so we aren't starting from the same place that they—"

"Not much difference between high and low tide, in the middle of the ocean," said Clyde. "Most days a foot, maybe, up or down. And the—"

"Wait!" Ivy interrupted. "Didn't we figure out that they lowered everything down from the top? Maybe we were supposed to *start* up there?"

Roselani shrugged, glanced at Clyde, then sighed, and sat back with her eyes closed, in a silent admission that Ivy might well be right.

"It still doesn't make sense to me, though," I said. "If your folks took the trouble to stuff a hole full of wood for a signal-fire, then the thing they were trying to signal about ought to be close by."

"Yeah, and if they wanted us to start a bonfire," Ivy added, "why didn't they split the logs, or leave some tinder?"

"That would've taken more time," Roselani said.

"Did they expect us to strike flint on stone?"

"Ivy! The Hawaiians weren't *savages*, banging rocks together."

"No! But they must've thought—"

"We didn't bring enough kerosene, that's all," said Lillian. "We should've brought a carboy."

"Or an axe," Clyde tossed in.

I turned to Roselani. "Did your folks tell you to bring an axe, or kerosene, or a torch? A box of matches, even?"

"What are you getting at, Katy?"

"Clyde—"

"Yeah?"

"Can you split one of those logs with your cane-knife?" I asked.

"Sure."

"Do it."

He grabbed one that was three or four inches around, stood it on end on a flat rock, and—to impress us, I'm sure—waited until the last possible moment to snatch away the hand he held

it with, as the blade came whipping down. The log parted about halfway, and the knife stuck tight. Clyde smiled, lifted the log up with it, and pounded the butt end down on the rock until it split open, down to the heartwood. And in an instant—with the drawing of a single breath—that sweet aroma…

It was sandalwood.

Ivy was quickest. "This stuff is worth a fortune!"

Roselani said, "Don't let *them* get any!" and picked up four logs.

Clyde snarled, "Like Bill was tellin' you, all along, eh, Lani? It's for *sellin'*!"

"Damn right!" Ivy grabbed four more, and stacked them on Lillian's outstretched arms.

Clyde strode into the water. The floating logs, confined by the bay, had stayed close together and not far from shore. "Miss Green—try catch 'em, yeah?" He pushed against a few pieces from one side. I waded in, swinging one log like a tennis racquet, to knock others into a loose raft that I urged toward the *Ka Leo*.

Lillian walked her armful out to the boat's stern, and tried to lift them over the rail.

"Just toss 'em in like fish!" Roselani called.

"No!" That was Clyde. "You might break somethin'. One of you—get in there."

"That's me!" Ivy hurried out through the water. Strong in the arms, but not weighing much, she hauled herself up to the rail, hooked first one leg and then the other, and slid over the transom on her stomach. Once she was in the cockpit, she took hold of the logs Lillian held up, then caught the ones Roselani tossed her. But she couldn't reach down far enough to grasp the floaters that Clyde and I had nudged toward the boat.

Reversing what we'd done in the hole, I passed two at a time up to her. A few got away from me, but I ignored them, and drew as many as I could from the densest group. Clyde, staying just beyond, pushed the stragglers back my way.

By then, two people bearing carbide lanterns had reached the foot of the trail, and were scrambling over the rocks toward us.

"Eh, Clyde! That you?"

Clyde stopped. "Jeremy?"

Roselani touched Clyde's arm. "Who's that?"

"Jeremy Waiau—you remember him? Went to Hilo High wit' us. He's a cop now."

"Sheesh! He's Bill's best friend! Hey, Jeremy—you was expectin' Bill, or what?"

"Yeah. He figured I'd know about old guns—how to keep 'em safe, and all."

"Well, there's no guns."

"I like see for myself, yeah?" the cop called. "Stay there. I comin' over."

"We're on the ocean side of the high-tide line!" Roselani yelled back. "Not on private property."

"Nobody said you're trespassing!" That was a woman's voice. Nan Brewer's voice! "But you've got to stop loading those guns on board."

"There are no guns here!" Roselani called out.

"Eh, Lani. You maybe like see the warrant? Mrs. Brewer went swore out the complaint. Now, I *gotta* look-see. It's o-fficial."

He had reached the shore, nearer to me than to her: a rugged man with a blue uniform and a holstered gun, shorter than Clyde, but heftier. Nan Brewer followed, in jodpurs and leather hiking boots, and (*uh-oh*) a holster on her belt.

"Don't try shooting off the guns. They're beautiful old things, I'm sure. And maybe some of them still work. But they're *so* old, they could explode in your face."

"Who's got 'beautiful old guns'?"

She was exasperated. "We've been watching you load them into the boat! You and Miss Green are corralling the long guns, wrapped in dark cloth. The pistols are in those smaller, thicker bundles that Miss Vernakis is handing up to Miss Powell right now, in the cockpit. Tell me: are there any really *old* pieces? I've alerted every collector I know; they're all ready to buy, although there is one fellow who's looking for a certain type of—"

"They no more guns!"

"Sorry, brother," said Officer Waiau. "Got the warrant, yeah? We stay searchin' you' boat. No *huhu*, okay?"

"Okay," Clyde declared. "You go search 'em. An' any gun you find—it's yours, brother, for *keep* 'em. But mo' bettah you wait for daylight, so you make sure you stay *seein'* right."

"I no more like waitin', brother. I like get home 'fore morning. All of you folks—stop what you doin'."

"We don't need to wait. I'll just *make* daylight." Mrs. Brewer pulled the gun from her holster, and I tensed up. But it was a *flare*-gun. She pointed it at the sky, and a red comet *whoosh*ed up from it, as high as the headlands. Atop its arc, the flare burst, illuminating the bay like a flashbulb for a few moments, before slowly fading.

Clyde shrugged acceptance, and headed for the beach. I was closer to the boat; I hoisted myself aboard, as the cop waded into the water. Ivy gave Lillian a hand, and helped her over the low stern into the cockpit. Only Roselani stood still, halfway between the *Ka Leo* and the shore.

A second flare went up, just as the cop hoisted himself aboard. We stepped out of his way, and let him look around. A third flare went up, and we could see he was puzzled. There was no mistaking the log piles in the cockpit for anything else. He glanced around again, shone his lantern down the ladder, and went below.

Lillian started lining up the logs, as a fourth flare was launched. But this one misfired, sputtered and spiraled down, trailing orange flame, nearly hitting Lillian in the cockpit, and spraying glowing bits of cardboard and phosphorus all around.

"Jump!" the cop yelled from below, as he scrambled up the ladder.

"But everything's wet in here," Lillian protested. "The wood won't burn."

Ivy screeched, "Gasoline burns! Come on!" She grabbed Lillian's hand and yanked her over the rail with her.

I grabbed up my shawl and ran to the rail, worrying only for a moment if I might hit one of the rocks in the water. Then I took

the plunge. I struck out with my arms in a makeshift Australian crawl, until the water was shallow enough that I could run faster than I could swim. But by the time I stumbled onto the shore, and looked back, the wheelhouse of the *Ka Leo* was aflame. Jeremy Waiau, arms spread, kicked off into a shallow dive, hit the water, and swam hard.

A cacophony of hisses and pops accompanied the sparks that issued from the sandalwood logs as they did, at last, catch fire. A few seconds later, something fell, burning, into the engine compartment, and a sheet of flame shot out through the cabin door.

Ivy and Lillian, wet through-and-through, open-mouthed and panting from exhaustion, waded onto the beach, and turned around to stare. By then, Roselani had come ashore; she and Clyde flopped down, side by side on the shore, holding hands. I sat back against the cliff beneath the arch, knees up. My shawl was soaked, but it was wool, and warmed my shoulders a little. Nan Brewer continued to stand where she'd stood all along, staring into the bay.

"Tide's going out," Clyde remarked to no one in particular.

"We'll never retrieve more than an armful now," said Roselani.

The cop stood still, helpless.

There was something vaguely beautiful in the sight, like fireworks. The *Ka Leo* didn't explode, exactly. First, flames popped out of odd places on the boat: a bright crack would appear in the hull, and a moment later, it would spurt flame.

When the gas tank did, finally, blow up, it burst apart—but not with a bang—more of a *whump*. Nevertheless, it took the whole top of the boat right off, and hurled flaming logs into the air. They fell in a spreading ring of small fires that hissed out as they dropped into the water, and drifted away on the tide.

# Thursday, December 4

ABOUT THE HIKE UP THE TRAIL, by the light of one lantern, clothes soaking wet—shoes, too—the less said, the better.

❀

The sun hadn't yet come up when we reached the top, but rather than wait for the first Hilo-bound train of the day, Nan Brewer and Officer Waiau drove us back in their cars. The road was narrow; the bridges had only one lane; and along many cliffs, tall palms served as posts for a thin wooden rail that—if not *kept*—at least *discouraged* cars from plunging over. Pink guavas lay thick on the ground all the way to town, almost overwhelmingly pungent in the humid air. A few houses clustered into villages along the way, with tiny storefronts still shuttered for the night, and gasoline stations behind antique pumps.

Motoring into Hilo, over a river bridge, we saw a dozen fishing boats putter across the bay, bringing in their night's catch. Behind them, the sun emerged pinkish gold from under gray streaks of clouds at the horizon, and for a few minutes, turned them yellow-gold, until finally rising above them. With that, the exotic colors paled and faded into plain old daylight.

I've always thought that sunsets are when the best colors come out. And I don't get up early if I don't have to. But that sunrise in Hilo made me wonder what I might be missing.

We ate the local breakfast special—fried eggs over scoops of rice, with brown gravy—at a little eatery the cops liked. But we spent the rest of the morning and most of the afternoon at the police station, explaining what had happened the night before. After much repetition, and a few beers from the station's icebox, we all agreed that it was an unfortunate accident. And Nan Brewer left, to catch an airplane back to Honolulu.

Some of the cops' wives had gotten wind of our predicament, and showed up with Victorian dresses they called *mu'umu'us*, that covered everything from neck to ankles. We wore them while our clothes were hung out to dry. We had to borrow soap and tooth-powder, too, since our overnight kits had also been lost.

Roselani had expected us to be hauling treasure, so she'd booked us passage back to Honolulu, not on the airplane, but on the overnight steamer *Hualālai*, a noisy tub, only half the size of the *Lurline*, that rolled at the mercy of rough seas in the channels between the Islands.

I stayed inside on a couch, near the center of the ship, where the motion was least apparent, sometimes sleeping, but more often wishing I could sleep. I didn't have an appetite, even by dinner time; and by nightfall, none of us had much to say to each other.

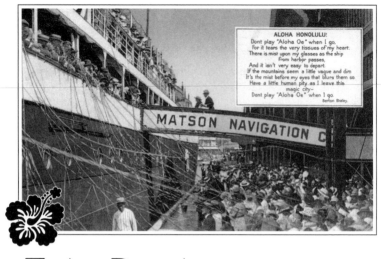

ALOHA HONOLULU!
Dont play "Aloha Oe" when I go.
For it tears the very tissues of my heart;
There is mist upon my glasses as the ship
    from harbor passes,
And it isn't very easy to depart.
If the mountains seem a little vague and dim
It's the mist before my eyes that blurs them so.
Have a little human pity as I leave this
    magic city—
Dont play "Aloha Oe" when I go.
                        Berton Braley.

# Friday, December 5

FROM WHERE THE *Hualālai* docked to where the *Lurline* was berthed, Honolulu Harbor was lined with military trucks carrying young men in army khakis and navy whites.

"Hey, driver!" Ivy leaned forward in the taxi. "Are we at war?"

"Naah!"

"Maybe the boys are on maneuvers," Lillian suggested.

When we reached the Aloha Tower, we found an enormous crowd of servicemen going aboard, but also dozens of young women—their wives—clutching babies or tugging small children by the hand. Everybody carried luggage, too, and nearly everyone (except us) was wearing a flower *lei*. The Royal Hawaiian Band played marches and waltzes, and some Hawaiian numbers, to which a dozen young girls in floral sarongs and *mu'umu'u*s performed a hula.

Ivy spotted Stan O'Malley at the foot of the gangway and edged her way through a phalanx of Oriental men in uniform, armed with long rifles, who stood at ease but alert along the pier, with their backs to the ship. "What's going on? These guys look like Japs!"

He lowered the clip-board he'd been holding; the pages flut-

tered in the warm ocean breeze. "A lot of 'em *are*. But they're the local kind. This is the Hawai'i Territorial Guard, and they're here to watch for saboteurs."

"And all these army and navy boys?"

"Routine transfers Stateside. Plus that, the top brass've ordered an evacuation of all non-essential personnel and dependents, wives and children."

Lillian said, "We'll have big crowds for our gigs!"

"It'll be crowded, all right," he replied. "The government has a longstanding arrangement with Matson. They can requisition our ships."

"They didn't give you much notice."

"Actually, Miss Powell, it was no surprise to us. Our sister ship, the *Matsonia*, is going out of service next month, for conversion to a troop carrier. You'd have known about all this yesterday, if you'd been where you were supposed to be."

"Huh?"

"At the Alexander Young Hotel. We got the word out to all the other people, but you and your girls weren't there."

"I didn't think we—"

"You didn't think, all right, Miss Powell! Come see me after we're under way."

We trudged up the gangway to the Cabin Class Promenade on Deck-C. While we'd been on the Big Island, the army and navy had turned the Cabin Class Lounge and the First Class Dance Pavilion into barracks. Rows of cots and double-decker bunk beds covered the floors. Dozens of soldiers wrangled their duffel bags, knapsacks, and rifles through the maze; others relaxed on mattresses, wearing nothing but dog-tags, undershirts, and skivvies.

"That'll put a crimp in our floor-shows," I said.

Lillian chuckled, "Oh, don't worry! The men'll clear a space for us, and cheer like they've never cheered before. Wait'll they see Roselani do her hula! Ever put on a show for men in uniform?" I shook my head. "A lotta wolves'll give us the whistle, but the MPs'll keep 'em from biting."

I felt uncomfortable sharing a room with Roselani again, though not enough to demand new arrangements. She may have felt the same way, because we just went straight back to 533 without a word, tossed our stuff onto our bunks, and changed into fresh clothes.

The moment came, though, when we began eyeing our instrument cases. We'd gone two days without playing, and needed to warm up. But only one of us at a time could use the cabin for a "woodshed," to practice in. I let her have it first, and she got out her pancake guitar.

It was almost noon anyway, and I wanted to go up on deck, partly to watch us leave, but also…

I stood at various places on various decks, until I saw him beside a rail, smoking one of his hand-rolled cigarettes. I waved and joined him.

Below us, uniformed servicemen were still wending their way aboard from the crowded dock.

"Got a date for tonight?" he asked me quietly.

"I hope so."

"I heard what happened. Stan got a call from the Hilo cops; they wanted to know if you girls really worked here. Did Nan Brewer make everything all right?"

I looked away and gave my voice a sarcastic grate. "Ye-e-sss."

"Didn't she?"

"She never once said, 'I'm sorry.' She got out a checkbook and a pen, and gave Clyde ten thousand dollars for a new boat. Roselani got the same, for all her efforts."

"What about you?"

"Ivy and Lillian and I each got a thousand. I assume there's some policemen's ball in Hilo, or a *lū'au* or something, that also got a generous check."

"Then it *is* all right."

"Well, *our* checks are drawn on a California bank; we can't cash them until we get back. Kind of an incentive to *not* bring up the subject on this trip, wouldn't you say?"

"Would you rather sue them?"

"Where are they, by the way?"

"She's coming back with us. Quart's on his boat. I talked to him by radio-telephone this morning. He left for Frisco yesterday."

"I bet it's bigger than a 'boat.'"

"Oh, just a little! It's eighty-five feet long."

"A yacht's a rich-man's toy, all right. Is it fast?"

"Yes, and he has a head-start; but we'll catch up and pass him tomorrow or Sunday. He has to follow the same track as the *Lurline*, which private yachts don't usually have to. But these days, the navy patrols the shipping lanes, and they won't guarantee any track outside of them. Of course, we don't want to run him down in the middle of the night, either." He waited a moment. "I'm sorry about your 'treasure-hunt', Katy."

"Stan told you about that, too?"

"He and Nan, both. It was a nice little dream. But you mustn't feel too badly. You came away with a thousand dollars, and you didn't get hurt. I'm glad." He took my hand—I liked that. "You'll be pleased to know that Danny Boy Ohara has made bail. His attorney filed a writ of *habeas corpus*, so unless the Line can produce hard evidence against him, the charges should be dropped."

"That's good news. D'you think we'll be off soon?"

"We'll be late. We have to wait for everybody there—" he pointed toward the servicemen below us "—to get on board. I wouldn't hold my breath for a noon sailing."

"Do you have to take on extra medical supplies for them? Bandages? Aspirins?"

"Only some ointment for athlete's foot; and Salvorsan for—"

"I know what it's for!" I laughed. "I'd better go down—"

"When we do get underway," he interrupted, "you'll want to come up here again, and watch from the deck. Leaving Honolulu is a much bigger occasion than leaving San Francisco, believe me. Everybody wants to come back to Hawai'i. I know I do."

In so many words, he had just asked me a serious question. I nodded. "Me, too."

We smiled, and he drew me closer. Then we kissed. A "French" kiss. He reached up with his free hand to caress my cheek, then my temple and my hair....

I pulled away from his mouth long enough to say, "I'd like to see you after work tonight." Then I slid my lips and tongue up to tickle his ear.

He whispered, "I'll be there for your last set."

We kept on necking for I don't know how long, until somebody wolf-whistled. A couple of sailors were pointing up at us. I stepped away, brushed my hands down the front of my shirtwaist, and gave him a big smile.

He touched his forehead—a sort-of bare-headed tip of the hat—and said, "Tonight..." and walked away.

I leaned against the rail, to let out the breath I'd been holding for what seemed like minutes. Who says a girl shouldn't make the first move nowadays? If he was hesitant to respond at first, well, that was just his way. Good men—real gentlemen—*aren't* "all hands," and they don't think you're easy if you smile at them. Mature men like him have manners, and they're considerate of a girl's feelings.

Maybe I had been on a treasure-hunt after all! He was even on my side about Bill, in agreeing that Danny Boy was innocent.

Or was it all an act? Was he the kind of heartbreaker who goes trolling for shipboard romances, and leaves his fish flopping and gasping on the dock when he sails away? I was ready to give in to him. But would it turn into the kind of love affair you read about in *True Confessions*?

❀

Noon came and went. They served us lunch, but just as I was getting a second cup of coffee, a steward picked his way through the Cabin Class Dining Saloon, and handed me a note: Stan O'Malley wanted to see me.

I remembered the way.

His door was open when I got there, and he waved me into a

chair. "I'd like you to share what I'm going to tell you with the rest of the Sarongs."

"Ivy's the bandleader. Didn't you want to tell her?"

"I already did. But this came in an hour ago." He passed me a sheet of mimeographed instructions. "There's going to be an emergency drill, and you girls are assigned to help people get to their lifeboat stations, calmly and quietly."

"The servicemen, too?"

"Everybody."

"When will this happen?"

"It wouldn't be much of a drill, if I told you! Or if the army and navy brass told *me*, either! They'll tell the captain, and he'll tell me, just before he makes his announcement over the loud-speakers. You just be ready. It could come any time."

I put this together with what I'd seen on the dock. "Do you think Japan is going to invade the Islands?"

He waited a moment. "If I were the emperor, I wouldn't stretch my supply-lines this far east, until I owned the whole coast of Asia. So, *me*? I wouldn't do it. But of course, I'm not the emperor; and frankly, Miss Green, it wouldn't surprise me if he did try to take Hawai'i someday. I don't hold with everything Mr. Brewer says—I think you know that. But he makes a good case for keeping a weather-eye on Japan. I'm sure none of our generals or admirals trusts Hirohito to be rational!"

"But if they're sending servicemen's wives and children back to the States—"

"It's a prudent move. Why put them at risk? Get everybody safe, so in case the shooting starts..." He looked past me toward the door, and lowered his voice, though I couldn't see or hear anyone outside. "Look. My friends in the Guard—the guys I was with on the dock, today—*they've* been told to get ready for a full-scale practice alert in Honolulu. Could be the same time as ours. One big drill, on land and sea both. We'll be just a little part of a bigger, coordinated picture, but my job is to make sure everybody on the *Lurline* is on the ball. The crew'll man the life-boats. You landlubbers—the social staff, the waiters, the cooks,

the entertainers—everything you need to know about what to do in an emergency, or a drill, is in those briefing papers. Just make sure everybody moves quietly and calmly up to their life-boat stations. So, the crew have their orders, and now you've got yours."

I suppressed the urge to salute. But instead of a nervous giggle, I asked, "What happens during our drill?"

"The captain gets the radio message, and gives me the signal. The sirens start up, everybody puts his life-jacket on, the crew uncovers the lifeboats and slings them out, the watertight doors are closed, and all radio traffic is suspended, except for S.O.S.'s and emergencies. In my opinion, Miss Green, and it's strictly my opinion, I don't think we'll get the alert on *this* trip. More likely, it'll come on Christmas day."

I squinted. "Why Christmas?"

He grinned, and suddenly flipped his clip-board up flat against his belly, strummed it like a *'ukulele*, and sang: "Washington at Valley Forge...Vo do-de-oh do!" (I got it. Washington crossed the Delaware on Christmas morning, and caught the British and the Hessians with their pants down.) "Most likely, this'll be just another crossing, like the last one. Well, except for—"

I said, "Yeah. Except for finding a man beaten to death, and—"

"And we got the guy that did it, Miss Green. Thanks to you."

"Umm, I have to apologize again, for making you look for John Kemp. And the oar, up on the Sun Deck."

"Apologies accepted. But the next time you see a wild goose, go chase it yourself."

"And cook it?"

He chuckled. "Stick to playing music. Don't play detective."

"I didn't intend to! But..."

"But what?"

"Do you really believe Danny Boy Ohara killed Bill Apapane?"

"It's not for me to say. He'll be arraigned on Monday."

"If it was somebody else, though…" I didn't want to say who I thought that might be.

"If it was, he's off the ship and gone two days now. You don't think he'd be crazy enough to ride *back* with us?"

"Is anybody riding back with us who might have known Bill on our way over?"

"Frank Todd, his wife Miriam—"

"Besides the crew, I mean."

"There's you four Sarongs, of course! And Mr. DeMorro—he's going back. Very unhappy, by the way. The Line cancelled all its South Pacific sailings. And Mrs. Brewer's on board, right across from DeMorro, like she was before. Mouse Ichiro is going back to his laboratory in California. And Jingo Mirikami's on board, too. His unit's being transferred Stateside, so he and his men are bunking in the Cabin Class Lounge."

"What about—"

"Sorry, Miss Green. Please excuse me. I've got work to do, and more people to alert to the drill."

"Of course. I'm sorry. Thank you."

As I left, he made a pencil-check on his clip-board, beside my name.

<center>❀</center>

It was nearly five o'clock when the ship's last whistle blew.

I went up on deck. Well-wishers crowded the dock, able at last to toss their streamers and shout their good-byes. The Royal Hawaiian Band, whose members had been lounging and smoking, and flirting with the *lei*-sellers and the hula-girls, reassembled and came to attention. They struck up Sousa's "Semper Fidelis" march until the ship began to move, whereupon they segued into "Aloha 'Oe"—the slowest rendition I'd ever heard. I had a momentary vision of Lili'uokalani in the ship's brig—of course, as I remembered right away, she'd been under house-arrest. And to my surprise, I had to dab the corners of my eyes with my handkerchief.

When we'd cleared the dock, passengers who were wearing flower *lei*s slipped them off, and tossed them into the harbor. I'd heard about that. Legend says, if the *lei* floats in to shore, you'll come back to Hawai'i. But how would you *know* if it did?

That conundrum brought on real tears, though I didn't know why. I felt as if I'd lost something, which didn't make sense. Having seen practically nothing of Honolulu, and only a tiny bit of the Big Island, I didn't know why I felt attachment. Certainly, my bird's-eye view from the airplane had been spectacular, but I hadn't done any of the things tourists were supposed to do. I hadn't peered at "the sights" from a bus window, or giggled over strange foods at a *lū'au*. Of course, I *had* eaten raw fish. And *poi*...I had to laugh. Ivy had told me, when she first called me long-distance, that eating *poi* was the *worst* thing I'd have to do in this gig!

I hadn't gone surf-riding, either; nor had I flirted with sleek, tanned beachboys at Waikīkī—though I had certainly flirted with a certain doctor.... I hadn't even *seen* Waikīkī, though, except from the ocean. And yet, as we glided past it now, there I was, blinking away tears. The putter of a small airplane overhead intruded on my thoughts. I looked up. It was towing a banner that read: ALOHA LURLINE.

Did people who flew back on the Pan American Clippers get the same kind of send-off, with a brass band, hula-girls, and flower *lei*s? I was actually glad I had gotten the full effect, seen the whole show. It was a short but pleasant sort of cry I allowed myself; then I snuffled, blotted my cheeks with my handkerchief, and swallowed a couple of times, until my tears dried.

I was ready to go to work again.

❀

As an audience, men in uniform were as rambunctious as Lillian had warned me to expect. The wolf-whistles and cat-calls started the first time they took a gander at the four of us, strolling up in our sarongs. They got even more raucous, though, when we

led off with an up-tempo number: Ted Nywatt's "Walking on Eggshells." A few of their buddies started dancing, and I have to say: the fellows who danced the girls' parts were no pansies! Some of them even outweighed their partners.

Roselani got them to quiet down a little for her weepy ballad, *"Ka Makani Kā'ili Aloha"*—Love, snatched away by the wind. But they clearly didn't care much for the slow numbers. They whooped it up for her comic hula, "Princess Pupule Got Plenty Papaya." And we wound up the set with a medley of the fastest hot swing tunes in our play-list. "That's A'Plenty" and Phillip DeMorro's "Devil-May-Care" set them all to clapping in rhythm—or in what they *thought* was the rhythm.

By the time we had finished the last of our sets at one o'clock, I was far more exhausted than I'd been on the westward crossing. But the sight of Swifty Boyd, waiting for me just outside the Dance Pavilion gave me a kick like a mug of hot coffee. I packed up my violin and sax, waved good-bye to the girls, and trotted away.

He steered me to the bar next door, and bought pink champagne for us both. A few First Class passengers gave him the usual nod of recognition, a "Hello," or a breezy "Good evening, Doctor."

But one man, who didn't even apologize for interrupting our *tête-à-tête*, launched into a complaint about his…well, I won't repeat what it was or how, exactly, it was troubling him, except to say that I was embarrassed. He demanded an examination right away. Swifty excused himself, but asked me to meet him in an hour at his office.

The hour passed slowly, though I was given two more glasses of pink champagne: one from a beribboned general, who wanted me to visit him if I ever got to Georgia. The other came from Nan Brewer, who beckoned me to sit with her, once the crowd at the bar had thinned out.

I asked after Quart.

"He phoned me an hour ago, from the *Osprey*—that's our

yacht. He told me to tell you again that he's sorry about what happened. We were *so* sure there'd be guns."

"Umm."

"Turns out, he's short-handed; two of his crewmen were called up for the reserves and couldn't leave Hawai'i. So he has to stand a watch himself."

"Mr. O'Malley said he's taking the same route as the *Lurline*. Are we likely to see him?"

"Possibly. We'll overtake him today or tonight. He won't reach San Francisco until the fifteenth or sixteenth.... Miss Green, are you all right?"

"What?"

"Your eyes seemed to glaze over. Are you feeling ill?"

"No. I...maybe I'm more exhausted than I thought. I'd better rest up. The Sarongs have got quite a voyage ahead, and we'll need our strength to play for all these boys. And their wives."

"Oh, the wives won't make much of an audience for you," she countered. "Half of them will be spying on each other, to see if anyone's taking up with a new man. And the rest will simply look upon you girls as competition. They'll boycott your shows."

"Oh."

"I'm from a navy family myself, remember? I know how sailors' wives are. They're young, most of them. Few if any have ever spent a night away from their husbands, except maybe a week or two, when the men were in training. Now, here they are, in the middle of the Pacific, being shipped back to their home-states, and none of them knows how long it'll be before they see their husbands again. The men could be sent away in the opposite direction, to Manila maybe, or some remote corner of the ocean, and the wives wouldn't even hear about it until the brass was ready to tell them."

"We know a lot of sad ballads," I said, "if they want a good cry."

"I think you should work them up. Do them a favor, too, Miss Green, and tell the other girls: don't flirt with too many soldiers, or be too frank about it. It'll make more tension than there already will be. All those men in the bunks—" she gestured indoors "—they're *other* women's husbands."

I still wanted us to play at her home in California, so I ought to have been civil, and stayed on that subject. But something had been nagging at me, and I decided to risk the gig by saying it aloud. "Did you have...some kind of arrangement with Roselani?"

Her eyes narrowed. "What do you mean?"

"You knew she was taking us to find...well, you were so certain there'd be a cache of arms. And now, I think that's what *she* expected to find, too."

"Yes. She lied to you about that."

"I thought so, when you showed up with that policeman. You were worried she might try to take everything away on her own and not give you...what was it? Half?"

"A little more than half."

"And you made a similar arrangement with Bill Apapane, right? So no matter who got there first, you'd—"

"No." That was a surprise. "Bill wanted nothing to do with us. He and Henry Kalaukoa didn't want to go get it, anyway. They wanted to leave it there, until they could take it all to Honolulu, to benefit their Home Rule party. We wanted to get hold of it right away. And Roselani was willing to share."

"So you paid for all four of us to take the plane, and the steamer—"

"Did you think she could afford that herself?"

"What about Bill?"

"What about him?"

"Did you meet with him, the night he was killed?"

She smiled. "Do you really think I had something to do with that? You saw us—you were there. We spent the whole night in our suite, entertaining guests."

"I think it's possible that you had something to do with—"

"Oh, please!"

"You and Mr. Brewer could have killed him together. Or *had* him killed. Maybe some crewman did the actual—"

"Stop it!"

"I can't prove it, but—"

She stood up. "Don't bother. You'll find there's nothing to prove."

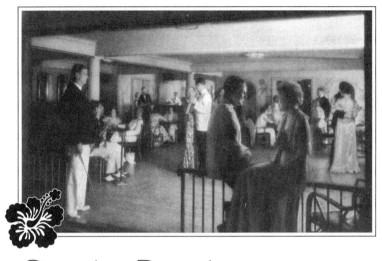

# Saturday, December 6

I TIPTOED BACK TO 533 about seven A.M., after a half hour of good-bye-for-now hugging and one-more-time kissing. It had been a truly wonderful night: brief, but steamy and sweet.

"Steam" arose the moment Swifty opened the door for me, opening both arms until I stepped inside, caressing my cheek with the tips of his fingers, and then wrapping me up till we were pressed, lips to lips, chest to chest, waist to waist, and knees to knees, and I felt the first little *prang* inside.

He made me laugh, too. He mocked his own "doctor" voice, to tell me that talking to Lillian confirmed a theory of his. ("I believe," he'd said, "that the reason girls who learn to surf at Waikīkī let the beachboys touch them all over, is because the feel of riding surf is what a woman feels as 'waves' when she's at the height of her libido in the sex act.") That was dry and clinical, but I have to admit, it made me want to try surf-riding.

The "sweet" came in his touch, starting with that first brush with my cheek. We half fell onto his bed, which (*ooh, too bad*) was not much wider than mine. My floral sarong stood out vividly against its plain yellow coverlet, in the wan light of a green-shaded lamp across the room. He reached for the

knot behind my neck, lightly tickling my shoulder blades as he undid it, never once scratching, or fumbling. The thin cotton slid off my shoulder; he pulled the rest away tenderly, and let it waft gently to the floor. I opened his collar-button and detached his collar. Then we undid his buttons together. All of them...

❀

"Wake up, your majesty!"

That, alas, was Ivy—not Swifty. I opened my eyes. She was fanning my sleepy face with a typewritten page. I had assumed that Roselani wouldn't notice when I came in—but obviously she did, and told Ivy and Lillian. I rubbed my eyes.

Lillian curtsied, said, "Breakfast in bed, princess," and handed me a roll and butter, a hard-boiled egg, and two strips of bacon, all wrapped in a napkin, along with a white ceramic mug of black coffee with one sugar.

"Want to hear the news?" Ivy was fluttering the page. "Seems there's only one dinner seating in First now. And the soldiers don't get music with their mess. So we'll have just one set in the foyer. But now we have to play a one A.M. set for the soldiers and sailors, in the Verandah. No change in the total number of working hours, so, no raise."

Lillian punctuated that with a Bronx cheer, then nudged me with an elbow. "Think the doctor can wait another whole hour for you to get off work tonight?"

Ivy chuckled. "Tell him not to start without you!"

Lillian pointed to my cheek. Evidently, I had blushed.

❀

Stan strode up to our table at lunch-time and without sitting, motioned me to join him at the side of the Dining Saloon that the waiters had already cleared.

"You may have been right, after all," he said. "Danny Boy Ohara is not a spy—Les Grogan confirmed that he and Danny Boy are trying to get a fix on some Japanese ham traffic, along

with a guy up in the Aleutians. Les told the navy brass about it when we were in Honolulu."

"Will you be looking for somebody else to toss into the brig? Mouse or Tad, maybe?"

His face told me he didn't think that was funny. "I wouldn't rule them out. Rubbish would've been my next choice, but since he isn't going back with us, I did tell the Honolulu cops what Mr. Brewer said about Rubbish selling scrap-metal to shipbuilders over in Japan. They're gonna keep an eye on him, maybe pay a visit to his junkyard next week, and see if he's got anything... explosive hidden there."

"I hope not."

"Me, too. He seemed like a regular guy. They all four of them did."

❀

"Ahoy, Miss Green!" The voice, calling from the Smoking Room as I passed the door, belonged to Phillip DeMorro. *"Hele mai!"*

"I beg your pardon."

"That's 'hurry to me' in Hawaiian. A pretty tongue, don't you agree?"

"Um-hmm."

"For songs, especially. Poor Bill! I did so want him to record that little ditty of his. I mean: How many more years could he really expect to ride the billowy waves? He needed to get out and sing—do *something*. Unless an athlete opens a restaurant, an entertainment gig is the easiest way for him to rest his physique, and retire gracefully. 'Home is the surfer, home from the sea.' A little gloss on Stevenson's epitaph, there."

I nodded.

"And of course, I had promised to find Bill a spot on the radio! Well, I went ahead and did it anyway. I spoke to my dear friend, Harry Owens, in Waikīkī, yesterday, and gave him the lead-sheet and lyrics. He said he'd pass it around; someone's sure to work up Bill's song, and Harry'll broadcast it on 'Hawai'i Calls.'"

"That's very nice of you."

"Harry did ask me, however: Who owns the rights? It's not published yet, or recorded. Who's to get the composer's royalties?"

"His sister, I guess."

"I guess, too. And I would have asked her myself, yesterday, but I couldn't find any of you there. The Sarongs were not at the Alexander Young."

"Miss Akau took us over to the Big Island for…an adventure."

"You didn't miss anything. I had the most awful time with the Matson officials in Honolulu. They were simply hell to deal with!" He punctuated this with a wave of his hand for another drink. "They wouldn't let me sail on to Australia—that's why I'm here, you understand, sailing back to California. They gave me a song-and-dance about bringing all of their vessels back to the States, for refitting as troop-carriers. Well, I don't see how they could carry more troops than they're already doing. But they did refund my through-ticket and give me this passage back, which went a long way toward amelioration. Of course, they had to lug all of my things back up to my suite for me, but at least they left my automobile right down on the Cargo Deck, exactly where it was on the trip over."

"Are Bill's things from your suite here, too?" I said that without thinking. Fortunately, it wasn't a *faux pas*.

"Oh, all of Bill's things stayed aboard. His luggage is in my trunk-room, and his new surfboard is still down in the hold, strapped to the top of my Chrysler, where it's been since we left Los Angeles. When you ask Miss Akau about the royalties, please find out if she intends to take possession of his possessions when we get to San Francisco."

"Of course."

"Don't get me wrong. Bill's death hit me very hard. I was very fond of him. I may not show grief the way Larry Olivier does— did you see *Wuthering Heights*? But I am deeply wounded."

"We're pretty downhearted, ourselves."

"After two days' adventure? Wherefore should you be sad?"

"It was a paying gig, but it wasn't much fun to play."

❀

After our extra-late set for the servicemen, I stopped off in my cabin, as I'd done the previous night, to put in my pessary before heading up to Swifty's room. But by the time I reached his door, I wasn't so much excited as exhausted.

I still felt warmly toward him, and had no regrets about having taken the lead in flirting and rolling his smokes. And he'd proved to be every bit as gentle and warm as I'd had any reason to hope for. But in my experience, the *second* night you spend with someone can be a let-down from the thrill of the first.

If he felt the same way, though, he didn't show it. He grinned, held out his hand, and drew me through the door-frame, saying, "Come in, come in. All patients with unmentionable conditions have departed."

When I didn't laugh, he picked up on my somber mood, draped a comforting arm around my shoulders, and led me through the waiting room and the examining room—lit only by the tiny red bulb on the autoclave—and into his stateroom, where a single shaded lamp beside the bed cast him in silhouette.

He started with something he'd done before: his thumbs in my hands, gently massaging my palms. Then he moved up my arm with the rest of his fingers, until he was massaging my neck. I half turned away, so he could do both my shoulders, too. He slowed down and turned it into a caress.

I subsided, letting myself ease back against his chest. He brought his arms down, slipped them under my arms, and wrapped me up in an embrace. I squeezed around to face him, put my arms around his neck, just as the first shivery *prang* launched itself up through my body, reminding me of what was to come.

And soon we were teasing as much as touching, and the great, vivid pangs that I had been longing for came to me, lofting like waves, urgent, insistent, and cresting in little whispery puffs of spray that tingled as they drifted down.

Exhausted, I snuggled up against him, the soft hairs of his chest against my ear and cheek, his arms wound tight around me, and the only sound beyond our breaths the rumble of the engines far away below....

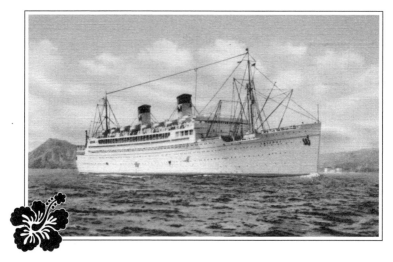

# Sunday, December 7

I WASN'T SLEEPING WELL. Swifty's initially comforting warmth proved stifling: I couldn't breathe deeply while snuggled up against him. And I couldn't roll all the way over without hazarding the edge of a bed never intended for two.

So I found myself wide awake, well before dawn, pondering why nobody was all one thing or another—why nothing was all black or white.

Quart was...well, a bigot. But he was hep to swing music, and rather generous. Nan was a wonderful singer, who we'd hoped might us get gigs in Hawai'i. But she was also a gun dealer! She'd been in cahoots with Roselani all along. By the time she told me about the guns she expected to find, it was just one more confusing and contradictory story about Hawai'i that I didn't have room in my head for. And Roselani—*whew*! Great on stage. Not so great up close. And that guff about keeping the races pure! Even Quart Brewer didn't talk like that.

Rubbish—now there was another generous and gregarious fellow. But he'd gotten rich selling scrap-metal that, I had to admit, could come back as a battleship. Danny Boy was a real gentleman now; but I was glad I hadn't met him when he was on his

mean streak. Even Stan, who seemed to be a darn good cop, always seemed to be glancing at my legs when he talked to me. Jingo—excuse me, Tad—was…well, isn't that just how it is with him? Tad had outgrown "Jingo"—and the friends that still called him that. And Mouse—I've met men like him, who are completely absorbed in very technical work. They're a bit awkward in company, which was probably why he was always challenging his buddies to Jan-Ken-Po. (Uh-oh! Was Bill trying to tell me…Mouse? It was *Mouse*? It couldn't be! He came out to help *carry* Bill.)

Maybe I was having a fever-dream, because Swifty wasn't immune to my ruminations. He was charming and intelligent, though he did, sometimes, lapse into that annoying "doctor" voice. I was intrigued by his attitude toward world affairs, and I liked his admiration for Mr. Gandhi. He was formal with me at first, but after a little flirting on my part, he got the hint, and started to flirt right back. I wasn't surprised it had led to this. I'd brought my pessary all the way from New York, just in case. I hadn't taken a lover in many months, and it was high time I did! I had no second-thoughts.

I still wasn't sleepy. And Swifty was taking up too much of the bed. But I wasn't worried. We'd have three more nights, and we're both smart; we'd figure out how to get comfortable.

I slid away, and sat up on the edge of the bed. The radium dial on my watch glowed quarter-to-five as I strapped it on. I retrieved my sarong from the floor and knotted it up behind my neck—a skill I had by now gotten so good at, that I finished just as I needed one hand for the doorknob. And with a little grin over how smooth and supple I'd made that motion—and then a wider grin over how smooth and supple I felt, all over, with Swifty—I let myself out.

❀

"What're you doing back here?" That was Stan's hail from the door of the Cabin Class Verandah.

I was standing at the stern rail, thinking more about where I'd

been than of what might lie ahead. Stan's appearance reminded me that this was the same place where he and I and Swifty had joked about the glowing "phosphorettes" in the wake, and that it was, therefore, the place where I'd first found myself attracted to the doctor. But I replied only, "Couldn't sleep."

He pointed toward the bow, and said, "Sun'll rise ahead of us, in an hour or so." But he cocked his head at my sarong—it was obvious I hadn't changed clothes—and though he didn't say so, it was obvious where I'd spent the night.

I chose not to register embarrassment, and said, "About that 'John Kemp' business—"

"Forget it, Miss Green. You couldn't have known."

"But it distracted me from looking for other clues that might have been *more* important. If I'd learned why Bill got into that fight, maybe I could have tracked his last movements, and learned who—"

"Stop! *I'm* master at arms. I can't let ordinary folks play detective on my watch. Look, Miss Green, you've got a lot on the ball. And I'm not saying I can't use some help, once in a while."

"Like from Gloria the hairdresser."

"Exactly. But she doesn't go around with a magnifying glass, sniffing the carpets for footprints."

"What about for blood?"

"Huh?"

"Wherever Bill had come from, he must have bled on the landing from that point on down. Unless he wasn't all the way up on the Sun Deck. Maybe he got hit on Deck-A, or Deck-B, or—"

"You already told me this, remember?"

"And did you check on it?"

"I went looking for a bloody oar. Also your idea."

"Then you should give the ship's clean-up crew a gold star: they were very efficient. By the time I went upstairs, around noon the next day, they'd already cleaned the carpets."

"No, they didn't. Only the Deck-D landing, where you found him. We're short-handed, remember?"

"Somebody cleaned. Everything was spic-and-span when I looked."

"Believe me, Miss Green: if a crewman had found bloodstains anywhere on this ship, I'd have been told about it."

"And there weren't any in the stairwell?"

"Only on Deck-D, where you found him. Did *you* see any blood on your way down, before you found him?"

I thought back. "I wasn't *looking* for any. And when I saw *him*, I didn't think about anything except trying to help." I closed my eyes and took a couple of breaths. "There was...only the usual stuff: cigarette ashes, some crumpled paper.... No, I don't re-member seeing any bloodstains. Not until I got to the landing where he was."

"And the only bloodstains the crew told me about, and cleaned up, were in the Deck-D Foyer, on the landing and down to the Doc's office."

"That means he was hit right where I found him—on the landing!"

"And the men in the nearest cabin to that landing were...?"

I was nodding, even before he paused for me to say, "Danny Boy, Rubbish, Mouse, and Tad."

"See?" Stan grinned. "You must be cold out here. Why don't you go put some clothes on?" Then he gave me a little wave, and walked away.

I turned back to gaze at the wake again. It took me a couple of minutes to realize that there was another explanation for the absence of blood on the landings above Deck-D. The stairs going *down* from there had no carpets—the treads were an open grillwork of steel. Bill might have been hurt somewhere *below* Deck-D, and hauled himself *up*!

He could have been visiting his old sweetheart, the manicur-ist, on Deck-F. But more likely, he'd been having a confrontation with Frank Todd—her husband, the "jockey"—down in the car-go hold. Bill knew the way: he'd gone there at least once before, to retrieve Phillip's music. And his surfboard was stored there: his surfboard, with its embarrassing swastika; his surfboard,

which Phillip thought was still strapped to the top of his Chrysler Airstream, but which in fact wasn't. That surfboard had a flat side, and a sharp fin, too.

<center>❀</center>

I went first to 533, and—quietly, so as not to disturb Roselani's sleep—exchanged my sarong for a brassiere, shirtwaist, and skirt, and my sandals for the rubber-soled deck shoes.

It didn't bother me that, contrary to the sign, no crewman was accompanying me down the Aft Stairwell. This time, I wouldn't tell Stan anything until I was certain.

Below Deck-D, the aroma of hot machinery, grease, and stale sweat grew intense. So did the hum of the engines and the noises of the ship's myriad machines, the not-quite-rhythm of clanks and thuds and groans. (Do the men who work down here—does their union steward—realize how loud this is? They could go deaf!)

I wasn't enjoying myself, the way I thought I would. It had seemed so natural, so consistent with my sense of myself as a bit of a daredevil, to be keen on (yes, Mother) morbid pursuits. Why else take this plunge? Why go down into the cargo hold, at dawn on a Sunday morning, to look for evidence of murder?

The door to the hold was shut. Against the clamor, no one would hear a knock. I spun the wheel, which ratcheted the latch out of its slot, pushed the door open, and called out, "Hello! May I come in?"

I expected to see someone at the desk. If not Todd, then some beefy fellow in his work-gang. So I was ready with a fib—that Phillip DeMorro had asked me to check if his Chrysler's tires had gone flat. And that I hadn't noticed the sign about having a crewman along.

I did *not* expect to see a man slumped over that desk, blood leaking from his head staining papers on the desktop and dripping onto the floor.

My instinct was to run to him and see if I could administer

first-aid. But I gripped the doorframe with both hands, and held myself back. No one had answered my "Hello." I listened, let go of the doorframe, and glanced from side to side. I edged in gingerly. The man didn't move. I looked around again, didn't see anyone. I approached the desk.

He was in the desk's armchair, his chest on the blotter, and his head, facing away, left side down.

It wasn't Todd, who sported a brushed-high pompadour. This man had coarse black hair. His right hand lay outstretched, toward the telephone, as though he'd tried to make a call. I stepped around the desk.

It was Mouse Ichiro, with a small hole (from a bullet?) in his forehead. He didn't have a gun, although I could smell something acrid, like burnt gunpowder. And something else. Not the now-familiar aroma of the hold—something more pungent, in the petroleum family, but "thicker" than gasoline. The pipes, around the perimeter carried fuel oil. Diesel oil. I looked around—suddenly anxious that I'd been distracted—then back at Mouse.

His left hand hung down from the armrest, fingers encrusted with a grayish-white powder. (Gunpowder?) A bullet could puncture a pipe—

A footstep! I heard it and spun around.

"Oh, thank goodness!" I saw a familiar—a *very* familiar—figure by the door. "It's Mouse, Swifty. He's dead. Shot, I think. Let's go tell Stan. I'm so glad it's you!"

His hands were in the pockets of his unbuttoned uniform jacket, and he spread it wide. So I trotted over and stepped within. I sighed again at his caress.

We walked together toward the door. He said, "I've thought all along that it was Mouse, and not Danny Boy, who killed Bill. When did you think so, Katy?"

I hadn't thought so at all, but it was reasonable. I had convinced myself that it was Nan Brewer, until I realized she couldn't have done it, at least not by herself. So I said, "I came down here thinking it was Frank Todd. Where is he?"

"I don't know." He looked around, then gave me a peck on the cheek. "Come on."

I smiled, and said, "Of course," in a reflective mood. "Mouse got to Bill right after I did. And when Bill *saw* him—there, in the foyer—he said 'Whassa-matta you?' He must have meant, literally, 'What's the matter with you? Why did you do this? Why did you hit me?'"

"Or…" Swifty took one hand out of his pocket, and turned it palm up. "He might have meant, 'Why are you going to do *this?*'"

"Do what?"

"Look over there." He inclined his head toward a corner of the hold. A wooden packing crate, ten or twelve feet long, had tipped over. And just beyond it, where several of the pipes turned the corner, a stream of diesel oil burbled out of two long gashes in the pipes, and spread into a widening puddle. That explained why the smell had been so strong in the hold.

The long side of the crate had been stove in—a fireman's red axe lay beside the crate—and a mound of gray powder had spilled out of it, into the puddle of diesel oil. Three wax candles stood in the middle of the pile on a little block of wood, their flickering light illuminating a stencil on one of the crate's sides that read: AG RES LAB—C BREWER & CO. "*That*—" said Swifty, "is Mouse's artificial fertilizer. And *this*—" he gestured to take in the entire hold "—is sabotage! Mouse was going to blow up the ship."

"Sabotage? It looks more like vandalism to me."

"You could call it that—unless you know chemistry. When a farmer needs to blow up a tree stump, and he doesn't want to pay for a charge of dynamite, he mixes diesel oil from his tractor with a cup or two of fertilizer—it's the potassium nitrate—" (*Ohhh! That know-it-all "doctor" again*) "—that's the main ingredient. Ordinarily, it comes from birds, from their…guano. But Mouse makes his nitrate fertilizer in a lab, instead of in a bird. Combine it with diesel oil and it's highly flammable. If the mixture is packed into a tight-enough space, with enough air, it'll explode."

"Like a bomb?"

"Very much like a bomb."

"Could it sink the ship?"

"Possibly. Even if it didn't blast a hole in the hull, it'd start a great fire."

"Could those candles be the fuse?"

"It looks that way. When they burn down to the base, in an hour or so, the flame will touch off the mix of diesel and nitrate, and it'll go *boom!* This early on a Sunday morning, chances are nobody in the engine room would notice some fuel gauges down, and come looking in here for a leak."

I looked around. "So, I guess Mr. Todd caught Mouse setting the bomb, and shot him, huh?"

"It looks that way."

"Then...where's Mr. Todd?"

"Gone to find Stan, I suppose. We should go upstairs, too, and phone him, just to be sure."

"There's a phone right here."

"Todd knows enough not to touch anything. And we better not touch anything, either. Let's go."

I turned, glanced back at the crate and the candles, and exclaimed, "Wait!"

"What?"

"Look—under there!" A pair of elevator shoes and argyle socks stuck out from beneath the box.

"Mouse must have pulled the crate down on top of him! Got Todd out of the way, first. Come on, Katy. Let's go."

"Then, who shot Mouse?"

"We better let Stan figure that out, too. It's a real mess down here. And I'm getting nauseated from the smell, aren't you?"

"I was just thinking the same thing; it's very strong."

"Let's go. We'll phone Stan from my office, and tell him to bring a clean-up crew for the oil, when he comes down here."

"What about those candles?"

"Go on ahead. I'll put them out."

He waved me through the door, and down the passage ahead of him. No one else was in the Aft Stairwell, as high as to Deck-

D, nor in the foyer there. But it was still early. Swifty put his arm around my shoulder and urged me down the corridor, through his waiting-room door, and into the examining room.

I expected him to pick up the telephone, and when he didn't, I reached for it.

"Hold it!"

"Stan told me, in an emergency, they can page him, even if—"

"In a minute. Give me a hug first." He opened his arms again. I grinned, stepped right up, and wrapped both my arms around his waist...and that's when I felt the gun. It was tucked into the back of his belt. I jumped away, but his hand came up and thwacked me hard across my cheek, making me lose my balance. Then he pushed me down into a chair.

I coughed, stunned. And before I could even convince myself to retaliate, he pulled the gun out of his belt. It was an automatic pistol, not much bigger than the hand that held it, but big enough to stop me from considering *ju-jitsu* to disarm him.

He kept it pointed in my direction while he took the chair across the examining table from mine. "How long have you known, Katy?"

"I just... He was—"

"About the surfboard?"

"What?"

"You went down to the hold to look at Bill's surfboard, didn't you? To see if that's what cut him and hit him. I shouldn't have told you about surf-riding and libidos the other night. It must have set you thinking."

"No. I went because a surfboard's sharp and flat at the same time. Like a bad singer!" I quipped. I even giggled. I didn't want to believe this.

"It should have gone off the boat in Honolulu, and gotten lost among a thousand others on Waikīkī Beach, where nobody'd notice his blood on it."

"What are you talking about, Swifty?" *Why did it have to be him?* "What's going on?"

"Isn't it obvious?"

"I guess it is, now. When Bill looked up at me and said, 'Doctor!' he wasn't calling for help. He was saying it was you—"

"And you brought him right back to me. Thank you for that, Katy. And for the oar, as well!"

"What?"

"While Stan and most of the watch were up on the Sun Deck in the morning, poking into the lifeboats, I had time to clean up the stairwell. Now I can say that Mouse was a Japanese agent, bent on sabotage."

"But he wasn't, was he?"

"Who's to say he wasn't? When that mixture down there goes off, he'll be incinerated."

"Bill met with *you* in the hold that night, didn't he? You tried to get him to give you the cache of arms that you all expected to find on the Big Island. What did you tell him?"

"I told him to look at Manchukuo—Manchuria—where the Japanese army put the Chinese emperor back on the throne. I said they'd restore *his* king, too, and that the guns his parents had hidden would help him retake the Islands. But he disabused me of that notion, insisting that he could not bring himself to turn against the United States. He said, even the prospect of *statehood*, which he detested, would be better than life under a Japanese occupation. He had been checking his surfboard, but I asked about the swastika on it. That's an interesting story, by the way—"

"I know about it."

"Anyhow, he started to tell me, and I took hold of the board. Once he'd let go, I flipped it up really fast, and caught him under the chin with it. Whereupon—as you surmised, Katy—he stopped to feel where it cut his mouth and nose, giving me the chance to swing it around and crack his skull."

"But why are you trying to sink the *Lurline*?"

"Oh, the ship need not sink! It will be sufficient if it's rendered helpless in the water, with the S.O.S. going out, saying we're 'unable to make headway.' Ideally, of course, it should also say 'great loss of life.' For propaganda purposes, that will be as good as sinking."

"But all these servicemen? The wives, too?"

"Don't you see? It's the impact of the act that makes sabotage so effective: the loss of something with great symbolic value. These people don't all have to die, and most of them probably won't. But some will, and that will be enough."

"Enough for what? I don't see how you or *anybody* can—"

"There is a war being waged in the world right now, and the United States is not anxious to get into it. There are many people, including Charles Lindbergh, who are actively *opposed* to getting into it. But an act of sabotage like this will be blamed on Japan, and it will draw America into the war right away—long before America is *ready* to go to war. And that will give Japan an early advantage."

"Why would anyone blame Japan for doing this?"

"Because I will tell them so. Stan may not be ready to believe the worst of someone with a Japanese name. But he likes to take the easy way out in most situations, as he did with Danny Boy Ohara."

I deeply regretted now having told Swifty that I knew *ju-jitsu.* He was staying well beyond my reach, across the examining table—which was bolted down, so I couldn't heave it over against him. I tried to think of a way to kick him, but he still had the gun out. I thought about raising a ruckus, too; but I doubted that anyone would hear us—they might not even hear a shot.

Why hadn't he just shot me, down in the hold? "What are we waiting for?" I asked. "You didn't put out the candles, did you?"

"Of course not."

I looked at my watch. "Shouldn't it, uhh…go off about now?"

He smiled. "What time is it?"

"Seven-ten."

He checked his own watch. "No. It's *eight*-ten. You forgot to reset your watch last night."

"I was distracted!"

"Eastbound, we give back the hours we gained coming west."

"Thank you, *Doctor!* But—"

"It's still seven-ten, back on O'ahu. We have a little less than an hour."

"Until what?"

"Well, this, of course. But something bigger, too."

"What could be bigger than blowing up the ship?"

"Actually, Katy, I don't know. I was expecting to wait in the Lounge, up in First, listening for the weather report on Radio Tokyo. They'll say something, a seemingly innocuous phrase or two, when the deed is done. I only know my own part in the enterprise—and it is only *one* part of an enormous, coordinated effort, I'm sure. Prime Minister Tojo is determined to expand the Greater East-Asia Co-Prosperity Sphere. And the Japanese are meticulous planners. They always act as a group, too. Everybody has to agree to a plan before they will execute it. And there's something truly fascinating about their military code: if the plan fails, then the one who brought it up takes full responsibility, and must then go kill himself. Isn't that magnificent?"

"How long has this been planned?"

"About two years."

"That's about how long you've been working on this ship."

He smiled. "I'll be taking my usual morning stroll on the Sun Deck, at the moment of detonation."

"When is that?"

"About nine o'clock. Ship's time."

"What about me?"

"You'll be dead by then."

He picked up a scalpel from the autoclave and tucked it, like a pencil, into the breast-pocket of his jacket—blade up.

I gasped.

"No, no! Don't worry. I have my psycho-neuroses, but sadism is not one of them."

"Great! When all your *other* psycho-neuroses have gotten you committed, I'll write to you in the lunatic asylum."

"You'll be found dead, here—that's true," he went on, as if I'd said nothing. "But you'll be slumped in that chair, right where you are now."

"Shot?"

"No! How would that look? Your friends must know that you spent the night with me. I'll say I wanted to end our affair, but you couldn't stand to be spurned, so you broke into my pharmacy cabinet, and gave yourself an fatal dose of morphine."

"My friends also know I never take dope!"

"They're sleeping a bit late, this morning. I gave them a somewhat larger dose of veronal last evening than what they'd had before. The explosion will probably rouse them out of bed, but it'll take them a while to find you—assuming the ship's still afloat, after the damage is done."

"So, if I hadn't found you down below, this morning—?"

"No. This is the day it had to be done, which meant I had to kill you, too. I expected to inject you with morphine while you were asleep this morning, and carry you out here to be found. But you left before I woke up."

"You planned to kill me, all along?"

"Yes. Ever since you found Bill out there in the foyer. I figured Mr. Todd or one of his boys would find Bill down in the hold, and that Stan would look for the killer only among the crew. I never imagined Bill would climb all the way up here, and try to get back at me. And I certainly didn't expect that whoever found him would know first-aid, and keep him alive. If he'd lived, he'd surely have told Stan what I'd said, about Japan, and so on."

"He might have told me, too, if you hadn't insisted I should keep him quiet."

"Well, Bill was the talkative type. He was delighted to tell me about the board and the swastika. I don't think he believed I was serious about Japan, anyway. That's why he never saw it coming."

"You said this—what you're doing—that it's part of a larger plan."

"Actually, I don't know what they're planning to do, but today is the day they're doing it—about eight in the morning, Hawai'i time; nine o'clock, *our* time. I assume it will be something like this, only on a larger scale."

"Sabotage?"

He leaned back in his chair. "I think they're mounting an invasion of the Hawaiian Islands. With enough warships, especially aircraft carriers, they could bombard Honolulu until America surrenders the Territory."

"I hope you're not telling me this in an effort to...recruit me. Because—"

"No!"

"—I cannot accept that your ends justify your means."

"Katy! I never even *imagined* drawing you in. You would never do this! You have no politics."

"Sure I do. I vote for F.D.R. I stand up with my union. And maybe I haven't waved too many placards, but I've played in the bands that get those rallies singing!"

"But you've never done anything truly political. And *this*—" he opened his arms "—is politics writ large."

"It's war!"

"'War' is what von Clausewitz calls 'politics by other means.' I'm actually going to be present—to be *right here*—when the first shot of this new war is fired. You might even say I'm going to fire that first shot. Oh, my role is more like that of a sniper than a foot-soldier. Not for me, the mass of nameless men in uniform. I'm out here on my own. But my mission is essentially just like theirs—I'm in a cause worth risking my life for."

"Worth *giving* your life for?"

"If necessary."

I didn't like hearing that, but it was good news. If he'd intended all along to die, he would have shot me in the hold, and set me on fire to be the fuse. "What would make that necessary?"

"If I should be discovered—by someone else, that is. Or if all my planning went for naught. But otherwise, I don't expect to take myself down with the ship."

That was *great* news! He had an escape plan, even if the ship sank.

"Would you kill yourself, like one of Tojo's boys?"

"You have to admit, their military code is a sort of religious

cult: it actively encourages suicide, and yet it keeps on attracting adherents. Isn't that amazing?"

"How do they do that? With a sword, isn't it?"

"Oh, that's not for me! And you've been glancing at the pharmacy cabinet. No morphine for me, either. I don't care to die in my sleep. If I'm going to do it, I want to savor every moment. Ever read Jack London's book *Martin Eden?*"

I nodded. That wasn't good news. Martin Eden drowned himself. And I knew now that if I didn't do something to keep the ship from blowing up, we'd *all* drown. There was no point in waiting any longer. I had to take the chance he wouldn't shoot me—or if he did, that I could get away merely wounded.

"You mentioned morphine," I said.

"I'll give you a little chloroform first though, so you won't struggle, and make a big, messy, and noticeable puncture. But it's painless. You'll just go to sleep and not wake up."

"Skip the chloroform. I'll just take the morphine."

"Right now?"

"I've never tried it. I never wanted to risk getting hooked."

He chuckled. "You certainly won't get hooked, now." He sat still, looking at me, for a couple of beats. Then he shrugged, and said, "All right." He kept the gun pointed at me while he eased his chair back, took three steps, pulled his keyring from his pocket, and unlocked the latch. But he didn't reach for a syringe. He took out a small bottle first, and a wad of gauze. "I think you ought to have the chloroform, anyway. Just in case you're thinking of trying your *ju-jitsu* on me when I get close enough."

"Come on. Get it over with!" I let my arms go slack, and dropped them to my sides. He took it as a gesture of resignation, and came around to my side of the examining table. He kept his eyes on me while his free hand unscrewed the bottle cap. But I grabbed the arms of my chair and stood up with it, lifting it behind me, and twisting myself around until I could heave the chair—backwards—toward where he stood.

I heard the bottle break, and the chair clatter to the floor.

Swifty went, "*Ooof*" as the wind was knocked out of him. I ran to the door, grabbed the knob, and yanked.

I did *not* scream for help and pound on doors—having thought through my escape while he was lecturing me. I could never have convinced any stranger that the ship's doctor had planted a bomb in the hold. At least, not in time to stop it. Either I had to go down into the hold and blow out those candles, or I had to find Stan. Despite "John Kemp," *he* would give me the benefit of the doubt.

I hesitated, trying to think where he might be. Then I remembered—a telephone. *Tell the operator, "extension one."* And there was a phone one flight up, in the foyer between the Cabin Class Lounge and Verandah. Plenty of soldiers would be camped out there, too, so I'd have protection while I placed the call.

I raced up the stairs, but I heard Swifty call my name just as I reached the next landing. A couple of bunches of men in uniform were lounging on the soft foyer chairs. I dashed over to the outside wall, grabbed the phone, and jiggled the hook.

"Katy! There you are—I was so worried." It was *him*. He'd run up right behind me! But he turned to the servicemen nearest to us, and said, "I thought she *wanted* me to kiss her." That drew a laugh—as he'd intended. "She comes on to me like she wants it, you know? And the next thing—"

"It's not true! Operator! Operator! Extension one! Down in the hold. Extension one! Down in th—"

"Aw, you callin' your mama?" a sailor snickered at me. "Your fella here—he's a man in uniform. You oughta give him a break."

"Let him kiss ya, honey!" another called out. Whereupon his buddies chimed in with, "You're one o' them sexy Sarongs, ain'tcha?" And "She's that Princess Poop-poop-a-doop, from the hula-hula!" And "Don' preten' you don' like it!"

"We *saw* you two, ya know?" a sailor said. "Up on deck, yesterday, when we was comin' aboard. You was kissin' him *then*, all right!"

A chorus of "And-how"s and "Yeah"s followed. They would never believe Swifty was a saboteur now.

"Honestly, Katy," Swifty said loudly, for their benefit. "I'm sorry."

"See? He apologized!" a soldier chimed in.

"Kiss him!" said another.

Then the chorus came in: "Kiss him. Kiss him. Kiss him! *Kiss him!*"

Swifty put both arms around me and drew me close. Then I saw it again—the scalpel blade, sticking out of his jacket's breast-pocket. And the closer he drew me, the nearer it came to my neck. If he didn't cut my throat he could at least sever an artery, and I'd be incoherent even if I didn't die right there.

He planted a kiss on my lips, and the chorus turned to cheers.

Swifty plucked the phone from my hand and reset it on the hook. "Come on, Katy. The boys have had their show. We'll go someplace where we can neck in private."

The cheers turned to wolf-whistles, and then to catcalls about my figure, his virility, and our likely children.

He didn't let go. He steered me to the double-doors that led out to the Promenade—the embarking and disembarking place, where the gangway gets attached. It was chilly enough outside that I actually appreciated the warmth of his clutch. But he still held me tight against the scalpel in his breast-pocket.

So I let him walk me to the railing. The *Lurline* was sailing right into the wind. A few soldiers who'd been smoking by the doors flicked the butts over the rail and went inside to warm up.

And then we were alone.

I thought for a second that I should scream loud enough to be heard indoors. But the men inside would figure I was just whining again. *He'd* say I was a tease or—worse—a suddenly reluctant nympho. And after that, *nobody'd* care what I said or did.

The only way to escape was to disable him and run again; and the easiest way to do that now was to stamp on his instep, even with my soft shoes, and push myself away from the blade. I lifted my left foot slowly. But before I could use it, he reached down to my waist, hoisted me up, and plunked me onto the rail. I had to drop my hands and grip it hard, to keep my balance.

He pulled the scalpel from his pocket and held it against my neck. "Don't move, Katy. We're going to stay right here together until...you-know-what happens. And at that moment, you will be so startled that you will accidentally fall overboard." He stepped in front of me, and drew close enough that if anyone came through the door and saw us, they'd think we were necking.

Was there a way I could flip *him* over the rail, without losing my balance or having my throat cut? I wasn't standing on deck, so I didn't have any leverage for *ju-jitsu;* and he outweighed me by more than enough to stay put if I tried to simply yank him up.

But the section of rail that he'd sat me on was the one that the crew swings out and attaches to the gangway. There'd be a latch. I felt for it, and found it under my left hand: a sliding bolt at the bottom of the teakwood rail, where it met the upright struts. The wind was still strong—I needed to keep my grip on the rail with the other hand. He was looking past me now, at the sea sprinkled with whitecaps. The sky was purple overhead, and a mousy gray down to the horizon. Sunrise, of sorts, was only a brighter spot of gray ahead of the ship.

I said, "Oooh, it's cold," and made myself shiver, to loosen his hold on me and conceal my left hand's movement, and the tiny click as I eased the bolt over. Then I said, "Sun's coming up—look!" And when he turned his head, I pushed hard against the standing section of the rail.

As it swung out over the edge, he lost his balance and fell face-forward—as I hoped he would. He tried to clutch the rail with his free hand, but grabbed my sleeve instead as he tumbled.

He was too heavy. I lost my grip. Pulled right off the rail, I fell all the way down into the ocean.

<p style="text-align:center">❁</p>

*Close the watertight doors!*
     Chilled, and squinting to see through the salty wetness, yet that was my first thought: Push the water back. Keep it away. Stand up! Why can't I touch the bottom? Salt water!

Something was humming. My head was plugged up. I shook myself all over, and wriggled my finger into my ear. A bubble popped, and I heard the hum. It was loud, but the pitch was going *down!* Going *away!* I swiveled, and caught sight of the *Lurline*, her stern high above me. Steaming…away. Away? *"Hey! No-o-o! Please! Help! Help me! Help…me."*

I had to catch my breath. Winded from treading water, I made myself float, so I could breathe again, but I was buffeted by the wake, by its churning foam that reeked of oil and sewage.

Where was Swifty?

*Cool head—main thing.* Isn't that what they say in Hawai'i? Didn't somebody tell me that? It made sense. Cool head—main thing…

<p style="text-align:center">❁</p>

I'm out in the middle of the Pacific, all right. More *out* than ever. Okay, at least I'm in the shipping lane. Boats will stay in the shipping lane. The navy's patrolling it. Somebody'd told me that, didn't they? Didn't they?

*Cool head—main thing.* Who knows where I went this morning? Who'd I tell? Swifty! Where is he? Why can't I see him? He must have plunged in near me. They'll *have* to look for the doctor. Turn around and look. *"Turn around!"*

I turn myself around, even though I have to take my eyes off the ship to go full-circle. He isn't in my trough of the waves; nor, when I'm lofted up, is there any sign of him in the neighboring crests and valleys. Has he done as Martin Eden did, and drowned himself?

I notice—with what little amusement the situation allows—that the water is very warm at the surface, but that down half a foot or so, it gets chilly; and where my feet are kicking, it's cold. Keep moving. *Keep warm—new main thing!*

The sky is overcast; the sun almost invisible behind I-don't-know-what-kind-of clouds. Storm clouds? Who knows? I want them to stick around. They'll postpone fainting from sunstroke. I dip my head back and wet my hair. That helps, too.

I can't wave my arms without sinking a little, but I tear through my buttons, slip out of my white shirtwaist, and wave it like a flag as best I can, wishing all the time that it was red, because I must look like just another whitecap on the vast blue sea.

I look like something different to the gulls, though—a new kind of flotsam or slop. Two or three wheel around and swoop low. I flop and flail like Ray Bolger in "Oz"—and keep it up for as long as they hang around. But either they don't like the show, or they don't want to wait until I'm dead. They fly away, up the wake and back to the ship.

The sun finally inches above the longest streaks of gray, and pokes through a blue hole in the next clouds up. I can still see the *Lurline*, but only because I still know where to look. Her smoke hangs back the longest, but finally it melts into what had been the long gray streaks, but are now a gathering and rounding-up of gray pillows.

"If I'm sailing off into war, at least I'll be wearing durable clothes."

I said that out loud. I'd said that out loud back in New York, too! How funny! I laugh out loud. But then I yell, "Come back with my clothes!" And I laugh again.

❀

I am reminded, again, that it's eight thirty-two—that it *was* eight thirty-two when I went in. I can't break the habit of looking at my watch, and good as it is, it isn't waterproof. I think I've been here half an hour now. How long can I live—wet? The rest of the day, overnight, I suppose, but only if nothing... *Fish must be somewhere under me!*

We had an aquarium. I used to dribble in the tidbits of fish-food. (*Mother! Tim's had his turn! It's my turn to feed them now.*) Only now, it's *literally* my turn to feed them....

I don't see the scraps and slops anymore. They've grown sodden, and they're disintegrating, settling down, down where it's colder.... Fish like it cold!

*Keep warm—main thing!*

❀

I'm blinking a lot. I should close my eyes. No! I have to see.

I squeeze out enough tears to keep them moist. Wipe the crusty salt away with my sleeve. Why not *wear* the shirtwaist again? Okay. That's better. And warmer. *Keep warm, main thing!* Wish I hadn't torn the buttons off.

I'm keeping my mouth closed as much as I can, although my nose catches every wave-crested splash, and needs wiping.

*I'll get through this.* I should sing. Give myself a rhythm to tread water to. Not too fast! Don't waste energy. Like I'm walking. Just enough to keep my shoulders out. Just the one- and three-beat.

What's that line? "...I'll cross the raging main"...? *What's that from?* "I'm off to my love with a boxing glove, ten thousand miles away."

"A Capital Ship"! I sang that with Mother and Father and Tim. Haaaa, haaaa. At least it's not "Asleep in the Deep." Keep on singing. It'll pass the time until somebody comes. "Someone to watch over me...until the real thing comes along." No! No torch-songs! No "sad-and-lonely one." No "blues in the night."

"Happy feet! I've got those happy feet.... " Sing something happy. Something funny!

I run through the Gilbert and Sullivan patter-songs; then as many of Cole Porter's "list" songs as I can remember. I segue into Larry Hart's ticklish, prickly lyrics, and I'm holding "Johnny One-Note"'s one note, *"Ahhh,"* when...Wait! Is that? A different note?

I duck my head, to wet my hair, and hear something like a rumble. I lie back again, chin up, ears under. Eyes closed.

It's low. But it's regular. It's a machine. An engine. *A boat! Where?*

I make my hands wiggle like flippers at my sides. And scissor-kick my legs, to get myself up as high as possible. Now, I turn a bit—wait—flap-*kick!* Turn again—wait—flap-*kick!*

There!

Get up higher. Fling my arms up, and then *splat* down! Kick! Smoke! *There!*

Grab the back of my collar. Haul up the shirtwaist! The cotton's so wet. Need both hands. Up, damn it! Yank! Got it! *Splat-kick! Splat-kick!*

If they don't see me, *will I be able to do this again?*

The cotton is so heavy, so wet and heavy. But I still see smoke, and I think I see a small mast.

I know S.O.S. It's dot-dot-dot, dash-dash-dash, dot-dot-dot. But I can't keep the soggy cloth up in the air for a dash's-worth of time. So I just wave three times. Then stop and rest. Wave three. Stop. Wave three. Stop.

Whitecaps don't come in threes, do they?

Three more waves and I have to catch my breath again. Settle, head back, ears under. Eyes closed. I should rest, shouldn't I? Save my strength, in case they go away…?

No. It's louder. I think. "Ummmmmmmmmm." *Don't do that!* Don't try to harmonize! Just listen. Is the pitch getting higher or lower?

*Same note!*

Wave three. Rest three. Wave three. Duck for three.

A quarter—no! A half. *A half tone up! It's getting closer!*

Wave three. Rest three. Wave three. Rest three.

*Fo-o-ogh! Fo-o-ogh! Fo-o-ogh!* A foghorn.

Wave three. Rest three.

*Sing three!* "He-e-ey! He-e-ey! He-e-ey!"

My ears are so full of water, I can't hear what someone is shouting from the deck. A sticky crust of salt blurs my vision, but I can see the ship. It's no ocean liner, but a big boat of *some* kind, with a white hull and varnished wood on top. And a smaller boat, slung over one side, and two oarsmen rowing to me.

One holds the oars while the other reaches down with both arms, and hoists me out of the waves, saying something. I still can't hear what, but I say, "Thank you," anyway. Probably a dozen times.

My hands grip the side of the boat, and I muster a little added momentum to climb—*flop*, more likely—over the edge, and sprawl face-down on the damp wooden planks, panting.

❀

*Water?* I'm getting wet again! *No!* I flail my arms.

But I make no splash. Taste no salt.

Fresh water! Someone is sponging my face, like Mother used to do....

"Miss Green! Wake up. You're all right now." Not Mother. A man's voice.

My eyes feel clean again. It's okay to open them and blink. He's looming over me. Pink face; white hair. Quart Brewer!

❀

I was lying on my back on something soft, the cushion of a narrow berth, with woolen blankets up to my chin. I was indoors...in a room—a wood-paneled cabin—lit by the yellowish bulb of a reading-lamp.

I sort of smiled, and muttered, "Thank you."

"You're all right now." That came from the doorway—a different voice. Another man. (*No!*) "You tried to kill yourself, Katy. Do you remember?" (*No!*) I had to see. I raised my head. Blinked.

He smiled. "You had me worried!"

"*Noooo!*"

It was Swifty Boyd. He was still wearing his ship's uniform, though it was drenched, like my own clothes, and clinging tightly to him.

Quart helped me sit up, tucked the blankets back around my shoulders, and held a white mug of hot coffee to my lips. "There's a little brandy in it," he said, "to help you rest."

I looked at Swifty, though. "No..." I coughed. It was hard to talk. I had to whisper, "No morphine?"

He glanced at Quart and shrugged. "She asked me for morphine first. Maybe I should have given her some—I mean: only enough to calm her down—because, when I wouldn't give it to

her, she broke the glass of my pharmacy cabinet, trying to get at it. Then she dashed out of the door and ran upstairs. I tried to keep hold of her—"

"The *hold*—"

"'*Hold!'* That's right. '*Hold me*'—it's what she kept saying. There were soldiers all around—they heard her. She was raving. She ran out on deck and climbed up on the rail."

"Were you really trying to jump overboard?"

"No, I—"

"She sat right up on it, and swung her legs over the water." Swifty turned to face me, square-on. "Of all the places to run to, Katy, you picked the *worst* spot—right where the crew had left the gangway latch open. I didn't know that when I got hold of your arm, or I'd have kept one hand on the rail. You grabbed my jacket and pulled me over with you."

"Lucky for you *both* that we weren't far behind," said Quart.

"I'm sorry, Katy."

"You—"

"I shouldn't have said...what I said. After a man sleeps with a woman, it's really unkind to tell her it's all over—"

"Unkind?"

"I didn't think you'd take it so hard."

"I didn't—"

"Just rest, Miss Green," said Quart. "And remember—there's always a reason to go on living. You'll be all right."

"I—"

"Lie back and sleep, now. We'll leave you alone. We can talk about what happened after you've had a chance to rest, and think—"

"No. The ship! The *Lurline*—"

"It's too far ahead of us now. We can't catch up and put you back aboard. We won't reach San Francisco till five or six days after they do. I'm sorry, but there's no way to get you there faster. And at least you're safe! You and Swifty both! Just rest, all right? Nan keeps some clothes aboard. I'll go look."

"They might not fit," Swifty said. "Katy's a couple of sizes

taller. Check the crew's lockers. I'm sure she won't mind wearing pants."

"I'll find something. Come on, Swifty. You need to rest, too."

Quart went out first. Swifty closed the door behind them, but slowly, staring at me through the narrowing gap, until the latch clicked shut.

I forced myself to get up, stretch my hand out toward the door, flip the latch, and lock myself inside. Then I flopped back on the bed, switched off the lamp, and closed my eyes again.

❀

Darkness. Night-time?

I rubbed the sand of sleep away. A little moonlight came through the porthole beside me. I rolled over and looked out. The ocean was dark against the night sky.

I reached up and flicked on the lamp. Brown wood paneling. A small porcelain sink in one corner, with a mirror and another lamp over it. A guest-cabin, no doubt: smaller than 533 on the *Lurline*, and much quieter. But not actually quiet. I swallowed, to clear my ears. There was an engine, somewhere, holding its rhythm and pitch steady against the off-beat solos of various creaks and groans, and an occasional percussion from the slap of waves against the hull.

I remembered all the singing and humming I'd done in the water. Then I made myself ignore the memory.

I was naked under the blankets. I held them to my shoulders and sat up, swinging my legs off the bunk. There was a wooden rail, a bit higher than the mattress, to keep sleepers from rolling out of bed.

Wait! *Dizzy!* I let the blanket drop and gripped the wood, forcing myself to breathe deeply until the whirling passed. I slid off the bunk, but kept my backside leaning against it while I stood up.

My brassiere, panties, shirtwaist, and plaid skirt—what I'd been wearing—lay over the back of a chair. They had dried, but were crusted with salt. How long would it have taken for them

to dry? *What time is it?* Black wool trousers, something whitish, and a striped, man-tailored shirt had also been left for me, hanging from pegs on the back of the door.

I tottered across the cabin, and braced myself with one hand on the sink. This ship wasn't nearly as steady as the *Lurline.*

The whitish garment was cotton: a frayed, button-flap "union-suit." I got into it and felt warmer right away; then into the shirt, and the trousers—I had to roll up the cuffs of both— and cinched the belt. The union-suit went all the way down to my toes, so I didn't need socks; but a thick woolen pair had been left for me, and I didn't see any shoes, so I pulled them on, too.

Instinctively, I looked in the mirror. My hair was tangled, and stiff with salt.

What had happened to the *Lurline*? How did Swifty—?

A knock. "Excuse me, miss." I didn't recognize the voice. "I have hot broth for you. May I come in?"

"Okay."

The knob turned, but the door didn't open. "It's locked."

"Oh. Sorry. Hold on." I tensed myself, in case something—or someone—dangerous were on the other side. Then I snapped the latch and pulled the door in.

A young man held a small tray with a white mug, a spoon, and a napkin. He was pecan-brown, and shorter than I, but wearing much the same clothes as had been left for me. He said, "I'll set it down here, all right?" and put it on the night-stand, under the lamp.

"What time is it?"

"Just after ten, miss."

"Where is Mr. Brewer?"

"At the wheel, miss."

"I've got to talk to him. Where's Doctor Boyd?"

"In the next cabin, miss."

I pretended to cough, so I could lower my voice. "When did you...rescue *him*?"

"Just before we found you, miss. The first thing he said was, we should look for *you*, that you might be close by."

"I need to see Mr. Brewer, right now."

He stood, unsure for a moment. "He can't leave the pilot-house."

"Will you take me to him?"

"Certainly, miss. Follow me, please."

In the corridor, I said, "I've never been on a yacht like this be-fore. It *is* Mr. Brewer's yacht, isn't it?"

"Yes, miss. She's called *Osprey*. You're on the cabin deck, in number three. And we go up here." He gestured me up a curved stair, into a wood-paneled salon. A dining table and galley formed the forward end, sofas and chairs the other, and a small fantail deck beyond. He opened a side-door and motioned me out into the breezy night. I followed him forward, grateful for the handrail along the salon's outside wall, since I didn't want to touch the seaside rail at all.

The crewman called, "The lady—to see you, sir!" and opened the pilot-house door for me.

"Thank you, uh…"

"Martin."

"Thank you, Martin."

Quart gave me a nod of acknowledgment, but kept his hands on the wheel. The undulating sea was all troughs between wave-tops, nearly as long as the *Osprey* itself, and we were heading straight *into* them, punching through each wave on the way up, until it broke over the bow with a swoosh of foam and spray, and the *Osprey* settled back down a little before continuing on.

Quart looked over his shoulder. "Miss Green! Are you feeling better? Swifty was worried you might—"

"I need to speak to you, Mr. Brewer. Alone."

"Take the wheel, Martin."

"Yes, sir." Martin stepped past me, and had one hand on the wheel before Quart relinquished either of his own.

"I'm short-handed, this trip," Quart told me, as he led the way back along the deck and into the salon. "There's only two in crew, instead of four. One just got his reserve notice, and the other man's wife is having a baby. Coffee?"

"Thank you."

An electric percolator stood on a shelf beside the dining ta-
ble, held down by two loops of rope. He filled a white mug from
the spigot and set it in front of me, along with a chinaware set
that had OSPREY and a stylized anchor on the sugar bowl and
creamer. Then he gestured toward a pair of canvas-slung wood-
en chairs—like movie-directors' chairs—at the lounging end of
the salon. One had CAPTAIN embroidered on the back, and the
other, MATE (Nan's, I supposed). I took hers, and settled my mug
on a small cocktail table between us.

"What's happened to the *Lurline?*"

"As I told you, Miss Green—" he spoke more slowly than
seemed necessary "—she's too far ahead, especially since we had
to stop...well, you know why. So, I'm sorry, but we can't catch
up now, and we can't ask them to stop, merely to take you up on
board."

"I meant—is the *Lurline*...all right?"

"Oh, she'll steam right through this weather. And it won't
bother us much, either. Don't worry. *Osprey's* made this run a
dozen times." (Not slow. Deliberate. As though he felt wary of
me—or as though I were a patient in a mental ward.) "So, I
would really appreciate it if you would take on some of the ship's
*non*-sailing duties. Housekeeping, perhaps, and helping the
cook in the galley, with—"

"Of course. But I need to talk to Stan O'Malley right now.
Can I—"

"Oh, he knows you're all right. I spoke to him right after
we picked you up. He said he'd tell your musician friends what
happened."

"He doesn't know what happened, and obviously, neither do
you!"

"Calm down, Miss Green."

"Let me call him on your radio-telephone."

"No."

"I have to!"

"You can't."

"*What?*"

"*None* of us can use the radio-telephone right now."

I waited a beat. "Why?"

"I don't want you to think I'm psychic, Miss Green, but do you remember my saying that we were going to have some trouble soon from the Japs?"

Another beat. "Sure."

"Well, we got *double* trouble today. Shortly after you, uh... took a header over the rail—"

"I did *not*! I was trying to get away from Swifty, after he—"

"Please. I don't want to hear about your love-life, Miss Green. Frankly, I thought you had more maturity. But it's none of my business. You and Swifty will just have to get along, somehow, for the next seven days. I must tell you something very important now, that perhaps I should have told you right away. But Swifty said I should wait until you were feeling all right, and I didn't want you getting hysterical, and leaping over the rail again."

*Cool head—main thing.* I held back, and let that pass. I'd show Quart I was calm. Rational. I'd find the right moment to tell him what really happened. "I'm fine now. Please tell me."

"Mouse Ichiro tried to blow up the *Lurline*."

"No!"

"Mouse soaked his own crate of fertilizer in diesel oil, and lit a couple of candles for fuses. Then he committed suicide—shot himself so he wouldn't be caught. Japs *like* to do that, you know—kill themselves. It's in their nature. Anyhow, someone must have seen Mouse doing something suspicious, because Stan got a phone call just before nine this morning, telling him to go down in the hold and take a look."

*One of the soldiers believed me.* What a relief! But now I had to convince Quart. "I'd still like to talk to Stan."

"Well, here's why you can't." He looked me right in the face. "The Japs launched their invasion of Hawai'i this morning."

"Oh."

"It was a sucker-punch. They didn't declare war—they just

sent dozens of planes all over O'ahu, and dropped bombs. They sank a battleship in Pearl Harbor: capsized it, with hundreds of men inside! And that's probably not the only ship they sunk. They bombed the Army Air Corps fields, too, so we couldn't send up planes to retaliate."

"I have to tell Stan—"

"Please. Just sit still and drink your coffee. There's nothing you or I can do about it. We got the news over the radio from Honolulu, about ten-thirty this morning. Governor Poindexter's put the Islands under martial law, so we're lucky to have sailed away when we did, or we'd be stuck there. Then the navy told all vessels to alter course and get out of the shipping lanes, in case there are Jap submarines along the regular routes. We're supposed to maintain what's called 'radio silence,' too, meaning: no transmissions, except for emergencies. We don't even know where the *Lurline* is right now, and we haven't heard from her since we hailed Stan, to tell him about picking you and Swifty up, which was—" he glanced at his wrist watch "—about nine hours ago."

"Then I'll tell *you*, Mr. Brewer, and you can decide whether this is an emergency or not."

But just as I began, Swifty yanked open the door, stepped inside, and closed it behind him. "Am I interrupting?"

"No! Come in, come in. Miss Green was about to tell me a story."

"I'd like to hear it. Let me just grab some coffee." He had borrowed some clothes from Quart. I wondered if he still had the scalpel in his pocket. Nodding a hello to me, he filled a mug, then went over and stood with his back to the outside door.

How could I tell Quart *now*?

"Did you find everything you need, Swifty?"

"The ship's just as I remembered it, Quart," he said. "You even gave me my same old cabin—thank you! So it was easy to locate the two most important things on board: the galley and the 'head.'"

"You're always welcome on board, Swifty, though I'm going

to have to ask you to work your passage, this time. I'm short-handed."

Swifty looked at me, made his tip-of-the-ten-gallon-hat gesture, and said, "Yes, sir. Eh-ee-yup!"

I didn't laugh, this time. I was seething.

"Go ahead with your story, Miss Green," said Quart.

"I was going to say: It was Swifty here who made that bomb on the *Lurline*. He killed Mouse so he could frame him for sabotage. Swifty was there when I found Mouse. He was *already* there, when I got down to the hold. I wanted to phone Stan, but he said we should go up to his office, and call from there."

Swifty chuckled. "She's obsessed with 'calling Stan.' It's like running to the teacher because I dunked her pigtails in the ink-well. Did you think he'd put me on report, for being a cad?"

Quart was looking at Swifty. I couldn't read anything in his face to suggest I'd made an impression; but he didn't crack wise, and he turned back to me.

So I continued, "When we got to the examining room, I remembered something from the night Bill was killed. As soon as we brought Bill in on the stretcher, Swifty sent us all away. He told me to go get Roselani and his nurse; and he told Mouse and Danny Boy to go find Stan. But he could have telephoned them, or had them paged! He *wanted* us to go away, to get out of there, so he could make sure Bill died on the examining table."

Swifty shook his head. "That's a vicious accusation, Katy."

Quart took his pipe out, checked the bowl, and put it in his mouth. "Are you saying Swifty killed Bill, too?"

"Yes! Of course."

"I talked to Nan by radio-telephone last night. She says you accused *her*."

"Ha! See what I mean?" Swifty was exultant. It was true, of course, but everything was different, now that—"And now you're accusing *me* of malpractice."

"No, Swifty. I'm accusing you of murder."

"Oh, please! Just because I…spurned you, doesn't justify making up something like this. I did *not* seduce and abandon

you, Katy. You're a grown woman. You practice birth-control! But your mind is unstable. You feel I mistreated you; all right, maybe I did. But your way of getting back at me is to jeopardize my career, and take away my license to practice medicine."

"I'd take away your liberty, too—maybe even your life, if I could! You'll get the chair for this."

"Hell! For two murders, I should get *two* chairs."

Quart chuckled. "And do these two chairs come with a dinette set?"

They both laughed out loud.

Swifty grinned at me. "Why don't you make it *three* murders? You could accuse me of pulling that crate down on Frank Todd, as well. Three's a much nicer number, I think. Go on. Accuse me. I dare you!"

"Frank Todd?" Quart echoed. "You mean the crew-chief down in the hold? Stan didn't say *he* was dead."

Swifty looked at him, then back at me. "Katy's crazy. She even tried to kill herself. Now she has to say something to make *me* look bad, instead of her. So she's talking about Todd—"

"*You* said Todd was dead, Swifty. Not Katy. Or Stan."

"Maybe Stan hadn't found him," I said, "by the time he talked to you. But I'll bet he's found him by now. Will you radio him, Mr. Brewer? Tell him to look where the doctor said to look: in the hold, underneath Mouse's crate of fertilizer."

"I told you: we can't radio him. We'd risk giving away our position."

"You've *got* to tell Stan!"

Swifty gave a snort of a laugh that twitched the untrimmed edges of his moustache. He said, "I need a smoke," and reached into his jacket. But instead of a tobacco pouch, out of his pocket came a gun—a different gun from the one he'd brandished on the *Lurline*.

"That's *my* gun!" Quart reached for it, but stopped short.

"Please don't move!" Swifty walked toward us, keeping his finger on the trigger. "Better still, Quart, get up and sit over on the couch. Not you, Katy. You stay right there."

Quart moved, and Swifty took the CAPTAIN's chair. With his free hand, he fished his cigarette papers and drawstring pouch out of his pocket and set them on the little table. But only then did he realize he'd have to put down the gun to roll his smoke, or else do it at some distance, beyond our reach. And the room wasn't that big. He smiled; his brow wrinkled.

"You can't keep us covered for a whole week, you know," Quart told him. "You're probably still tired from being in the water. You'll fall asleep long before we reach San Francisco."

"But it's only a day or so back to Honolulu. I can stay awake *that* long, with your excellent coffee. The Imperial Navy will have taken the Islands by then."

"And welcome you as a hero?" Quart asked. "Is that what you figure?"

"They know I've played a small part in their operations. I gave it the old college try!" He chuckled, made a mock punch with his fist, said, "Go 'Chrysanthemums'—beat 'Eagles'!" and then laughed out loud.

"But what the Japs did—without even declaring war first—it's barbarous!"

"Please, Quart. The whole world is barbarous. There's no point in 'declaring' war anymore. If you need to make war, you just do it! You were saying we should round up everybody with a Japanese name, and put 'em in labor camps. You didn't say we should declare war on *them* first! The important thing is: we are *at* war now, and everybody has to choose sides. I grew up in Paraguay, where there's always been a 'strong-man,' a dictator, if you will, running the country. It's the most efficient form of government these days: no legislative delays, no political parties. Just decision followed by action!"

"I thought you were anti-imperialist, Swifty—something we could actually agree upon. What happened?"

"I've told you all along, Quart: for colonies to achieve independence, they need a champion to fight alongside them, against their colonial rulers. France helped America against England. That's what Japan has been doing in Asia, these past ten

years or so. I could make the case for why America should sup-
port the Japanese effort, instead of opposing it. But why make a
speech? This is faster, and frankly, it's more exciting."

"Did you…do everything that Miss Green said?"

"Probably, yes."

"And you really believe that Japan—"

"I don't have to believe *anything*, Quart, to do what I've done.
I don't happen to believe, for example, that Hirohito is a god,
nor that life under his rule is heaven on earth. And as for Tojo's
military men—a good number of them are psychopaths, who
look upon the Chinese the way Nazis regard Jews. But if the
United States has the right to declare a Monroe Doctrine, and
insist that America's interests lie everywhere in the Western
Hemisphere, then Japan has the same right in East Asia."

"And Hitler, in Europe?"

"Why not? He's merely the twentieth-century Napoleon, the
new Charlemagne, the 'thirteenth Caesar,' if you will. Strong
men have always sought to rule Europe."

"Madmen, too," I said quietly.

"Look, here is what's going to happen." Swifty had reverted
to his annoying "doctor" voice. "After only a couple of years,
this war will be bogged down in trenches, like the first war was.
Maybe not literally in trenches, but stalemated in some way.
Then all the 'great powers'—the ones who are still standing—
will stop the war, and divide the world among themselves, along
relatively defensible lines. Hitler gets Europe, of course; Musso-
lini takes the Mediterranean and Africa; Stalin gets *mainland*
Asia, along with Persia and Arabia. The United States gets the
entire Western Hemisphere, North and South America both—
just as President Monroe said it ought to. And Japan gets
the rest of Asia and the Pacific Ocean. Neat and tidy, and—
finally—stable."

"A world-wide war can be stopped, just like *that*?"

"There are two kinds of people, Quart, just as there are two
kinds of nations: the strong and the weak. I'm one of the strong.
You're one of the strong. You are, too, Katy—it accounts for

much of your appeal. But I have you both at a disadvantage, so you're *honorary* weaklings today. As for nations, Japan and Germany are obviously the strong ones. Holland, France, Belgium…they're already conquered; and England is on the ropes. If the colonial powers can't defend their own homelands, they deserve to lose their colonies. Japan already holds most of coastal Asia, from China down through Korea, out to Formosa and the Marianas—Saipan and Guam—and east through the Marshall and Caroline atolls. By this time next week, they'll have Hawai'i, too. Then French Indochina and the Dutch East Indies will fall; British Singapore and Malaya soon after that. India's so fed up with England that they'll actually *welcome* the Japanese as liberators! Did I mention? Japan will take the Philippines, too, because the United States didn't bother to give it back to the Filipinos after the Spanish-American War. Don't you see? It's the *Asian* people's turn now. It's finally they, themselves, who will work things out for the good of their own countries. And who better to give Asians back their own countries than one of their own?"

He was eyeing the cigarette-makings, clearly wishing for a smoke.

So I said, "Let me roll one for you."

He smiled. "Thank you." Then, for Quart's benefit, he added, "That's her flirtatious gimmick, like losing at miniature golf. Go ahead and roll me one, Katy." He pushed the pouch and papers across the little table to me, keeping the gun well in sight.

"Can I have one, too?"

"You don't smoke."

"It won't kill me!"

He laughed out loud.

I sprinkled far too many flakes onto the first paper, and let the roll get too loose before I licked the edge. It looked more like an ice-cream cone than a cigarette. My second attempt was tighter, and came out more cylindrical, though when I licked it, I had to pinch the far end to keep the flakes from falling out.

"Good enough," he chuckled, as I slid that one across the table to him, and took the other for myself.

I put the small end of the cone to my lips, raised myself up off the chair, and leaned forward—

"Hands on the table-top, where I can see them!"

I nodded, letting the cigarette bobble, and kept my hands flat on the cocktail-table. He leaned forward, snapped his Zippo alight, and held the flame for me, his eyes staring straight into mine.

It was just what I'd hoped he'd do.

As I leaned in, he couldn't see me slip my thumbs under the edge of the table. I inhaled, and drew the flame into the cigarette—just deep enough to set the paper and an inch of loose tobacco alight. Then I *blew* straight out!

Smoke and embers shot into his eyes. Smoldering flakes singed his hair and stung his cheek. I hoisted the table and flung it at him, knocking the gun out of his hand. Quart bounded up and hurled himself at the gun, but Swifty did the same, and they tumbled onto the floor together.

I couldn't see who got hold of the gun, but it went off underneath them with a muffled report. I steadied myself, getting ready to use *ju-jitsu* in one last fight for my life. But it was Quart who stood up with the gun, and Swifty who lay underneath, groaning, and clutching a blood-red splotch on his thigh.

"Bring me that rope that's holding down the coffee-urn, Miss Green. I don't care if it spills."

He handed me the gun when I brought the rope, and he snugged it around Swifty's wrists and ankles with thick sailors' knots. Swifty continued to blink tobacco soot out of his eyes.

We stood him up—with his leg wounded and his ankles hobbled, he moved more by hops than by steps—and led him toward the stairwell. The ship pitched a little more dramatically just then, and Swifty's feet slipped; he tried to keep his hip against the outside door for support, but fell to the floor, wriggling in pain.

Quart stuck the gun in his waistband, and stepped around to help Swifty up. But then he jumped back. Swifty had freed one hand from the rope and slashed Quart's cheek with the scalpel

that he'd somehow retrieved from his jacket pocket. Before Quart could pull out the gun again, Swifty had slit the binding from his feet, flexed his knees, sprang up, and unlatched the door behind him. Then he called out, *"Sayonara!"* and flung himself through the door, straight over the seaside rail, and dove headfirst into the ocean.

I expected Quart to run outside, yell, "Man overboard!" and toss a life-preserver. But he didn't. Pinching his cheek to stanch the blood, he stared out to sea, panted until he'd caught his breath, and then closed the salon door.

Quart made the radio call on the Marine band—it certainly qualified as an emergency—and when Les Grogan picked it up, he got Stan to come to the radio shack. Ivy insisted on coming, too. So, with Les switching to different radio bands every few minutes, to confuse anyone who might be listening, we got in almost an hour's worth of talk. By then, it was past two in the morning.

The Sarongs would meet the boat when I got to San Francisco; there wouldn't be another crossing to Hawai'i on the *Lurline* now, anyway—and no work for dance-bands on a troop-carrier. Ivy said Lillian was going to do what she'd said she would: go down to the Women's Army Auxilliary and ask about enlisting. So Ivy figured she'd better stick with Lillian, and keep her out of trouble. Roselani was keeping her distance from them, and merely "phoning in" her parts with the Sarongs, because whenever she was off-duty, she and Phillip DeMorro and Nan Brewer were working up a new act that *didn't* include Ivy or Lillian.

Stan wanted all the details about Bill, and about Swifty, too. I told him what I knew, but I couldn't help thinking—more than once—how confused I'd been, because everybody had two faces. Swifty had seemed so attractive to me, smart, and funny, and seeming to care about other people. Not just patients, but people he didn't even know, who were fighting for their countries'

independence; and he'd sounded so distressed, when he told me he couldn't "save" Bill's life. So…well, I guess I had jumped to conclusions. But I wasn't going to lose any more sleep over him. He did try to kill me. Twice.

Stan wanted me to know it was Jingo—sorry—*Tad* Mirikami who'd made the call. Palling around with his fellow soldiers in the foyer that morning, he'd heard me trying to phone Stan, before Swifty hustled me out on deck. Being in the ordnance department, he volunteered to go down into the hold with Stan. He was the right man for *that* job.

❅

I hadn't yet eaten a full meal, but the *Osprey* was still pitching through the waves, and the smell of our diesel's exhaust never seemed to blow away. All I could manage to get down, along with more coffee, was a couple of slices of bread and guava jam.

With a crewman at the helm, Quart and I stood at the rail beside the pilot-house, looking out to sea. A gibbous moon peeked through the clouds, but the waves were still high; and each time the *Osprey* pitched through them—we were still "beating to windward," he said—the decks were drenched.

"Goddamn Japs!" he muttered—for about the fiftieth time that night. "I told you they're trouble."

I sighed, knowing I'd have to endure hundreds more of his "I-told-you-so's" over the week ahead. But I couldn't chastise him; he'd saved my life. Besides, he was the captain, and I was…well, one of the crew now, with beds to make up tomorrow, and floors to sweep, and dishes to wash. My sax and violin were sailing away, far ahead of us; there'd be no way I could practice for a whole week. But we'd have music on board: Quart had brought along his portable phonograph, and the valise full of hep swing platters.

"Swifty told me," I said, "that one of the things he admired about the Japanese was that they would kill themselves if their plans fell through. And that, like Martin Eden, this would be his way of doing it."

Quart said only, "Mmmm." He tapped his meerschaum pipe out on the palm of his hand, letting the little red embers whip away and flutter astern, like a comet's tail, to burn themselves out in the breeze, and fall, extinguished, into the sea.

I found myself saying, "*Ka makani kāʻili aloha.*"

He beamed. "I know that song!"

"I just learned it."

"'Love, snatched away by the wind.' Right?"

"Yes."

He didn't say anything more for a couple of beats, then he tucked the pipe back into his jacket pocket. "Hell of a way to end a love affair."

I nodded. "Hell of a way to start a war."

# Afterword

I WAS BORN IN 1946, so I created the ostensible author of the Katy Green mysteries, Hannah Dobryn, to "remember" Pearl Harbor *for* me. But I have researched the era—I also play its music—and although *The Last Full Measure* takes a few liberties with history, it is not counter-factual.

The *Lurline* of this adventure is the *Lurline* that carried movie stars in the 'Thirties, and servicemen in the 'Forties. She continued to carry vacationers to and from Hawai'i until 1963, when she was sold.

But her name had become such a draw that another Matson liner was re-christened *Lurline*, and sailed the same San Francisco–Los Angeles–Honolulu route for seven more years. In 2000, despite an effort to hook her up to a San Francisco pier (like the *Queen Mary* in Long Beach), that *Lurline* was sold for scrap and was "lost" while under tow in the Southern Ocean. The Matson Line does operate a ship called *Lurline* today, but she is a container-freighter.

A 1933 brochure trumpeting the maiden voyage of the *Lurline*—with an enormous, colorful, and detailed rendering of

its deck-plans—has hung on my office wall throughout the development of this adventure. Additional onboard details, as well as the specifics of inter-island steamers and "amphibian" airplanes, come from various photographs, postcards, advertisements, and brochures in my collection. I also learned much from *To Honolulu in Five Days* (Ten Speed Press, 2001): a well-researched and generously illustrated book about the *Lurline*, and about the Hawai'i to which she sailed in her heyday.

The Hawai'i of 1941 was much like America's rural farm states. But to most American tourists, it must have looked like a foreign country. Barely one inhabitant in four was "white," while one in three was of Japanese ancestry. Pidgin English was more common among the general population than "proper" English. (Linguists maintain, by the way, that what people in Hawai'i speak is a "Creole," and not a true Pidgin, although they don't expect to see the colloquial word replaced any time soon.)

The Pidgin spoken in *The Last Full Measure* is rendered in the way I hear Pidgin spoken today. This is probably anachronistic, and may well include some more recent catch-phrases. But the accents and cadences of pre-war Pidgin are lost, and what little was transcribed is now inadequate for constructing dialogue. So I hope I may be excused for attempting to render this musical and expressive, uh, Creole into print. The most accessible books about it today are in a series beginning with *Pidgin to Da Max* (The Bess Press, 1992).

I have endeavored, wherever possible, to use historical facts to advance the plot and establish the characters in *The Last Full Measure*. The *Lurline*'s radioman (Les Grogan was his real name) did report to the U.S. Navy that he heard unusual Japanese radio traffic during the westbound crossing, November 28 through December 3, 1941—though nothing apparently came of it. And Radio Tokyo did broadcast the phrase "East wind, rain" in its weather report, upon the success of the attack. No

actual sabotage was attempted that day against the *Lurline*, but she did leave Honolulu on December 5, bound for San Francisco, with a large contingent of servicemen and dependents aboard; and she did alter course in response to the news from Pearl Harbor.

Pacific Home Systems did put a swastika—as noted: the ancient Hindu good-luck symbol, not the Nazi insignia—on their best surfboards. And the Cal Berkeley Bears did shut out the Stanford Indians, 16–0.

In 1941, C. Brewer & Company was the oldest of the "Big Five" most powerful businesses in Hawai'i, and it owned or operated the largest sugar cane fields and mills on the Big Island. But it was no longer a family-held company, and it had not been run by anyone named Brewer for many years.

What happened in Hawai'i in the 1890s is still open to interpretation. Indisputably, Lili'uokalani was deposed by a committee of Honolulu merchants; there was a brief armed *putsch*; the queen was convicted of certain crimes; and after considerable lobbying and debate in Washington, and the election of a new president, the United States did annex the Islands.

But whether the queen was a victim or a tyrant, and whether annexation was a blessing or a curse, is still debated today. In 1898, Lili'uokalani wrote her autobiography, *Hawai'i's Story* (Mutual Publications, facsimile edition, 1990) to make her case in Washington; and many subsequent books have followed her lead and taken her side. The Annexationists' case is especially well made by Thurston Twigg-Smith, grandson of one of the committee's leaders, in *Hawaiian Sovereignty: Do the Facts Matter?* (Goodale Publishing, 1998). Feature films have never covered the drama, but *The Trial of Lili'uokalani* is a provocative stage play—first mounted in Hawai'i, in the 1970s—that playwright Maurice Zimring based on court transcripts.

The international situation in 1941, as presented here, is also historically valid. Japan had withdrawn from the League of

Nations in 1933 to protest majority votes against its actions. The emperor and his inner circle felt they were entitled to issue a "Monroe Doctrine" of their own, to get around embargoes by seizing other countries' natural resources, and to "liberate" European colonies in Asia.

In July 1938, *Fortune* magazine ran a cover story about Japan that complimented its industrial progress, but also noted the growing use of its armed forces to secure raw materials from other countries. By 1941, anyone who followed current events would have known that Japan was governed entirely by militarists and career soldiers, most of whom publicly expressed anger at the continued American embargoes of oil, steel, copper, and most scrap metals.

Though Japan had surprised and trounced Russia's navy at Port Arthur, at the turn of the century, American naval strategists did not expect it to happen to *them*. In *The Armed Forces of the Pacific* (Yale University Press), published in June 1941, Captain W. D. Puleston, U.S.N., wrote: "The greatest danger from Japan, a surprise attack on the unguarded Pacific Fleet, lying at anchor in San Pedro Harbor, under peacetime conditions, has already been averted. The Pacific Fleet is at one of the strongest bases in the world—Pearl Harbor—practically on a war footing and under a war regime. There will be no American Port Arthur."

What the League of Nations could not resolve in the 1930s, however, haunts the United Nations today: Can *any* country declare that its national interests lie—and hence, that its hegemony should extend—beyond its own borders? Does any country have the right to seize the natural resources of another? And is any country ever justified in launching an unprovoked war?

Details of Hawai'i's scenery and day-to-day life come from my own experience. I was lucky to have worked in Hawai'i, as a newspaper and television reporter, from 1969 to 1980, when life there—outside of Honolulu, and especially on the "neighbor"

Islands—was still almost entirely rural, with sugar or pineapple plantations dominating the landscape and the economy.

I spent seven of those years in Hilo, on the Big Island. My very first glimpse of Onomea Bay came at sunrise, driving along the original narrow and palm-fringed "highway" that today's tourist maps call the "scenic road." You can still visit the bay, but you won't find the arch. One afternoon in 1958, during an otherwise insignificant little earthquake, it collapsed into the sea.

—Hal Glatzer

Glenn Carlson

# About the author

Hal Glatzer worked for eleven years as a newspaper and television reporter in Hawai'i. He is a singer and composer in the swing and jazz tradition, and produces award-winning audioplay adaptations of his Katy Green mystery series. He also writes tongue-twistingly alliterative "minuscule mysteries" in the radio–private eye style. Glatzer and his wife divide their time among San Francisco, New York, and Honomu on the Big Island of Hawai'i. He may be visited and e-mailed at www.lastfullmeasure.info.

# MORE MYSTERIES
## FROM PERSEVERANCE PRESS
🂡 *For the New Golden Age* 🂡

Available now—

*Face Down Beside St. Anne's Well*, **A Lady Appleton Mystery**
**by Kathy Lynn Emerson**
ISBN 1-880284-82-0
Susanna Appleton's foster daughter, Rosamond, is certain her French tutor has
been murdered: Buxton, site of ancient Roman baths, is popular with court-
iers and spies alike. And the imprisoned Mary, queen of Scots is clamoring to
pay another visit to the healing waters....

*Paradise Lost*, **A Novel of Suspense**
**by Taffy Cannon**
ISBN 1-880284-80-4
Appearances deceive in the kidnapping of two young women from a posh
Santa Barbara health spa, as relatives and the public at large try to meet envi-
ronmental ransom demands, and the clock ticks toward the deadline.

*Crimson Snow*, **A Hilda Johansson Mystery**
**by Jeanne M. Dams**
ISBN 1-880284-79-0
The murder of a popular schoolteacher shocks South Bend, Indiana. Young
Erik Johansson was in Miss Jacobs's class, but his sister Hilda, housemaid to
the prominent Studebaker family and preoccupied with her pending marriage,
refuses to investigate this time—until Erik forces her hand. Based on an un-
solved case from 1904.

*Face Down Below the Banqueting House*, **A Lady Appleton Mystery**
**by Kathy Lynn Emerson**
ISBN 1-880284-71-5
Shortly before a royal visit to Leigh Abbey, the home of sixteenth-century
sleuth Susanna Appleton, a man dies in a fall from a banqueting house. Is his
death part of some treasonous plot against Elizabeth Tudor? Or is it merely
murder?

*Evil Intentions*, **A Feng Shui Mystery**
**by Denise Osborne**
ISBN 1-880284-77-4
A shocking and questionable suicide linked to white slavery and to members
of an elite Washington D.C. family embroils Feng Shui practitioner Salome
Waterhouse in an investigation that threatens everyone involved.

*Tropic of Murder,* **A Nick Hoffman Mystery**
**by Lev Raphael**
ISBN 1-880284-68-5
Professor Nick Hoffman flees mounting chaos at the State University of Michigan for a Caribbean getaway, but his winter paradise turns into a nightmare of deceit, danger, and revenge.

*Death Duties,* **A Port Silva Mystery**
**by Janet LaPierre**
ISBN 1-880284-74-X
The mother-and-daughter private investigative team introduced in Shamus-nominated *Keepers,* Patience and Verity Mackellar, take on a challenging new case. A visitor to Port Silva hires them to clear her grandfather of anonymous charges that caused his suicide there thirty years earlier.

*A Fugue in Hell's Kitchen,* **A Katy Green Mystery**
**by Hal Glatzer**
ISBN 1-880284-70-7
In New York City in 1939, musician Katy Green's hunt for a stolen music manuscript turns into a fugue of mayhem, madness, and death. Prequel to *Too Dead To Swing.*

*The Affair of the Incognito Tenant,* **A Mystery With Sherlock Holmes**
**by Lora Roberts**
ISBN 1-880284-67-7
In 1903 in a Sussex village, a young, widowed housekeeper welcomes the mysterious Mr. Sigerson to the manor house in her charge—and unknowingly opens the door to theft, bloody terror, and murder.

*Silence Is Golden,* **A Connor Westphal Mystery**
**by Penny Warner**
ISBN 1-880284-66-9
When the folks of Flat Skunk rediscover gold in them thar hills, the modern-day stampede brings money-hungry miners to the Gold Country town, and headlines for deaf reporter Connor Westphal's newspaper—not to mention murder.

*The Beastly Bloodline,* **A Delilah Doolittle Pet Detective Mystery**
**by Patricia Guiver**
ISBN 1-880284-69-3
Wild horses ordinarily couldn't drag British expatriate Delilah to a dude ranch. But when a wealthy client asks her to solve the mysterious death of a valuable show horse, she runs into some rude dudes trying to cut her out of the herd—and finds herself on a trail ride to murder.

### *Death, Bones, and Stately Homes,*
**A Tori Miracle Pennsylvania Dutch Mystery**
**by Valerie S. Malmont**
ISBN 1-880284-65-0
Finding a tuxedo-clad skeleton, Tori Miracle fears it could halt Lickin Creek's annual house tour. While dealing with disappearing and reappearing bodies, a stalker, and an escaped convict, Tori unravels the secrets of the Bride's House and Morgan Manor, which the townsfolk wish to hide.

### *Slippery Slopes and Other Deadly Things,*
**A Carrie Carlin Biofeedback Mystery**
**by Nancy Tesler**
ISBN 1-880284-64-2
Biofeedback practitioner/single mom/amateur sleuth Carrie Carlin is up to her neck in snow, sex, and strangulation when her stress management convention is interrupted by murder on the slopes of a Vermont ski resort.

## REFERENCE/MYSTERY WRITING
### *How To Write Killer Fiction:*
**The Funhouse of Mystery & the Roller Coaster of Suspense**
**by Carolyn Wheat**
ISBN 1-880284-62-6
The highly regarded author of the Cass Jameson legal mysteries explains the difference between mysteries (the art of the whodunit) and novels of suspense (the hero's journey) and offers tips and inspiration for writing in either genre. Wheat shows how to make your book work, from the first word to the final revision.

### *Another Fine Mess,* **A Bridget Montrose Mystery**
**by Lora Roberts**
ISBN 1-880284-54-5
Bridget Montrose wrote a surprise bestseller, but now her publisher wants another one. A writers' retreat seems the perfect opportunity to work in the rarefied company of other authors…except that one of them has a different ending in mind.

### *Flash Point,* **A Susan Kim Delancey Mystery**
**by Nancy Baker Jacobs**
ISBN 1-880284-56-1
A serial arsonist is killing young mothers in the Bay Area. Now Susan Kim Delancey, California's newly appointed chief arson investigator, is in a race against time to catch the murderer and find the dead women's missing babies—before more lives end in flames.

*Open Season on Lawyers,* A Novel of Suspense
**by Taffy Cannon**
ISBN 1-880284-51-0

*Too Dead To Swing,* A Katy Green Mystery
**by Hal Glatzer**
ISBN 1-880284-53-7.

*The Tumbleweed Murders,* A Claire Sharples Botanical Mystery
**by Rebecca Rothenberg, completed by Taffy Cannon**
ISBN 1-880284-43-X

*Keepers,* **A Port Silva Mystery**
**by Janet LaPierre**
Shamus Award nominee, *Best Paperback Original 2001*
ISBN 1-880284-44-8

*Blind Side,* **A Connor Westphal Mystery**
**by Penny Warner**
ISBN 1-880284-42-1

*The Kidnapping of Rosie Dawn,* A Joe Barley Mystery
**by Eric Wright**
Barry Award, *Best Paperback Original 2000.* Edgar, Ellis, and Anthony Award
nominee
ISBN 1-880284-40-5

*Guns and Roses,* **An Irish Eyes Travel Mystery**
**by Taffy Cannon**
Agatha and Macavity Award nominee, *Best Novel 2000*
ISBN 1-880284-34-0

*Royal Flush,* **A Jake Samson & Rosie Vicente Mystery**
**by Shelley Singer**
ISBN 1-880284-33-2

*Baby Mine,* **A Port Silva Mystery**
**by Janet LaPierre**
ISBN 1-880284-32-4

**Available from your local bookstore or from
Perseverance Press/John Daniel & Co. at (800) 662-8351
or www.danielpublishing.com/perseverance.**